EMOTIONAL IMPACT

AMERICAN

Michigan State University Press | East Lansing

April Kingsley

FIGURATIVE EXPRESSIONISM

EMOTIONAL IMPACT

♾ The paper used in this publication meets the minimum requirements of ANSI/
NISO Z39.48-1992 (R 1997) (Permanence of Paper).

 Michigan State University Press
East Lansing, Michigan 48823-5245

Printed and bound in the United States of America.

19 18 17 16 15 14 13 1 2 3 4 5 6 7 8 9 10

LIBRARY OF CONGRESS CATALOGING-IN-PUBLICATION DATA

Kingsley, April.
Emotional impact : American figurative expressionism / April Kingsley.
pages cm
Includes bibliographical references.
ISBN 978-1-60917-373-9 (ebook)—ISBN 978-1-61186-084-9 (pbk. : alk. paper)
1. Figurative expressionism—United States. I. Title.
ND212.5.F53K56 2013
759.13—dc23
2012028500

Book and cover design by Charlie Sharp, Sharp Des!gns, Lansing, MI.
COVER ART: Paul Wonner (American, 1920–2008), *Gods in Wood and Stone*, 1969, Casein
on paper, 16½ × 13½ inches. Eli and Edythe Broad Art Museum, Michigan State University,
Purchase funded by the Friends of Kresge Art Museum and the National Endowment
for the Arts, 72.73 © Estate of Paul Wonner.

g green press INITIATIVE Michigan State University Press is a member of the Green Press Initiative
and is committed to developing and encouraging ecologically responsible
publishing practices. For more information about the Green Press Initiative and the use of
recycled paper in book publishing, please visit *www.greenpressinitiative.org*.

Visit Michigan State University Press at *www.msupress.org*

CONTENTS

FOREWORD

This book is the record of a collection. The story begins in 1959, when the Kresge Art Museum at Michigan State University opened. At that exciting time, faculty member Charles Pollock, Jackson's elder brother, used his New York connections to Clement Greenburg, William Baziotes, Morris Louis, Kenneth Noland, Larry Poons, and others to shape a strong collection of Color Field paintings. But those heady early days were followed by years of scarce financial resources and inadequate staff that reduced acquisitions to a trickle.

Fast forward to 1999, when the position of Kresge Art Musem's first full-time curator was advertised nationally. Candidate April Kingsley, who was well known for her highly regarded book *The Turning Point: The Abstract* *Expressionists and the Transformation of American Art* (1992), impressed us during the on-campus interview by the depth of her familiarity with many of the artists represented in the collection. During the interview, she suggested the museum focus on collecting Figurative Expressionism, a logical extension of the existing holdings of the museum, and work that few others were acquiring at the time. Once Dr. Kingsley began her tenure at MSU, this collecting niche became a reality as she called upon her singular knowledge of artists and collectors, especially those in New York. Since figuration played a subordinate role to pure abstraction in the mid-twentieth century, many of the paintings were relatively affordable. Many of the artists were personal friends whose careers Dr. Kingsley followed

as a critic for the *Village Voice*, *Art Forum*, and *Art International*, and as a freelance New York curator. Additionally, she knew many from summers spent on Cape Cod. Through generous donations of art as well as a substantial financial contribution from an anonymous New York foundation to support the initiative, Michigan State University's Figurative Expressionist collection began to take shape.

Our goal was to represent each artist with several examples of his or her style to show variety, depth, and change. In several instances, this was accomplished through purchases that led to donations from artists, collectors, and dealers who believed in our project. Since the Figurative Expressionist approach could be found across the country, the collection includes paintings by artists working in California, Chicago, and elsewhere, although the majority and strength of the collection represents New York. Gaps are inevitable, as paintings by several artists, such as Richard Diebenkorn and Willem de Kooning, were beyond our financial means; consequently, they are represented by prints. While this book is about a specific collection and is illustrated with works of art from that collection, the wealth of information it contains paints a much broader picture of this less heralded twentieth-century approach in which the artist never lost sight of the figure.

Again, the years passed. I stepped down as director of Kresge Art Museum in spring 2010. April retired in 2011, the year that the Kresge closed. The collection was subsequently transferred to the Eli and Edythe Broad Art Museum that opened on the MSU campus in November 2012 in a new building designed by Zaha Hadid.

A wealth of gratitude is owed to many people who supported the Figurative Expressionist initiative, including the anonymous New York foundation and numerous donors of works of art, as well as to members of the former Kresge Art Museum staff who shepherded this publication to print—Bonney Mayers, Ilene Schechter, and especially Registrar Rachel Vargas—and the staff of the MSU Press—Gabriel Dotto, Anna Kramer, and Kristine Blakeslee. I would like to give special thanks to April Kingsley for her spirited championing of the artists you will read about here, for opening my eyes to artists unfamiliar to me, and for her significant contributions as Kresge Art Museum curator for over eleven years. ■

SUSAN J. BANDES | *Director Emeritus, Kresge Art Museum (1986–2010)*
| *Professor of Art History*
| *Michigan State University*

It might be said that I've led something of a charmed life. Before leaving the Master's program at NYU's Institute of Fine Arts with a curatorial degree, I had to do two internships in New York museums. My second was at The Museum of Modern Art (MoMA) with William S. Rubin in Painting and Sculpture. My first task there was to gather photographs of the Abstract Expressionist artists whose works were going to be in a major exhibition at MoMA the following year. Rubin was writing the text except for the sculpture, which was William C. Agee's to cover. Thus my first task had me visiting the greatest living artists I knew of in their studios and selecting pictures for the book with them. (I got to talk with Barnett Newman about the nine-inch tiling of walls and floor in his studio, for instance: it was to make it easy to size his 18-foot paintings in multiple 18-inch units to bring good fortune Hebrew-style.) I found myself building a scale model of the exhibition space with Rubin and making scaled-down approximations of the selected works that he could move around to try out changes. I've used a similar system ever since for my own exhibitions. We were only able to pull the exhibition itself together in time for the scheduled opening; the essays by Rubin and Agee were not far enough along to print. The show was nothing short of spectacular; we were seeing a large body of American Abstract Expressionist masterpieces together in a museum for the first time.

So from the beginning my direct contact with artists has been important to

my understanding of their work. I knew so many of that first generation, which helped the writing of my first book (*The Turning Point: The Abstract Expressionists and the Transformation of American Art*), but I know (or knew) many more of the artists in this book and have for a long time. I share my fondness for Abstract Expressionism with them and can not only understand but also feel along with them their need for more in their work: more energy, excitement, power, and clash (of color, of mood, of . . . something). But perhaps the most important thing they find missing in abstract art is a story, or the chance of a story being played out right before your eyes. Classic in this regard are Robert Henry's ceaselessly magnetic/enigmatic paintings that inevitably draw you into their mysteries. You enter them fascinated, asking questions, and feeling you can't leave without answers. But mystery veils every painting here to some degree, only skipping Diebenkorn's drawings' utter clarity. What is a Wedgwood vase doing amid all of Fromboluti's paint-table clutter? Why is a giant serpent crawling over Speyer's sleepers? What's happening in Jackson's heavenspace? And how did the person get into Henry's green sea from nowhere? Kriesberg's people communicate with birds, Trieff's with animals and skeletons, Speyer's with terrifying spirits, Beauchamp's with camels and wild horses, and Vera Klement's is a double world of abstraction/figure, female/male.

For me, Klement sums up the situation for all these artists in a few words:

I dreamed of a yet-unknown figure that inhabits a luminous space. . . . I wanted to move forward, to find a new way to make the figure from the kind of painting that the Abstract Expressionists had developed. To make the figure out of the paint itself. ■

INTRODUCTION

Figurative Expressionism has taken about as many different forms as the artists practicing it have had different styles, unlike abstraction, which is simply categorized as pure or semi, objective or non-objective, geometric or lyrical. Certainly the kinds of figurative expressionism practiced in Europe at the beginning of the twentieth century were not the same as those seen in the United States before World War II, which, in turn, are very different from the kind created here after the experience of post-war action painting by the artists in this book. Taken most broadly, all art that involves the distortion of natural forms and colors to convey strong emotion can be termed expressionist. Van Gogh's writhing sunflowers or throbbing old shoes are both paradigmatic and innovative in this regard. The Fauves and German Expressionists in the first decades of the century went on to greater color intensity and increased abstraction. One American philistine describing his reaction to a Fauve painting in 1910 called up the image of "what a particularly sanguinary little girl of eight, half-crazed with gin, would do to a whitewashed wall if left alone with a box of crayons."[1]

Americans were a lot slower to begin "expressing themselves" in paint than European artists. Perhaps this was due to a native puritanical reserve or a reluctance to loosen the sure hold they had on painting realistically. From its beginnings in the limner's art of sign painting and likeness-taking, American art had depended on clear focus and linear exactitude. The Europeans, on the

other hand, had centuries of solid grounding in painterly techniques behind them. American painters edged into expressionism through the "dark impressionism" of the Munich School by studying there. Derived from Hals and Velasquez, this wet-into-wet painterly technique led to dazzling feats of bravura painting in the hands of John Singer Sargent and William Merritt Chase at the turn of the century. Robert Henri and the fellow members of his "black gang" (the Ash Can painters) used it too, but in the service of such lowly themes—the back alleys and grimy rooftops of New York—that their efforts were greeted with howls of rage. Their work was said to be a deliberate conspiracy to blacken the eye of America. Yet the few brave painters to attempt Frenchified expressionism, such as Alfred Maurer and Max Weber, met with barely kinder rejections, despite the gentle nature of their subjects. Ultimately, the hyper-intense landscapes and nature-inspired abstractions of Marsden Hartley and Arthur Dove were the best of what John Baur has termed

America's "personal experiments" in expressionism.

During the 1930s, the remaining traces of our mild painterly "expressionism" infused energy into Social Realist and Regionalist painting. The dynamic figural distortions of Thomas Hart Benton and William Gropper vigorously expressed the ideas of that time. In the following decade, a faceted, claustrophobic, encrusted kind of Europeanized expressionism dominated figure painting. Moreau, Rouault, and Soutine seemed to set the example for artists like Abraham Rattner, Hyman Bloom, and Jack Levine, whose work was in stark contrast to cooler realists like Edward Hopper and Andrew Wyeth.

The Abstract Expressionists, or Action Painters, who formed the New York School, which took over leadership of the art world from Paris, changed everything. Suddenly, with Jackson Pollock flinging paint onto the canvas, Willem de Kooning's whiplash lines, and everyone else making personal statements with gestures of their own, artists were free to

express themselves in paint. The universal truths were now art as self-discovery, as risk taking, as gesture, fraught with tension and anxiety, fast and full of New York energy. The way these Action Painters were discussed by critics had its effect as well. Pollock had been singled out in the 1940s because his art was so angry, tense, and violent in its expressiveness. Clement Greenberg described it this way in 1946: "Pollock's superiority to his contemporaries in the country lies in his ability to create a genuinely violent and extravagant art without losing stylistic control."[2] De Kooning's paintings in his 1948 show were described as passionate and having a fierce energy. In them, the process of painting was said to be an end in itself—the subject. This is particularly important for our Figurative Expressionists since the paint is their subject, too, or at least equal in importance to their ostensible subject matter. Artist/critic Paul Brach wrote at the time that Franz Kline's paintings were symbol and physical fact united in a single gesture and that Kline

conveyed "the immense excitement of the single creative act" in works that were statements of an acute crisis.[3] The immediacy of his brushstrokes, their whack-in-the-solar-plexus impact, made even Pollock's flung paint seem almost casual by comparison.

Thomas Hess's article "De Kooning Paints a Picture" appeared in *Art News* in March 1953; at the time, de Kooning was showing six large *Woman* paintings at the Sidney Janis Gallery. The article's focus on process was of direct importance to the emerging Figurative Expressionists, but the indirect effect of the symbolic subject matter became at least as important for them, since it shone a spotlight on the emerging issue of representation. Some critics in Hess's circle even began to discuss the more painterly paintings by traditional representational artists in the same manner and with the same praising tone as they used for the Abstract Expressionists. The rhetorical style (full of words like 'energy,' 'angst,' 'immediacy,' and 'impact') that had come into existence to describe Abstract

Expressionist paintings became general currency during this period. A classic example of this was Alfred Barr Jr. when he organized *The New American Painting* for The Museum of Modern Art in 1959, an exhibition surveying both post-war generations of artists—abstract and figurative. In describing their work Barr said:

Many [artists] feel that their painting is a stubborn, difficult, even desperate effort to discover the 'self' or 'reality,' an effort to which the whole personality should be recklessly committed. *I paint, therefore I am.* Confronting a blank canvas they attempt "to grasp authentic being by action, decision, a leap of faith," to use Karl Jaspers' Existentialist phrase.[4]

When, early in the 1950s, Pollock and de Kooning painted pictures containing recognizable imagery, they were greeted with dismay by the orthodox followers of Abstract Expressionism but as portents of the future by all those who welcomed a return to the figure.

The way the Greek chorus echoes, magnifies, and

diminishes the relative importance of the action taking place on the stage in ancient dramas is close in spirit to the way sophisticated New York art critics manipulated the readers of their reviews and articles to support certain artists and to disregard others. They defended their favorites like Midas his gold, though, in public. But the complexities of artist-critic relationships are far too great for this modest format; suffice it to say that the artists in New York benefited from critics' attention when they most needed it—in the 1940s and very early 1950s—and were usually able to carry on by themselves when that became necessary later. Whether one sees the figure at mid-century as something that had to go—as the majority of pro-abstraction artists and critics did—or as something to be combined with other media, our brave artists began to feature nudes in bucolic settings: the edge of the sea, a pond, the woods, or the beach at night, alone or in groups, indoors or out, but always embedded in their surroundings, one with them.

When the last century passed the midway mark, the artists with our attention here were too serious and romantic to accept Pop Art or the cartoonish Chicago style, but they did identify with the efforts of the older artists on the West Coast like David Park, Elmer Bischoff, Richard Diebenkorn, and Nathan Oliveira. Too committed to painterly ideals for Photorealism and to excitement in painting for Minimalism, these committed Figurative Expressionists have continued to this day to paint strong, even powerful examples of work with a commitment to the passion of painting. The East Coast artists included in this book are Robert Beauchamp, Miriam Beerman, Nanno de Groot, Elaine de Kooning, Robert De Niro Sr., Sherman Drexler, Louis Finkelstein, Sideo Fromboluti, Grace Hartigan, Robert Henry, Lester Johnson, Irving Kriesberg, Nicholas Marsicano, George McNeil, Jay Milder, Nora Speyer, and Selina Trieff.

All these artists steadfastly maintained a strong dual allegiance to the figure and to Expressionist paint handling

for more than half a century, although occasionally some have made side trips of personal exploration. The core group of eastern Figurative Expressionists consisted of Robert Beauchamp, George McNeil, and Jay Milder—New Yorkers, each of whom created their own worlds of characters with functions. Bob Thompson, Gandy Brodie, and Nanno de Groot in Provincetown in the early years were a big stimulating impetus for their early work. Most of the artists seem to phase in and out of tighter/looser paint handling. Irving Kriesberg often used bird and animal stand-ins for his figures, and Robert Beauchamp went through a phase of painting camels and flaming apples. Robert De Niro painted at least as many still lifes and unpeopled interiors as he did figurative canvases. Finally, Nora Speyer and Sideo Fromboluti paint the figure during the winter, but not in their summer months on Cape Cod, preferring to paint from nature when it is lushly available. Only Nicholas Marsicano, George McNeil, and Grace Hartigan can be said to have

stayed with the figure and a "New York School look" through thick and thin.

But all the artists involved themselves with the primacy of paint, with finding their image in the process of painting itself, and with the physicality of paint, even though there are, of course, marked differences of degree of execution and of intent among them. De Niro, Hartigan, and McNeil had already built or begun to build reputations for themselves as fine Abstract Expressionists by the fifties, and therefore they can be seen as bridge figures (along with Elaine de Kooning). Marsicano, Drexler, De Niro, and Fromboluti have a calm, almost classicizing attitude toward the figure, yet their work continues to have that raw, aggressive lack of ingratiating smoothness that we associate with Abstract Expressionism.

The artists in this collection mostly came to maturity—meaning that they came to an epiphanous understanding about themselves and their art—at some point in the 1950s, a decade that is grossly oversimplified in many people's minds.

Everyone has strong ideas about it—about Eisenhower and McCarthy, the Cold War politics and retrograde economics, and the good things: the music, the familial love, the glimmerings of a hope for the expansion of personal freedom. It was an extremely complex period, not the least so in the art world of the day. While Abstract Expressionism was growing stronger every year, gaining adherents and acceptance, there was a "back-to-the-figure" undertow that pulled toward conservatism and simplification rather than forward with the complexities of Figurative Expressionism.

As Tom Hess so eloquently put it in his assessment of the current scene in 1956, these artists "have had to follow on the stage of public scrutiny the applause and catcalls which have greeted Abstract Expressionism since 1940."[5] Most of them were in their thirties and had come to New York because it was the only place for an artist to be at that time. Sideo Fromboluti recalls it as a "period of enthusiasm, post-war optimism and re-evaluation.

Our street was crowded," he remembered, "with young artists like ourselves, all bubbling with art talk, their studios filled with canvases."[6] There was essentially no interest in what was going on in European art, which was considered to have died. New York (or San Francisco for some) was where it was happening, where art was alive. Greenwich Village was a true artists' community. Aside from The Club on 8th Street, where anyone who thought artists weren't verbal would be readily set straight, there was the Cedar Tavern, to which everyone retired after the effusive but, at least initially, dry discussions to "wet their whistles" with some of Johnny's draft beer. Even on non-Club nights the Cedar was packed. A newcomer could meet just about anyone she or he had ever heard of in the art world by hanging out there for a few weeks and going to openings at the various co-ops on nearby 10th Street. The art world was that tiny then, and the big stars were just other painters like yourself who welcomed you into their midst. They may have progressed from

the nickel cup of coffee nursed along for hours with extra sugar and cream at the Waldorf Cafeteria to beers at the Cedar, but few could afford even the occasional, celebratory boilermaker. Kline was on welfare in 1953, and no one was making much money from painting sales. Pollock's death in 1956 changed all that.

Many of the artists in this collection got their start in one or another of the co-op galleries, largely in Greenwich Village (NYC): Nanno de Groot, Lester Johnson, and Nicolas Marsicano were members of the first co-op, the Tanager Gallery, where Robert Beauchamp and Nora Speyer were also invited to have exhibitions; Robert Henry showed at the James; Jay Milder at the Phoenix; Selina Trieff at Area; and Beauchamp, Elaine de Kooning, and Lester Johnson went to the March Gallery. The artists joined together to pay the modest rents on the lofts or storefront spaces they found, fixed them up themselves, hung each other's shows, met once a month to argue about new members, policies, etc., and sat in the

galleries themselves if they couldn't afford to hire a sitter. Many remained friends for life, even after they moved to uptown galleries and other life situations. The 10th Street co-op scene of 1952–1965 was the crucible, the literal mixing vessel in which the New York art world was formed.

In the late 1950s, when the current leaders in the field of painting were beginning to look warily over their shoulders for a new but as yet not recognized group of ambitious painters to overtake them, the pros and cons of abstraction were much discussed in and outside of the Club, the Cedar, and the co-ops, most of which had both figurative and abstract artists as members, though generally abstractions outnumbered figurative paintings. An abstract work was said to offer the viewer a potentially richer experience than a representational work because it gave the viewer's imagination far more room for play. In a representational painting, the artist delivers a specific subject already fully worked out on the canvas in the painting process. American Figurative Expressionists

would say that they offer the best of both worlds, real images to spark the imagination, but no closure: rich color, freewheeling lines, and movement, spatial interplay, and painterly nuance instead—all the wherewithal for viewers to build an entire imaginative world of their own.

However, as Leo Steinberg pointed out in his catalog essay for the 1957 Jewish Museum exhibition of *The New York School: The Second Generation* (which included a number of the artists in this book), painterliness and wild attacks on the painting field often made for images that were difficult to decipher, particularly when they weren't based on the figure. Even "where a painting is more or less clearly representational," he said, "the image is to be guessed at or ferreted out, and the visual form remains paradoxical, inharmonious." He continued:

Still lifes belie their names to look like upheavals, and all the apparatus of table and kitchen sink confesses to a disturbed, enforced co-existence—as in the work of [Felix] Pasilis. Hyde Solomon's close-up of grass flits over the canvas like Roman candles before the discharge. Wolf Kahn's self-portrait seems to look out at a firing squad, and the studio around him takes on the fierce brightness of a hallucination.

Steinberg felt that in these difficult, even recondite, abstractly painted representations,

the rupture between content and appropriate form is wider than ever; we are invited to stare into the gap and to experience the tension of irreconcilable poles. Not a healthy mind in a healthy body is the pervasive reality, but a strained consciousness and an ill fitting physique.[7]

Though Steinberg saw this kind of painting as heir to the long tradition of modernist negation out of which "all that was left was a lawless energy, free to congeal into forms, but only in accordance with laws that fell from its own operation," the artists in this collection would disagree. They would align themselves with Willem de Kooning, who said he painted the way he did in

order to put more into it—more feeling, more romance, more everything.

Psychology professor Thomas Styron termed this kind of work a "figurative hybrid" of Abstract Expressionism, saying that it "embodied an esthetic based upon the interdependence of the highly emotional stance of the artist, his volatile and undisciplined application of the medium, and the essentially cathartic symbolism which resulted."[8] Styron calls Figurative Expressionists "hot," both psychologically and in terms of paint handling. Since the paint predominates, the figures tend to "emerge from the matrix," he said. This was particularly true in the early days of this kind of painting, when the imagery was often barely identifiable; it is far less so today. Styron makes no differentiation between New York–style figurative expressionism and that of the West Coast, nor does he discern the differences in content and spatial concepts between American Abstract Expressionist–inspired figuration and the European-inspired figuration of artists like Jack Levine, Joseph

Glasco, the Soyer brothers, and Abraham Rattner.

The spatial differences are readily seen in the polar gap between the modeled atmosphere and chiaroscuro of realist Raphael Soyer and the pushed-and-pulled planar surfaces of Hans Hofmann. Levine or David Aronson may blur the edges of their forms, but the paint is not the carrier of the meaning any more than it is in one of Ben Shahn's temperas: the depicted images and their expressive distortions carry the message directly to the viewer. No effort is required to read the content of such traditionally constructed paintings. The artists in this collection build their figures out of the paint itself. They do not just re-surface or decorate the figures with painterly touches to blend them into a unified statement. To most of these artists, the presence of the figure, however inexactly rendered, means a hold on reality in its barest form, a thereness, which is like a lifeline in a maelstrom of conflicting emotions and ambiguous signs. More often than not the figures do not

do much, are not located in very specific settings, and avoid narrow or clichéd interpretations. Like de Kooning's *Woman*, the figure is a kind of formless rock, but still something to grab onto. This group of independents is primarily concerned with visual matters, not literary ones. Because they see no need to tell a story in their pictures in any traditional sense, and because their faith in the power of paint to convey emotion is unshakable, they made no real break with their Abstract Expressionist roots.

The 1980s saw a revival of interest in figurative art as a whole, with artists such as Julian Schnabel, David Salle, Cindy Sherman, Robert Longo, and Robert Mapplethorpe taking over the art world stage. The exhibition for which Styron wrote the catalog quoted above, *American Figure Painting 1950–1980*, was one of a string of exhibitions during this decade to revisit mid-century developments. Two originated at the Newport Harbor Museum in California: *Action/ Precision: The New Direction in New York, 1955–1960*, in 1984 and *The Figurative Fifties:*

New York Figurative Expressionism in 1988. Both traveled around the country.[9] The first of these, as the title suggests, concerned the idea of "action painting," first discussed by Harold Rosenberg in an article in *Art News* in December 1953, which he wrote after seeing Hans Namuth's photographs of Jackson Pollock "in action" painting. It focused on six painters —Norman Bluhm, Michael Goldberg, Grace Hartigan, Al Held, Alfred Leslie, and Joan Mitchell—only one of whom (Hartigan) included any recognizable imagery in featured paintings. As if to balance things better historically, the second Newport exhibition completely concerned 1950s figuration in New York. It did not include work unaffected by Abstract Expressionism (the Soyer brothers, Levine, et al.), landscapes, or still lifes. However, the inclusion of Fairfield Porter, Larry Rivers, and Alex Katz, for whom the content is not carried by the paint but presented overtly, goes back on their promise to select "artists whose work reflects the style and methods of abstract expressionism."[10]

No two of the artists' paintings in this book are similar, and yet they are all decidedly different in a similar way from other representational painting. All of their surfaces are alive, active, and activating. There are no areas of flat, monochrome, unmodulated paint. Nora Speyer's practically carved pigment may rise to the greatest heights and Selina Trieff and Sherman Drexler may vie for the lowest still-painterly surfaces, but the gamut in between is as various as can be. Because they remain true to their Abstract Expressionist legacy, each has his or her own way with paint—they may brush, pour, spray, palette knife, and/or drip it on, or use their fingers—and that way is their identity, their signature. Basically, this large group of artists can be seen to be of two minds: one concerned primarily with traditional studio culture, the other with world culture. Some just need a model or an idea of a model to work from; others also need the stimulation of fantasy, literature, religion, myth, the real and the imagined, in which to embed their figures. ▨

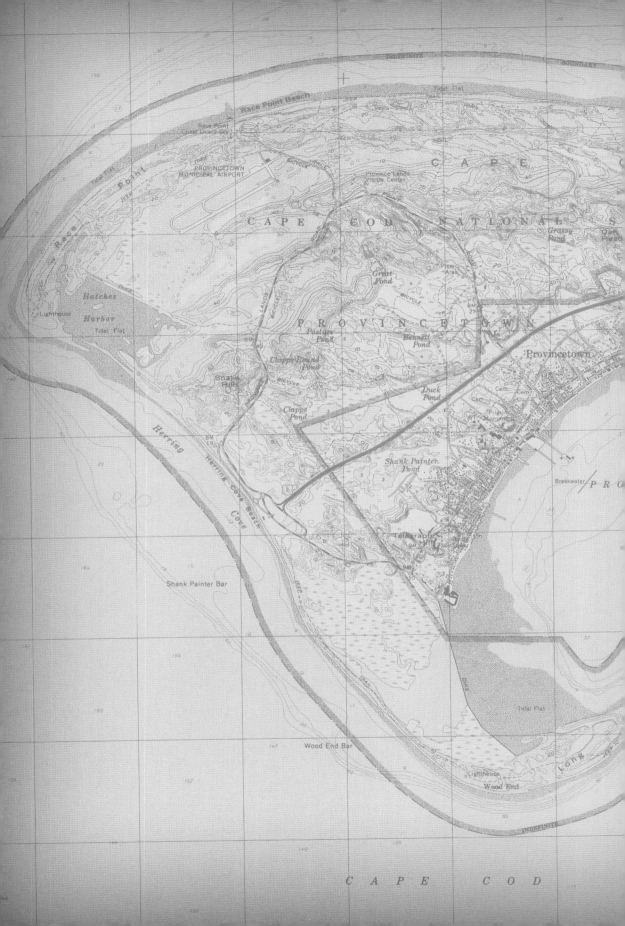

PROVINCETOWN

n the 1950s, Province-town was a hotbed of artistic activity, primarily due to the presence of Hans Hofmann's summertime branch of his famous 8th Street art school in Greenwich Village, whether or not one actually studied there. Many of the Abstract Expressionists summered there at the tip of Cape Cod, and one powerful figurative offshoot of Abstract Expressionism was formed there. Shack studios could be rented for very little, and there were plenty of evening jobs available in the town's many restaurants. That left the days for painting and the nights for partying, both of which were accomplished with tremendous gusto. Nude bathing in the ponds at night or on the beaches in the daytime, sunset horseback rides on the dunes and shore, wee-hours revelry in Provincetown's

bars and shadowy backyard gardens, drinking and trying other paths to altered consciousness—all these combined to provide artists with a reality that readily translated into fantasy when put on canvas. Jan Müller, a Dutch artist with a bad heart who died tragically young, started this new approach to the figure. His nudes in the landscape—pastoral idylls—supplied the necessary level of abstractness by their apparent unreality to ease the way toward figuration. Many who were influenced by Müller or who were on parallel paths themselves used a similar approach to the figure: Robert Beauchamp, Selina Trieff, Sherman Drexler, Jay Milder, Nanno de Groot, and Bob Thompson.

Early in the 1950s, after five years of studying with Hofmann, Jan Müller (1922–1958) had begun to

resolve his patchy mosaic compositions into figures and foliage. Around 1954, the year he had an open heart operation to replace a diseased valve with an artificial one, he based his figure-in-landscape paintings on literature and classical themes, such as the rape of Europa, biblical stories, Shakespeare, *Faust*, and *Don Quixote*. Women are depicted as sacrificial and men as dominant, often on horseback. His painting style was deliberately crude and executed on rough wood panels—a lack of preciousness that was a genuine response to both his financial and his physical situation. He was a driven artist aware with every click and clack of his plastic heart valve that time and resources could not be wasted.

Bob Thompson (1937–1966) came to Provincetown the summer after Müller's death, when the talk of the tragedy was everywhere in the large but closely entwined community of artists. Müller's work had been shown at the Sun Gallery since it opened in 1955, and Bob Thompson, Robert Beauchamp, Lester Johnson, and Jay Milder among the Figurative Expressionists showed there as well. Thompson painted *The Funeral of Jan Müller*, 1958, with Müller's figural style and spatial organization in mind but with the downbeat drabness of Lester Johnson's *Men*, in blacks and grays against cold, stark white. But after he returned to New York that winter his paintings were full of echoes of Müller—his multicolor, bucolic settings and male and female nudes in the forest (though robustly colored, not ghostly white) intermixed with horses and beasts of prey. While Müller's figures are blocky and brushy, Thompson's are all curves, but they are locked into the overall composition in parallel ways. Both seem indebted to Paul Gauguin and the Fauves for color and to the Old Masters for structure. In New York in the 1960s, now thoroughly versed in Müller's work through his friendship with Jan's wife Dody, Thompson's style crystallized into flat, cookie-cutter shaped figurations acting out fantastical adventures on stages preset by the Old Masters. The paintings of Robert Beauchamp, who seemed to turn Provincetown parties into nights on Walpurgis, and the imaginative hybridizations of Thompson's pal Jay Milder both probably played a role in his development at this time as well, but heeding Dody Müller's advice to keep looking at the Old Masters had a profound effect. It

Nanno de Groot
Lady in the Kimono, 1956

Oil on canvas, 34 × 86 inches
Gift of Pat de Groot, 2005.29

allowed Thompson to make visual jazz. A composition by Poussin or Seurat, Manet or Piero della Francesca was as familiar to him as a popular song, and therefore just as usable as a base from which to go off on his own riffs, jazz style, and then return to the "tunes" he loved.

Nanno de Groot (1913–1963) spent his first summer in Provincetown in 1949 with his third wife, artist Elise Asher, at the age of 36, after a life on the sea in various seafaring roles, drawing on the side. It was the summer of *Forum 49*, the legendary series of panels, talks, and exhibitions organized by Fritz Bultman and Weldon Kees at the Provincetown Art Association. It included forums on art, literature, psychiatry, and politics; lectures on architecture;

film showings by Joseph Cornell; and an exhibition of work by Abstract Expressionists such as Adolph Gottlieb, Jackson Pollock, Robert Motherwell, Mark Rothko, and Hans Hofmann. Bultman, who was an Abstract Expressionist and former Hofmann student, lived in Provincetown at the time, and his axial linear drawing style and black-and-white paintings from 1947 on had to have influenced de Groot's *Linear Figures* and *White Goddess* paintings of 1950–52.[1] By the following year, upright seated women painted in reds, greens, ochers, and grays took over, and de Groot's palette broadened along with his subject field. He joined the co-op Tanager Gallery in 1954, though he was also showing in commercial galleries. De Groot's figures were usually

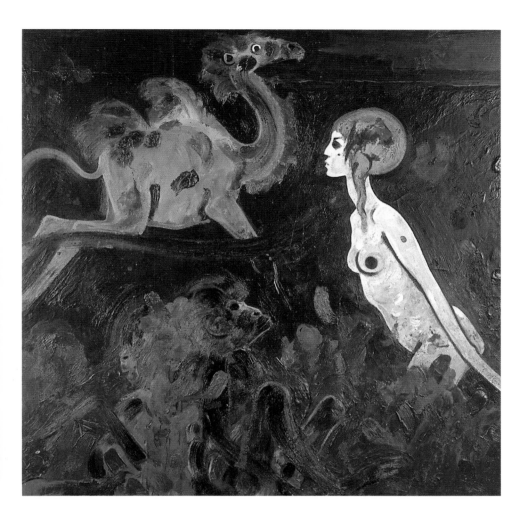

featureless and generalized even when portraits. *Lady in the Kimono*, 1956, was one of the earliest of the "Pat Series" of seated women paintings of his future wife Pat de Groot. Its unusual dimensions, 34 × 86 inches, make it feel like a horizontal Asian scroll— still life on a table at the right, black woodstove in the center, and Pat in a kimono on the left side. In 1956, de Groot rented Bultman's studio for the summer, and he showed the seated women paintings he made there at Nat Halper's HCE Gallery in Provincetown. The following year he began painting bouquets of flowers and also created a large canvas of *Bathers* standing in two groups of four on the dunes at the shoreline, which in its repetitions and patterning strongly recalls the mosaic

Robert Beauchamp
Blue Monkeys, 1965

Oil on canvas, 70 × 70¾ inches
MSU purchase, funded by The Judith Rothschild Foundation and an anonymous New York foundation, 2001.18

effect of Jan Müller, who he undoubtedly knew, and who was to die the following year. Still lifes, landscapes, and seascapes occupied him for the rest of his life, all painted with Van Gogh–like energizing impasto. Sea and sky, grasses and tree limbs quiver with life so vibrantly they seem three-dimensional.

The other early American Figurative Expressionist to come to national attention having benefited from the Provincetown esthetic was **Robert Beauchamp** (pronounced Bee-chum) (1923–1995). His art-life story is paradigmatic. He was born in a rough-and-tumble Denver slum and carried a tough cowboy persona like a protective vest his whole life. He started studying art in high school in order to get out of study hall, and lucked into a very knowledgeable, helpful art teacher who had studied in Paris. By 16, he was starting to paint and he won a scholarship to the Colorado Springs Fine Arts Center, where nationally known Boardman Robinson was teaching. After a year of heaven he spent three years in the navy daydreaming of art school, and when he got out he returned. From there he went to Cranbrook Academy, leaving in 1950 when he found out about Hans Hofmann and his school in Provincetown. He took off on his motorcycle, leaving the cloistered protection of Cranbrook for the freedom of

Robert Beauchamp
Black and White Horses, 1972

Graphite on paper, 36 × 85 inches
Gift of Nadine Valenti-Beauchamp, 2008.39

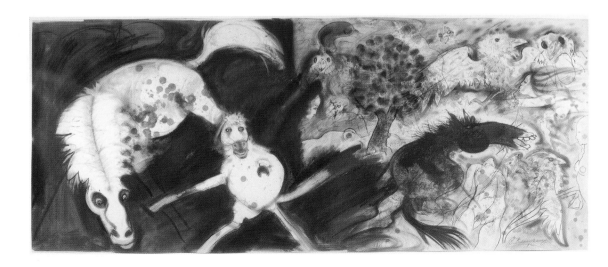

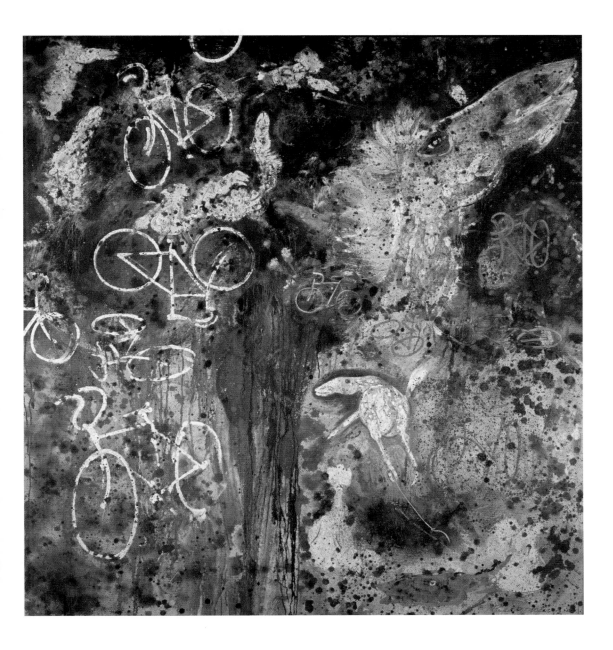

life in an artist's colony at a very exciting moment.

I felt I was in paradise. I was studying with Hans Hofmann, a man greatly respected, a man with great personal charm. He had more energy and knew more about painting than anyone I had ever known. It was an intense summer—sun, sea, dunes, parties, fucking. Hofmann helped me see that through purely plastic means, pictorial elements

Robert Beauchamp
Untitled (Camels and Bicycles), 1973

Oil on canvas, 69¾ × 65 inches
Gift of Nadine Valenti-Beauchamp, 2001.27

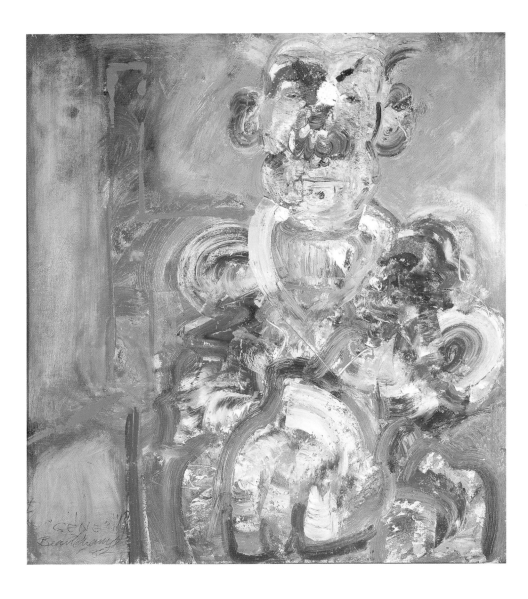

could transform themselves into a spiritual experience. Sounds grand, and so it is, but it's what makes a masterpiece. I studied with Hofmann for another three years—an intense schooling. We all worked our asses off.[2]

After three more years of heaven, he woke to the reality of a poor young artist's life in a loft on the Bowery in New York City. "It was an emotional thing," he said later. "I felt abstract art was too remote from immediate life, that I had to wear blinkers when I walked out onto the street."[3] He began to feel that pure, abstract painting was too

Robert Beauchamp
Gene, 1982
Oil on canvas, 48 × 42½ inches
Gift of Lawrence Shainberg, 2008.38

esoteric for him living where he saw "all that human pain, all that waste. I went back to the figure and I've been painting it ever since . . . the figure, heads, trees—things that meant something to me."[4]

The first work he showed (at the co-op Tanager Gallery in 1954) was described by one reviewer as "slashes, swirls, blots and cuts of the brush" filling "every inch of his nervously handled canvases." But the critic added that "the savagely distorted heads" and other "uncomfortable images" that appear in the midst of this "welter" "are well served by [his] agitated manner."[5] Who, aside from Hofmann, were Beauchamp's art influences at this point? Very likely Hieronymus Bosch, perhaps Henry Fuseli, William Blake, James Ensor, Emil Nolde, Paul Gauguin, the Fauves, anywhere fantasy

and actuality comfortably intertwined. Around him, it would have been Jan Müller's bacchanals and dream-like *fête champêtres* dappled with patches of bright color or Bob Thompsons's even more intensely colored intermixes of figures and animals in Arcadian settings. The painterly verve and variety, though, were pure Beauchamp. He believed that painting figuratively opened up more expressive possibilities than abstraction, but that realism was limiting in the other direction. He found it boring.

It's much more exciting to use your imagination, to paint from your head rather than to copy nature closely. The abstract expressionist way of painting has given me a kind of freedom and flexibility—such as throwing colors on a canvas and making them into a butterfly, or a horse, or leaving it a color that

articulates the space—keeping the possibilities open ended.[6]

Reality is at least as important a source of inspiration for Beauchamp as the imagination. His early paintings were inspired by the actual experience of nocturnal skinny-dipping and partying in the Provincetown forests and dunes, just as surely as the animals he painted are viewable in the zoo, and the excruciatingly painful portraits of his dying brother Gene were painted out of anguish and love.

Since he literally finds his images during the painting process, a curve may suggest a breast, a slash may lead to a horse's mane, or symmetrical lobes of pigment may become a baboon's behind. "I paint a floating world where everything is possible, organized abstractly," he said. "I distort, fantasize,

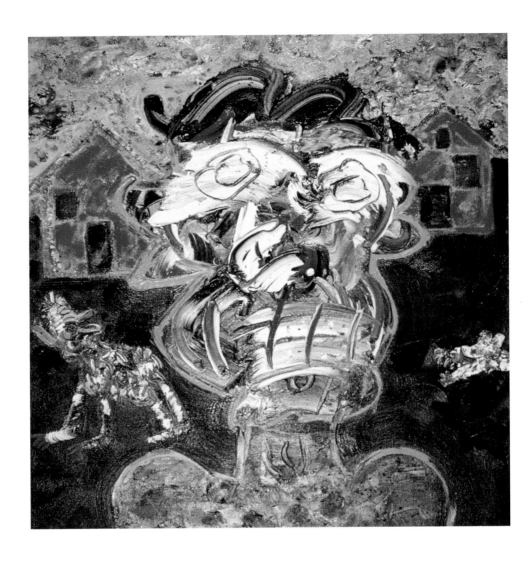

and pile in the images."[7] The hallucinatory strangeness of *Blue Monkeys*, 1965, threatens to overwhelm its physical lucidity. The luminous nude female seems to have terrified the fleeing camel and fascinated at least one of the seated monkeys as she passes through the underbrush as if on a quest. She is his typical woman: moving head high through the world with total disregard, wordless, bent on her own thoughts. As the 1960s went on, more figures and creatures crowded into a given canvas, flying around, leaping, tumbling, even floating upside down, and not in scale with one another or with the objects interspersed with them. Fantasy creatures

Robert Beauchamp
Untitled (Man in the Street), 1993

Oil on canvas, 28 × 26¼ inches
MSU purchase, funded by an anonymous
New York foundation, 2001.14

appear: a warthog/giant rat and demonic, outsized animals, birds, insects, even fish. Camels tumble amid a rain of bicycles and blue water cascading down the picture surface in *Camels and Bicycles* of 1973. Soon giant apples and lighted matches also began floating through his paintings. They were not in his mind in 1969 when he made an inventory of his imagery for *Art Now*.

A nude girl jumping rope, horses, blue-bottomed baboons, fish and fish hooks, octopi, pregnant woman, water, bricks, flower, feet, erections in the rain, hair, bees in flight, teeth, teardrops, scorpions, fruit, flies, belly buttons, cheese, light bulbs, crowing roosters, and fighting cocks, and barking dogs, a view of the alps, a maple seed, check marks and X marks, a wet handkerchief, skin tone, meat, snakes, fangs, floating feathers, dancing girls and running, diving, tumbling men.[8]

The incident-packed, speeding paintings of the early 1970s began to be shrouded in high-key mists of spattered, then sprayed-on paint. Edges disappeared with this atomization, and with them the incisive bite of his line. Then, in the 1980s, the faces of the people he loved and, later, his own visage began to appear out of the mists as they must have been rising to the surface of his consciousness. One of his brothers died of alcoholism; another, Gene, already paralyzed by polio, contracted cancer and began his own physical disintegration. Then it was Robert's turn as the 1980s waned and he, too, was diagnosed with cancer. Gene, in his wheelchair, or with a sketch of it scratched in the paint beside him, is painted over and over obsessively, sometimes in a double portrait with the artist. Gene's half-shut eyes are ringed in black as if to symbolize the beating he is taking. Beauchamp's wife's eyes are sad; most of the eyes are sad, and dogs always are barking or snarling viciously. *Man in the Street*, 1993, has such dogs, but the man's blank white eyes are like headlights beaming in the darkened street. His mouth is barred shut, and his naked body is blue as if deceased. A mute zombie in hell. The demons were real, not fantasies any longer. Beauchamp poured everything he had into these late paintings, knowing there would not be many more. The energy is frenzied, and in terms of varieties of paint handling he far surpassed his mentor Hofmann in virtuoso techniques, like an organist pulling out all the stops. He died in 1995. ■

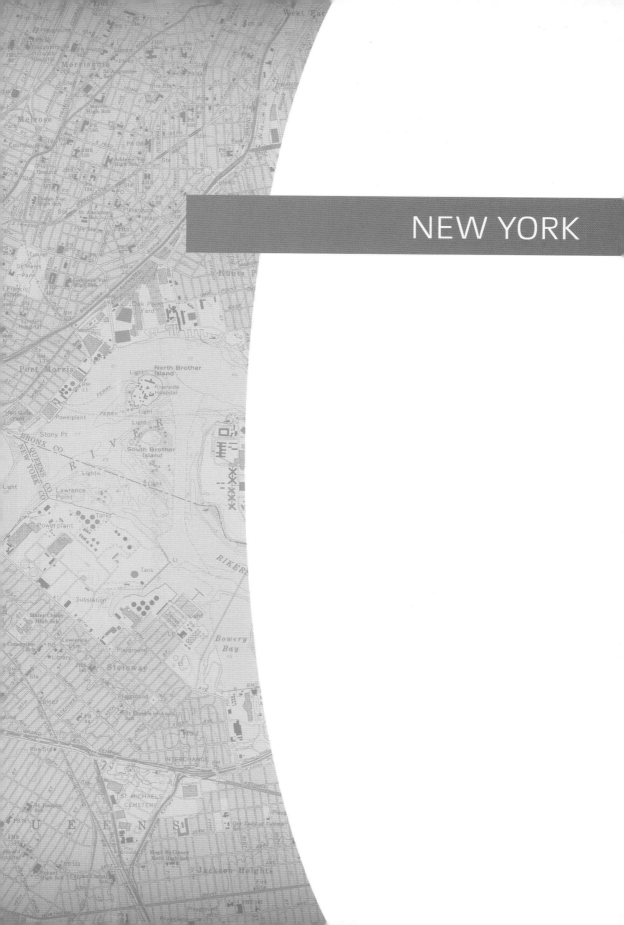

NEW YORK

George McNeil

Waiting II, 1973–1979

Oil on canvas, 75 × 60 inches
MSU purchase, funded by an anonymous
New York foundation, 2001.16

G

eorge McNeil (1908–1995) led two art-lives: the first, starting in the late 1920s while a student at Pratt Institute, as a Cubist involved with structure, the other as a figure-based expressionist encouraged by Hans Hofmann in his teachings at the Art Students League and later in his own schools, where McNeil worked as his class monitor. McNeil was one of the founding members of the American Abstract Artists, a group of largely post-Cubist, proto-geometrical abstractionists who banded together in 1936 to create exhibition opportunities for themselves because they were nonexistent in New York then for American abstractionists. But from 1949 to the 1960s, Mc-Neil was a full-steam Abstract Expressionist whose paintings were structurally sound but powerfully expressionist and rich in color. He showed at Charles Egan's New York gallery as did Willem de Kooning and Franz Kline, whose work had aspects in common with his. Like them and many of their friends,

McNeil loved music and jazz in particular, and it is easy to see the influence of the syncopated rhythms of jazz in his clashing colors and planes. Frequently figure and ground cut almost savagely into each other, giving a sense of dynamic movement. . . . Ultimately this is a deeply urban art, full of the pulsing energy of the modern city.[1]

All that changed after 1960, and the change lasted for the rest of his life, with the incorporation of the figure. He started drawing in Mercedes Matter's life-drawing classes, which followed Hans Hofmann's model where axes are

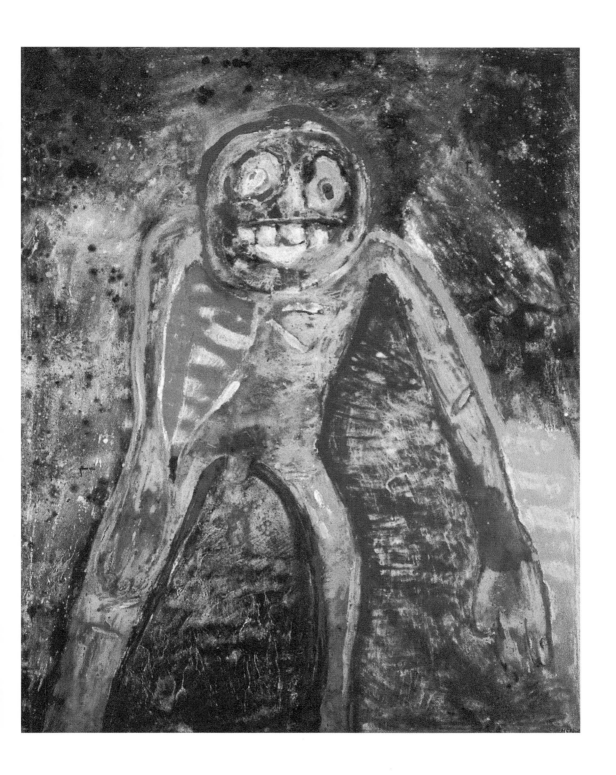

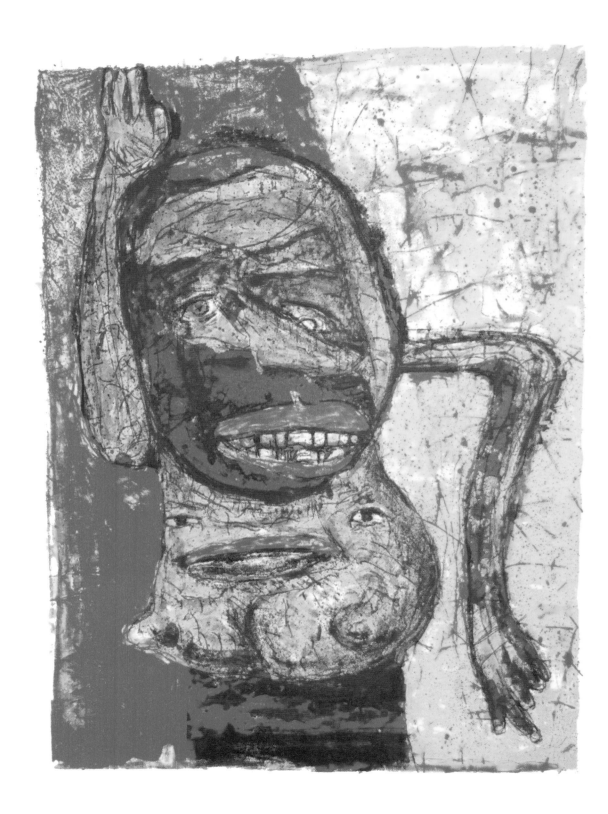

George McNeil
Philadelphia Woman, 1976

Lithograph, 30¹/₁₆ × 22⅛ inches
MSU purchase, funded by the Office of the
Vice President for Research and Graduate
Studies, 2007.10.2

emphasized, so nothing like typical figure drawing emerged in his work. Instead, the buried imagery—that was probably stimulated by the many manifestations of Surrealism around him in New York during the 1930s and 1940s—that was not allowed to surface in his geometric abstractions of the 1950s now began to bubble forth in painted expressions of states of mind and being.

McNeil's early men and women coalesced in a light that is imaginary . . . loomed up through the quietude, the meditative texture of the painter's solitary workplace. The artist's energy, his characteristic exuberance, gives them all a family resemblance.[2]

At first, he didn't know whether the paintings would turn out to be an abstraction or figurative. It happened in the most natural way, in the

process of painting, and yet ingeniously.

My basic approach has been that of materializing figures from random beginnings which are then related more and more until perhaps 78% of the final form is derived from abstract composing. Thus the subject matter has been improvised into being.[3]

The side of a limb defines a plane, and the other side of it defines a plane of another shape and color. Each element is safely locked into a larger compositional structure. He termed it "formed expressionism." This is easy to see in *Waiting II*, 1973–1979, and in his many other single figure paintings of dancers, bathers, shouters, clowns, birds, and singers that occupied him in the 1970s. But his later work, especially the "graffiti" and "disco" paintings of his last years, are so

jam-packed and youthfully vibrant that few can believe they are the product of an artist in his eighties.

He worked hard to attain some skill at graffiti[4]; he listened to the music and watched disco action on television and consulted his clippings files, but he never went to a disco or tried street art himself. He did his research because he was a very thorough man. Before 1977 his figures represented states of being that could be termed generic. *Waiting II*, for example, seems fraught with anxiety or fear about what is being awaited. The figure seems both frightened and frightening. Other states of mind to explore were joy, penitence, elation, maternal love, awe at the night sky, and uncertainty. Subjects varied from *Party Girl* to *Nijinsky*, from a Green Enchantress to Bedlam, from Clarabel to

Charles Ives. Mythological figures like Artemis, Procne, Prometheus, Ondine, and Cymbeline, even Pere Ubu also make appearances. But after the late 1970s he purposely focused on the absurd things people do, wear, ornament themselves with, or fancy themselves as. He often used pure color and extreme figural distortion in an effort to lift his paintings "to the highest state of pictorial excitement."[5]

The fierce and joyful power of his imagery was unmatched and is as evident in his lithograph *Philadelphia Woman* as it is in any of his paintings. She dances to a heavy beat, her naked torso taking on a physiognomy of its own. She is alone, as the figures inhabiting McNeil's world tend to be, facing the world head on as if in a challenge. The predominant red/green/yellow hues offer maximum expressionist clash and clang. Using the figure to divide the background and thereby unify all three elements—figure and two backgrounds—on the same picture plane is one of his standard compositional devices. She is a precursor of his late disco dancers in a tough, graffiti-tattooed urban milieu.

George McNeil's very long career was successful early on; it bloomed in the 1950s with the full appreciation of his Abstract Expressionist work by his peers and the art world powers, but slacked off in popularity in the 1960s and 1970s. He moved into a hyper-energetic American Figurative Expressionism and suddenly was reborn in the 1980s along with contemporary Neo-Expressionism. He and some of the others in this book were treated to retrospectives during this time, and sales were good, but it felt odd. As McNeil put it, "I've been told my abstract landscapes and my beat-up figures make me part of the New Expressionist movement. This disconcerts me because I have been an old expressionist for so long that it isn't funny. I am like Moliere's Monsieur Jourdain who was surprised to learn he had been speaking prose all his life."[6]

Although **Irving Kriesberg** (1919–2009) was calmly magisterial where McNeil was manic, and McNeil confined himself largely to humankind whereas Kriesberg's world was populated by many different species of animal, avian, and amphibian, the two artists share a great deal as fearless colorists, attacking the canvas with loaded brushes full of brilliant pigment and applying it with gusto; natural lifelong

teachers either in the class-room or through books; and serious artists appreciative of the role humor can play in art.[7] Irving Kriesberg's immensely sophisticated world contains manifold elements: representatives of primitive cultures and religions, cartoon characters, historical figures, superheroes, animal stand-ins of all sorts, nature, artifice, humor, pain, and emotions both trivial and profound. Every painting is full of multiple allusions, sources, and potential meanings because his head was filled with imagery from global cultures and times prehistoric to the present.

As a child in Chicago, Kriesberg drew—at home on the kitchen table, at his tailor father's workplace on extra stiffening sheets,

Irving Kriesberg
The New Baby, 1953
Tempera on masonite, 21¼ × 26 inches
Gift of the artist, 2002.36.1

at the Field Museum every Saturday—and as a teen he earned a scholarship to the School of the Art Institute of Chicago. In 1946 he had his first major exhibition at the Art Institute, five years after graduating from there. That was followed by three years in Mexico, which charged and liberated his painting style and brought out his innate expressionist leanings. He was included in MoMA's 1952 *Fifteen Americans* exhibition with Mark Rothko, Jackson Pollock, and William Baziotes, and by the early 1950s he was exhibiting his paintings and animations nationally and internationally. His style was more painterly then, but the subject matter was typically enigmatic. *Dancer with Sheep*, 1952, for instance, features a naked dancer with vaguely Picassoid anatomical aberrations, cavorting before a calm and kingly goat and a flock of sheep in a rocky landscape. Dancing, a core part of many world religions and most cultures, was a central activity in his paintings. *The New Baby*, 1953, lying completely open to the world as newborns do, seems to enjoy the four dancing figures leaping for joy all around. Seeming both observed and diagrammed, the dancers could slip into the pages of a comic book or onto the walls of a cave painting with equal ease. The clashing reds and greens and the free brushwork both say "expressionism," but also remind us of the vibrant colors of Mexico. During his years there, besides painting murals for the Ministry of Agriculture and experimenting with clay in the ceramics workshops in Tlaquepaque, he worked at the Taller de Gráfica Popular, a printing-craft center established by the government and run by Leopoldo Méndez. Very powerful populist imagery came out of the Taller in support of the workers. Its vigor made an indelible impression on Kriesberg. His boyhood days in Chicago's Field Museum had alerted him about the existence of other world cultures, so three years of immersion in one of the oldest and most sophisticated, the home of the Mayans and Aztecs, had to have had a profound effect on him.

In 1955 Kriesberg had a one-person show at the prestigious Curt Valentin Gallery accompanied by an illustrated catalog with a foreword in the form of a letter to him by the renowned sculptor Jacques Lipchitz, who mentions that Valentin told him, on first seeing Kriesberg's work, that "there is a real painter, a rare bird, not only here in America, but all over the world."[8] Picasso's influence on

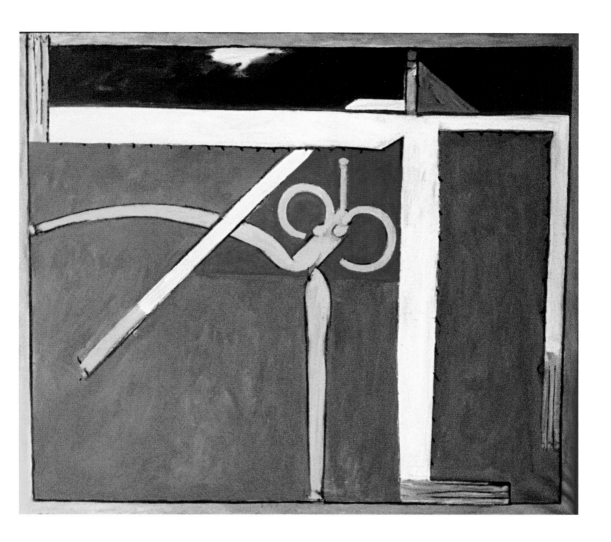

him is discernible but not, as it was with so many artists, obtrusive; likewise, Matisse's. It is more like he was paying homage and moving on to his own formworld. Birds and tall, long-legged dogs are featured, along with dancing. A series of *Street Faces*, 1954–1955, are highly abstract and point to his future ability to fill the whole canvas with a face on a much larger scale. One painting of a striding male figure with a bird in his outstretched hand also foretells the future in 20 years.

In the 1970s Kriesberg created a group of large paintings composed of elongated, often striding geometrical figures rendered in planes of

Irving Kriesberg
Malcolm, 1982

Oil on canvas, 74 × 62¼ inches
Gift of the artist, 2002.36.3

color. They seem both rigidly, regally formal and primitively simplified at the same time. The lanky, hairy *White Ape* dominating a 1973 canvas has one leg running across the top, the other at right angles standing on the ground, with both arms angling off in other directions. The white ape provides a bright frame for the yellow dancing female highlighted by red and green background planes. One figure is all curves, the other completely rectilinear, but both are stick figures that recall Matisse as much as Egyptian hieroglyphs, comics characters, and Tantric designs. Mythic celebrations or dreams are evoked by these distorted, energetically commingling animal, human, and potentially spiritual figures. African art historian George Preston Nelson described Kriesberg's contribution from his point of view:

In these paintings of the 1970s, which are a bridge between the abstract expressionist related figure painting of the 1960s (Rhino Horn, Chicago, West Coast, Neo-Expressionism) of which Kriesberg is also a herald, the essentials of his conceptual and formal vocabulary are lucidly revealed. The work is akin to, but clearly does not fit into any of the above mentioned ways of seeing. In these works of the 1970s we see the repertoire of the colossal figure, often evoking an image of the religio/mythic (Krishna, Buddha), historical/legendary (*Harvest Woman Tiger's Belly*). The horizon is seen from afar . . . as if we are at a great distance or in orbit.[9]

Biblical proportions and the momentous are sensed in other paintings, especially the monolithic heads, such as *Malcolm*, 1982 (inspired by Malcom X). A head that

is six feet in height is a head to be reckoned with, just as ancient Olmec, Constantinian, and gargantuan heads in the jungles of the Far East continue to be even when in ruins. Monologues and dialogues were another frequent Kriesberg subject, like dancing. They often seem Talmudic, which is appropriate to the sedate thoughtfulness that pervades his work, undaunted by the high-key color applied with Fauvist daubs and dashes and unfazed by the cartoonish drawing elements. Whether this is a monologue or a dialogue is unclear. Neither the bird nor Malcolm X have an open mouth, but they seem to make eye contact and to be highly alert to each other. Malcolm seems sage and rational, engrossed in his conversation with the bird or listening to its pronouncements. Political and

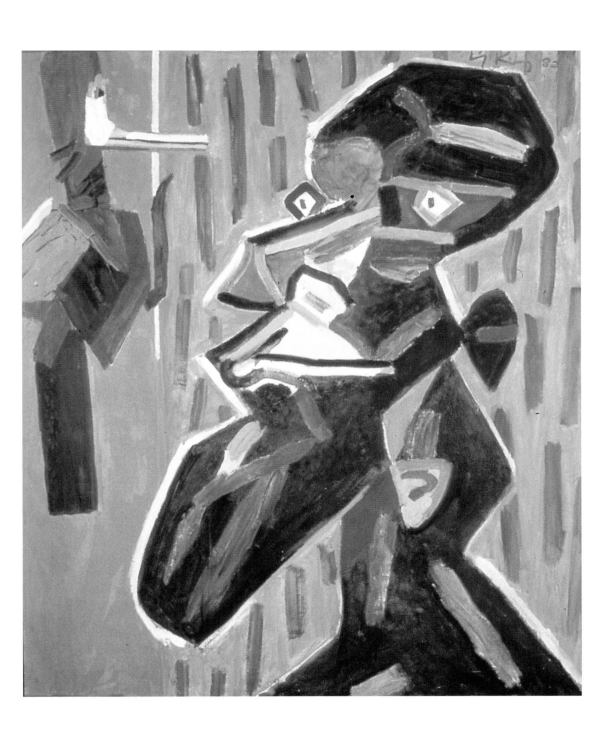

Irving Kriesberg
The Journey, 1988

Oil on canvas, 75½ × 60¼ inches
MSU purchase, funded by the Richard
Florsheim Art Fund and the Kathleen D. and
Milton E. Muelder Endowment, 2000.27

personal references are rare in Kriesberg's work, and yet this painting contains both. As one might expect from an artist resolutely reluctant to discuss the meaning of his work, the fact that this painting refers to Malcolm X really tells us very little, yet somehow concern and communication seem to be conveyed. Hebrew religious practices were observed in Kriesberg's Chicago home, but he and his brother got to spend their Saturdays and holidays drawing in the Field Museum instead of going to synagogue as boys. He once told a story about finding out about the existence of another museum, the Art Institute of Chicago, and braving a trip there with his brother one day, only to be terrified by an image of Christ on the cross and the approach of two nuns. The boys ran nonstop out of the museum and never

went back.[10] (He did of course, later, when he went to art school there.) It is unlikely then that an interpretation of this painting as referring to Christ talking to his Spiritual Father might be valid.

Nevertheless, Irving Kriesberg's paintings often can read as ascensions; scenes of supplicants awaiting the word of god-like beings, floating, disembodied heads/skulls, mythic creatures, and devils presiding over nature's wisest life forms. We wonder, are we seeing a resurrection?[11] He did say that biblical subject matter was often present in his early work, and "confessed" that his intention in later work was no less religious, that his strange, dream-like images reference something mystical. In a letter to a friend explaining what he meant by "American Expressionism," he said it had more involvement with fantasy, imagination,

and religious expression, by which he meant nothing specific, "but rather a generalized sense of the sublime." Not religious doctrine, but "a psychological striving for a state of otherness, a seeking to go beyond, a groping for the absolute."[12] The directness and spontaneity of Abstract Expressionism, its physicality and tendency toward magnitude, made it the perfect vehicle for reaching that other state. The way of painting and the goal, seeking the otherness, fuse in Kriesberg's painting *The Journey*, 1988. What is seeking but a journey, fraught with dangers and perhaps with delights, traveling along the edge of the known world, as we see in this painting? A mythic figure strides over the earth, its reach seeming as wide as a continent, dwarfing the globe, and the life forms stream along in the same direction

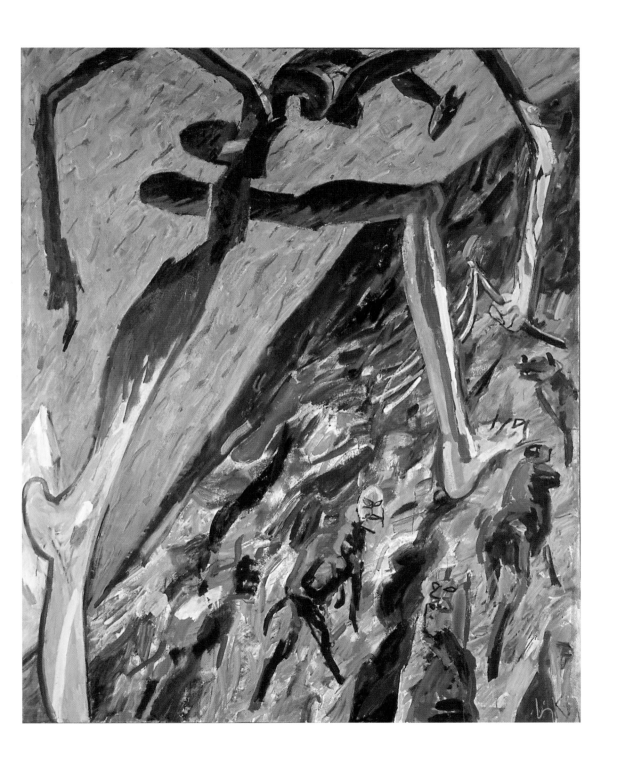

as if all are fleeing or all are seeking as well. Even the stars and planets are reduced to streaks streaming through space alongside the orbiting mass of life. The colors are intensely rich and variegated, yet clear and brilliant. The richness of Kriesberg's color augments the sensation of "otherness" and may tie into some subterranean religious feelings, but the fact that he wrote three books on color that were in print for decades may also be a factor in its quality.

Kriesberg painted more than one canvas featuring a giant striding figure navigating the edge of the world in the company of fleeing hordes of little people and creatures. It is an apocalyptic vision but like one that we see only too often on the news these days. Dore Ashton wrote:

Kriesberg has drawn humans and animals in many different relationships, often echoing ancient images. Yet, in the swift decisions—those linear decisions of movement—Kriesberg keeps the spontaneity of evolving form. These cranes and apes and starlings and ingénues are apparitions that arrive as he works, and the effects of highly charged color and atmosphere are illusions created with remarkably limited means. The resilience that characterizes Kriesberg's figures . . . lends credence to the notion that the stories, legends, myths he has assimilated over the years are thoroughly integrated into his imagination and read through everything he does.[13]

The stop-action look of Kriesberg's paintings is especially striking in his "Changeable Paintings" of 1956–1968. With 14 or more attached panels providing at least 20 possible painting configurations, these highly unusual magnum opuses are about as close to film as painting can get. One, pointedly titled *Roslyn Diary (Altarpiece)*, 1967, includes a crucifixion, a reclining red lion, a white rhinoceros, a haloed frog, a bird on a rainbow, and streams of vaguely amphibian creatures, apes, and flamingoes on altarpiece wing panels. Changeable paintings such as this, along with titling the works *Storyboard Scenes*, point to his lifelong involvement with animated film. Kriesberg liked to make things move. He explained:

My interest has always been in sequence and narrative. Not a specific story but the idea of progression and change. The problem is how to make the static painting convey these experiences. These various formats are means toward that end.[14]

In the video (*Tashilham*, which means "fortuitous journey") he made of a studio visit with a longtime friend—the poet, psychotherapist, and anthropologist Judith Gleason—they look together at a series of 39 small, interrelated paintings on board (about 19 × 14 inch verticals). She tells him what she sees there, and he is reluctant to affirm her ideas, but finds ways to explain his intentions and conjoin his perspective with a version of hers. This "storyboards" tale begins like Genesis with undefined space, divides into earth and sky; a protagonist emerges, a dog, and a landscape with a bird announcing something that the dog receives as a message from the spirit world transmitted through the mouth of the bird. "The animals look fierce, but have a benign side," Kriesberg narrated.[15] The two creatures evolve through different forms of abstraction, at one point recalling Tibetan gods trampling injustice. Over the course of the twenty-some images, which come to

feel like cels for an animated film, completely abstract paintings are intermixed with the action scenes just as they are in the Tantric art with which he was quite familiar.[16] In the end you sense the presentation of a new, reborn self.

Unlike Irving Kriesberg—who readily let a single figure, human or not, carry an enormous weight of meaning in a painting, even carry it alone—**Jay Milder** (born 1934) packs his paintings full of incident from the beginning. Believing like a Cabalist that the spirit lives in the negative spaces, the "white light" between positives—be it in Hebrew writing or life itself—he paints in such a way that you see the surround before you pick out the subject it is surrounding.[17] In a 1966 painting, *Dreaming House*, energy, mystery, and animism abound. The little girl in the porkpie hat and knee socks wearing a pink dotted dress is sort of swimming in houses that float around her in space. A toy(?) dog or pony awaits his young playmate/passenger. By this time, Milder was exhibiting in New York and Provincetown galleries and was linked in critics' and the

art public's minds with Beauchamp, McNeil, Johnson, and Bob Thompson. He had studied art at the University of Nebraska, in Paris with Ossip Zadkine and André Lhote, at the Art Institute of Chicago, and in 1958–62 with Hans Hofmann. But he had also "studied" jazz back home in Omaha, where there was a lively jazz scene in the 1940s, and in Paris, which informed his rhythmic pictorial structures and never lost its hold on him. His approach to the medium of paint has always been experimental.

Subway people and biblical figures dominated Milder's paintings of the 1960s. *Seventh Avenue Messiah*, 1969–1970, is a turning-point painting. Lighter in hue and mood, and large, it contains an abundance of incident—people, animals, fish, birds, and a glittering, mobile, tower-like vehicle with "Kabbalah" written down its length. Called an "urban visionary" by critic Donald Kuspit, Milder began painting biblical fragments and Cabalistic numerology in semi-geometric forms within a circular space filled with chain-like "chakras," vivid color, and intense brushwork. In the all-over *horror vacui* (a fear of empty spaces) one

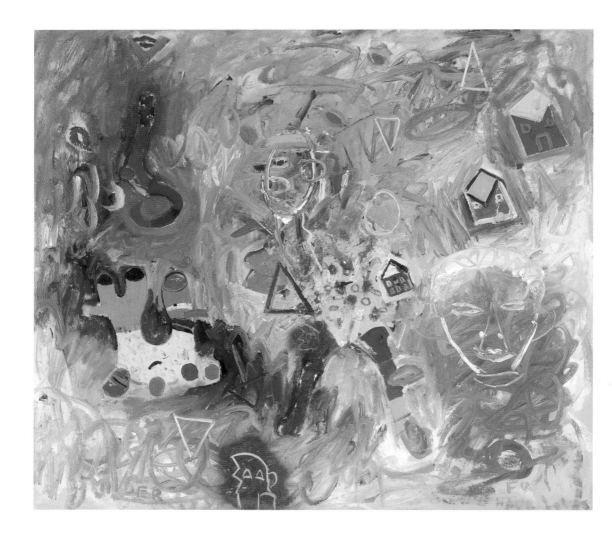

discerns faces, numbers, ani-
mals, people, and symbols. A
painter friend referred to the
"religious frenzy" in which
Milder paints as being true
to the Abstract Expressionist
spirit. It also fits given his
subject matter. Once Jacob's
ladder started to be a subject
for him in the mid-1960s,
Milder's ties to the real world
of people in his work became

part Abstract Expressionism,
part religious fervor, and part
the movements he saw in
mid-century Europe: primar-
ily the brutish expressionism
of *art brut* and the CoBrA
group, and later, Rhino Horn,
a group of exhibiting human-
ist painters with a surreal or
visionary bent.

Milder's deep commit-
ment to spiritual matters,

Jay Milder

Dreaming House, 1966

Oil on canvas, 34 × 38¼ inches
Gift of the artist, 2010.10

to religion, and to Judaism in particular, is rare in these very secular times, but he is involved with it to the point of near-obsession. *In the Beginning V* (from the *Messiah* series) and his many depictions of Jacob's ladder, Noah's ark, the Garden of Eden, the Cabbalah, and other key biblical stories reflect his heritage from the Hasidic mystic Reb Shem Tov of Breslov. This strain of Judaism spoke to the positive energy that is a result of God's goodness, and he transformed that powerful, joyous energy into his personal brand of expressionism. Like the others here, he applied the paint lavishly and, in his case, brusquely. No negatives, all positives, the paint (made using his own formula) is caked, slathered, and sprayed on. His work proved to be an influence on the young artists of the

1980s, particularly the Neo-Expressionists and the graffiti imitators such as Basquiat. Like the Cabbalah, Milder's paintings can be interpreted in many different ways. The seemingly abstract forms are genuinely figurative and they contain messages through ancient numerology inside of concentric geometric forms, which are based on mystical encoded knowledge. They grope for spiritual energy on Earth.[18]

The airiness disappeared in the 1980s as he began mixing ash and other things into the paint, thickening it and creating great surface density. Noah's ark and Jacob's ladder return as favored subjects, but pinks and blues, though slightly darker, remain common. More numbers begin crowding in, symbolic of many things to a Cabalistic thinker. All these are symbols to him, archetypal images

with universal meanings that last over time.

My work has to do with symbols, not signs. When I say I personify shapes instead of doing figures, it's for that very reason. This is the crux of my art, and what I am getting at. I lock together certain elements in a seven progression. I use Cabalistic geometry which is pre-Pythagorean. I build my gestalt on a numerical equation built on seven tones or types of resonations. I believe that painting is based on geometry and revelation.[19]

Jay Milder's palette lightened considerably in the 1970s and became more open and spacious. Elements seemed to float around the pastel atmospheres as if they were out in space and weightless. Fantastic creatures were formed out of unlikely and unnamable materials that

might seem humanoid or like amalgams of animal, bird, and insect. Numbers swirled about in more or less dense clusters, words appeared, like "Tao" and "Marine," but many of the specific things that used to populate the canvases began leaving. At the end of the decade he changed again, and so it went within a similar framework.

"Milder counts among his creative influences music— mainly jazz, Shostakovich, and African rhythms—but also mysticism, the Cabbalah, some excerpts from the Old Testament, Talmudic tales, Buddhist, Sufi, and Maat philosophy, alchemy and numerology," explains Dinah Guimaraens, curator of *Jay Milder Expressionismo*, his 2006 retrospective in Rio de Janeiro.[20] Thus when looking at a painting such as *Noah's Ark 3*, one can potentially read

the red circles as chakras, or as pointing to the four cardinal directions, and the numbers have various significances for the differ- ent mystical approaches. According to Guimaraens, Milder "speaks about his art as the representation of a bird's flight over an embodied landscape where the chakras become its meridian points."[21] Critic Judd Tully summed up Milder's fusion of the primal with highly conscious intel- ligence this way:

The artist's cabalistic narrative, tattooed with combinations of mysterious numbers, and incised alphabet letters, transmogrifies into floating faces and kneeling animals. The menagerie of images intensifies the sense that this is an eerie and apt allegory in our own violent time of so-called ethnic cleansing and environmental horrors. The epical story in paint

is open to interpretation, but it is Milder's gestural energy and superb color sense that makes this series [the Ark paintings] such an exuberant and excessive success.[22]

Robert Henry's (born 1933) paintings are not based in religion, literature, art history, political or social themes, or any other customary source for pictorial ideas. They may be some of the strangest paintings ever painted, but they are based on his experi- ences imagined into paint. He enclosed these words of Friedrich Nietzsche on a small slip of paper with the postcard reproductions of recent paintings for a gallery exhibition in 1998:

The fine artist must have the power of coining the ordinary into a thing never heard before and proclaiming the universal so simply and profoundly that the

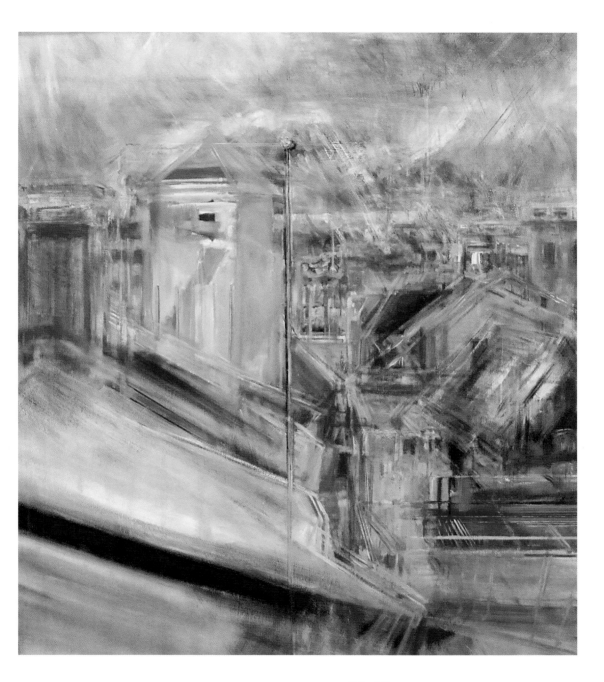

Robert Henry

Hilda's Tower, 1965

Oil on canvas, 70 × 60 inches
Gift of Sarah Henry, 2010.20

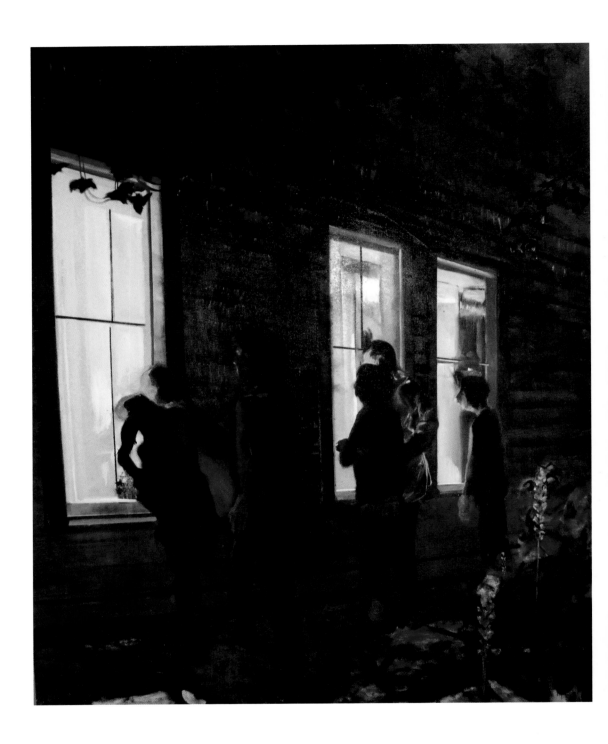

Robert Henry
Voyeurs II, 1988
Oil on canvas, 72 × 60 inches
Gift of Jane Henry and Tobin Harshaw, 2010.19

simple is lost in the profound and the profound in the simple.[23]

The more familiar with Henry's paintings one becomes, the more appropriate these words sound for describing their effect. He paints single figures vividly expressing their emotions. In *Longing*, 1997, a clothed sailor on a small green rectangle almost seems ready to jump into the sea of blue that covers the rest of the canvas, except for the sailboat on which another man stands, beckoning to him. The strain of longing is expressed throughout the landlocked man, from his craning neck to his timidly offered hand, out of the sailor's reach. In another of the same year, *Wish Fulfillment*, a man in a suit and tie stands head down, arms hanging at his sides, cowering ever so slightly, encircled by a crowd of clapping, cheering,

fist-pumping people. As always with Henry's paintings, you can read the tumble of complex thoughts going through his mind and theirs. He paints crowds, a painting rarity. Aside from performers bowing to cheering crowds, he paints street scenes viewed from a window, playgrounds, water parks, buildings with people seen inside the windows, jumping from the windows, gathering on the roof, people in a pit looking up, people ringed around one looking down into it, and processions of dead or wounded martyrs being carried on makeshift biers through urban streets.[24]

Over his 50-year work life, Robert Henry has changed what he paints every few years and sometimes how he paints. He studied with Hans Hofmann in Provincetown in 1952–54, as the paintings that resulted suggest. He also

studied with Ad Reinhardt, and with Kurt Seligmann and William Baziotes (two Surrealists) the following year at Brooklyn College. While it is impossible to trace their effect on him, the variety of approaches to both abstraction and the figure that he took for the rest of the decade, into the 1960s, and probably ever since, may well have resulted from that mixed experience. Some periods and particular paintings have a Surrealist cast to them. Occasionally, from the early 1960s and throughout the 1970s, he made paintings that were mega-constructions of dissimilar but physically connected panels with abstraction coexisting with representation. His long fascination with how we see and how to represent that in a painting led to paintings like *Hilda's Tower*, 1965—though this is an imaginary subject, most of

Robert Henry
In the Green Water, 1993

Oil on canvas, 60 × 72 inches
Gift of Michael Gorin, 2010.21

the paintings in this vein were done from observation. Henry was experimenting to create a sense of greater depth in his work using variable focus and the multiplication of edges for out-of-focus effect. He had discovered that in the eye, instead of blurring at the edges like an out-of-focus camera, the edges separate into many echoes, like reverberations. He also found that the sense of depth increased when one looked at the work from an angle. The effect in *Hilda's Tower* and other paintings is somewhat disorienting, but creates a sense of speed and excitement that can energize a painting and give it power. He worked at this problem of focus for more than ten years.

Viewing cars from above is the subject of at least 17 paintings. Viewing city areas

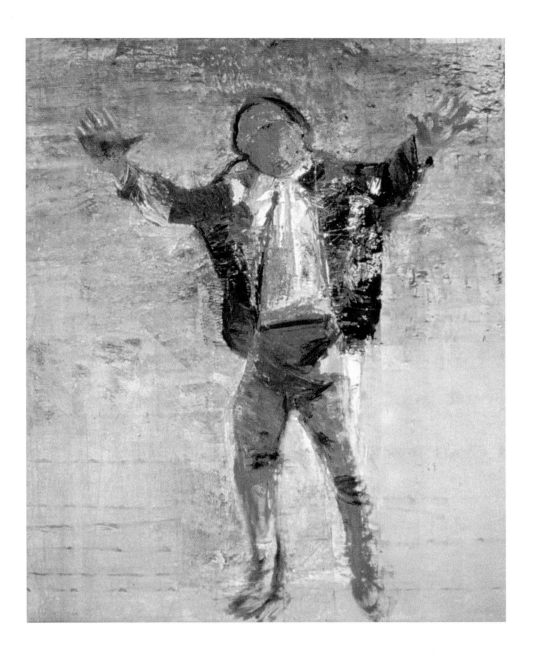

filled with people from a distance, viewing down into pits, and looking across streets into peopled buildings all provide unusual viewing angles and strangely mysterious content. It is artist as voyeur, which Henry openly admits in a series of paintings with that title. *Voyeurs II* of 1988 is typical of the series in its aura of mystery with no answers. The people peering intently into the lighted room

Robert Henry
Up Against It, 1994

Oil on canvas, 50 × 40 inches
Gift of Emma Gorin, 2010.22

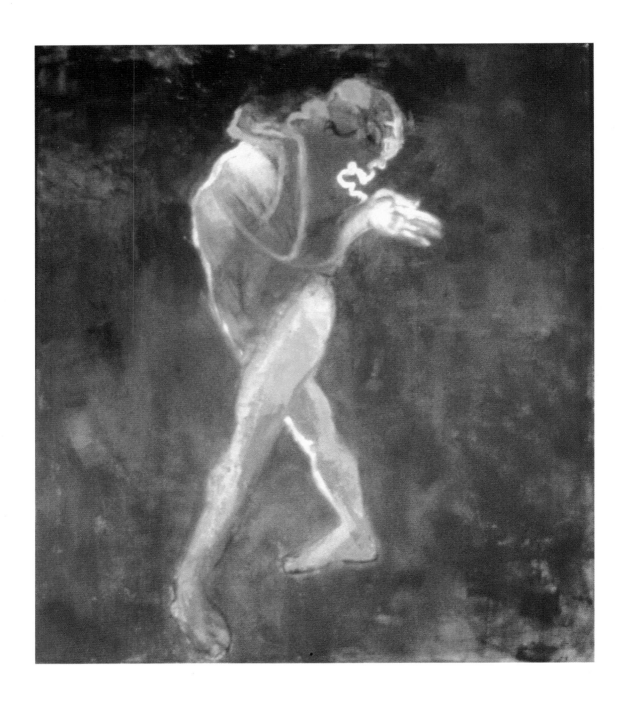

from the darkening woods outside give no hint of what they see, and our view of the inside is limited. The bright light inside is golden pink on the left, pale blue and pink in the middle, and through the last window perhaps there is a glimpse of a doorway. Is it a dance, a party, or has something terrible happened? One of the peerers/peepers has an arm linked through the arm of another, but is it for comfort? The light screen of foliage between us and the action adds to the mystery. The subject, rich enough for a series of paintings, may have been inspired by John Sloan or Edward Hopper, both of whom had a strong interest in the subject of views through windows into private scenes. This painting has many Hopperesque aspects, and the lighting in particular is reminiscent of his *Rooms for Tourists* at Yale. Hopper is

an inescapable presence on Lower Cape Cod. The building that is the subject for the Yale painting is in Provincetown where Henry studied and where he and his wife Selina Trieff spent years before buying property on Martha's Vineyard. They returned in the 1990s when they purchased a large multi-story house on Main Street in Wellfleet, and Henry subsequently became president of the Provincetown Art Association and Museum.

Trieff never paints water, but it is a frequent subject for Henry. In his imagination, water is a place where you're not safe in boats and you definitely don't belong in a storm, with or without boats. His boats are always dumping out their passengers or about to crash down over them, and waves are sweeping all away with tsunami force. Even artificial waterslides can turn on their riders. In the 1990s he

did a series titled *Ship of State* in which the seas are ever rough and the ship is often missing, presumed sunk. People, in groups, in pairs, or singly are battling the sea. In the painting *In the Green Water*, 1993, the tiny head amid the swirl of green and black water does not seem destined to bob there forever, and we see nothing nearby that might be of aid. Still s/he had to come from somewhere on something, unless s/he was simply dropped from the sky or swept out to sea. Green is a difficult color to use normally because of its earthy connotations, but Henry has a way with green that makes it both real and abstract at the same time. He can paint an entire interior scene pale bluish-green and make it convincing.

Although the subjects that don't interest Henry are few, people predominate. *Up*

Selina Trieff

Gilles, Self-Portrait, 1979

Oil on canvas, 72 × 54 inches
MSU purchase, funded by the Richard
Florsheim Art Fund and the Kathleen D. and
Milton E. Muelder Endowment, 2000.26

Against It of 1994 is typical in its everyman straightforwardness—a faceless man in jacket and tie literally up against something—but its meaning is a complete mystery. Is it a glass wall? Is that blood on his jacket and tie? Is there a yellow flower in his lapel? Has he run there to escape something? Is he facing a gunman? Did the police tell him to assume the stance of a prisoner? Like another in what may be a series, *The Man Behind It* (of the same year) also seems to be pressed up against an invisible wall. Something similar happens with *Miss Butterfly*, also 1994, in which nothing is straightforward. It would seem that she is a dancer, but we do not really even know if she is female, as all anatomical markers are hidden. The way the light strikes her face makes it, too, indiscernible. In a drawing study for the painting she is clearly female with wavy hair and a pretty face. The white light has not electrified the curves around her mouth and chin and obliterated the telling detail as it has in the painting. This is the way the artist solves the mystery:

I am able to invent images that represent my feelings and beliefs without being limited by what I see before me. I have a firm belief that these images, which have entered into me and then emerge, almost as if of their own will, in the drawing process, have intrinsic meaning. But the meaning does not come first; the drawing does.

The meaning is like the meaning of dreams.[25]

These five paintings point to only a few of his many subjects. Among his favorites not already mentioned: Chinese-influenced landscapes in scroll-like formats, Janus heads, nudes, speed, woods and dunes, fishermen, horses, street life, cars, and his family. His subjects are as varied as the way they are painted. He says: "I want to avoid having a routine method for painting. Rather than looking for a signature style, I have used multiple and varied approaches in the belief that the unity of the work resides in persona, the spirit of the artist, not in the style."[26] Look carefully enough and you can catch him doing a "Degas" or a "Gauguin," or maybe a "Homer." He is open stylistically, and his paintings' stories are left open as well. He says, "I don't know what they will turn out to be, I just start drawing. If I know too much, it gets too still. I try to keep my work alive."[27]

Selina Trieff's (born 1934) paintings are unlike anything

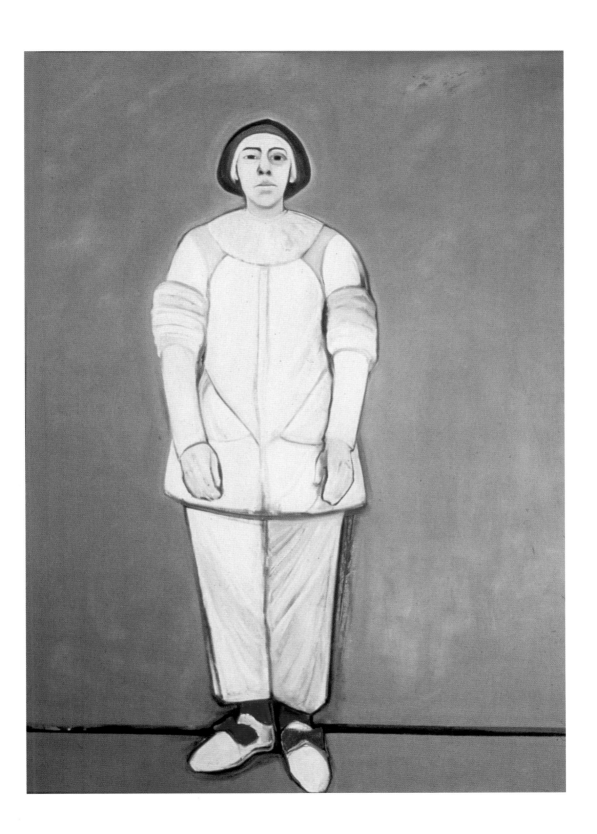

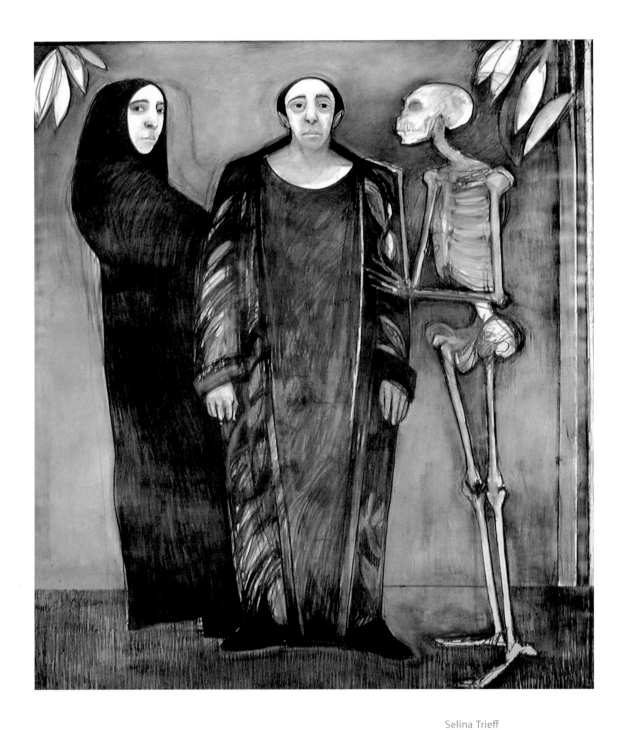

Selina Trieff

Untitled, 1984

Charcoal on paper, 72 × 60 inches
Gift of the artist, 2000.25.1

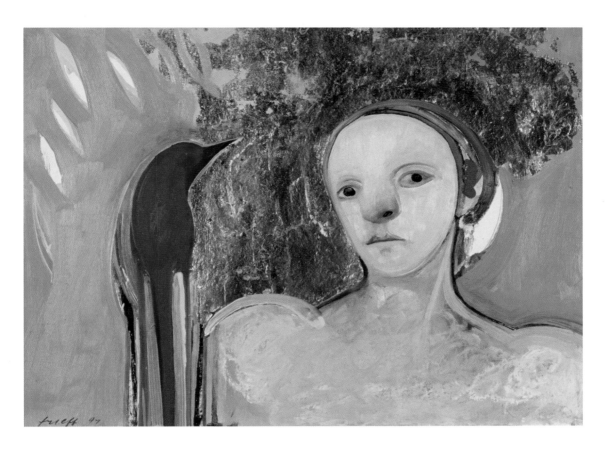

else in contemporary art. Their iconic power and surface treatment have their closest parallels in late medieval and early Renaissance paintings. Their frontality, hieratic force, high seriousness, icon-like gold and regal red surfaces, backgrounds, and clothing all work together to recall a distant, but critical, period in art history. Yet, this is too easy. There is humor here as well—the guard pigs, enthroned goats, chickens and sheep, and most importantly her dog, Louis (pronounced Louie). Initially, Louis belonged to daughter Jane (also an artist), but eventually he went to live with her mother and father, Selina and Robert Henry. All three artists have their studios in the same building, so wherever Louis went he was a possible painting subject. Whatever Louis did, however he draped himself or slept, was funny, and Selina loved to paint him. The private world surrounding Selina

Selina Trieff
Woman with Red Bird, 1997

Oil on paper, 17⅞ × 24 inches
Gift of the artist, 2000.25.3

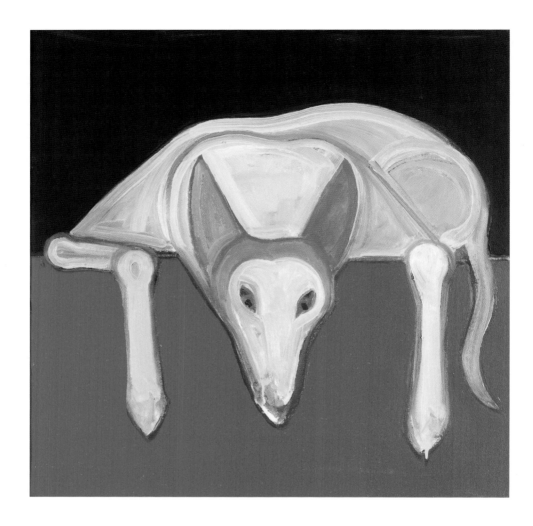

also contained something central not yet mentioned: the poetry of ballet. It seems to go on around her, to incorporate her by entering her paintings, constantly and silently. The aura of compelling solemnity, noble but unthreatening, elevates her subjects (both human and animal) above mere mortality. Her two daughters, Sarah and Jane, dressed in leotards, hooded or just skull-capped, let their erect posture, poses, and balletic movements combine to reinforce Selina's poetry.

The high seriousness that surrounds Trieff's figure paintings may stem from her studies at Brooklyn College with Ad Reinhardt and Mark Rothko. Born in Brooklyn, she was studying painting in her teens, and by the time she

Selina Trieff
Louis, 1999
Oil on canvas, 24 × 24 inches
Gift of the artist, 2000.25.2

was learning from these two most high-minded people in the art world, she must have been ready to make a deep commitment to art. Those two artists demanded it. Art was serious life-and-death business for them. With occasional detours into humor in the animals she included later in life, and the occasional use of bright red to light up a relatively monochrome palette, applied gold leaf and its yellow and orange echoes were the only colors, besides black, that she seemed to use. In the 1980s greens came in, and a bright blue entered the picture in the 1990s. It was as though, at long last, Hofmann's lessons on color were finally finding resonance in her work. But she also made a large number of life-size figures in charcoal through the years. The Broad/MSU museum's *Untitled*, 1984, charcoal on

canvas-backed paper, at 72 × 60 inches, is an unsettling work: death in the form of a caring skeleton (hands reaching out to calm her) on one side, her young daughter, the figure of death enrobed in black, on the other. Selina looks tired, resigned, and yet still massively powerful, however lacking in happiness. Her feet set wide apart, one fist clenched, you don't get the sense that she is going to give up easily no matter how inevitable death is. The token signal of life, the leaves in the top corners, appear in many of her paintings, rarely elaborated upon as they are just signs. Life-size, it and her other charcoal works may well be unique to her—her personal artistic property. She became obsessed with drawing because she kept trying to work it into the paintings without succeeding. "I can see now where I may have

been battling the drawing part of my painting for years, and what it took to win that battle was just to draw."[28]

Velasquez and Goya may seem likely ancestors for Trieff, but the Abstract Expressionists were her parents, or at least her teachers. They gave her permission to move the paintbrush or the stick of charcoal freely. Although Hans Hofmann's colorism didn't seem to have affected her at first, his control of pictorial dynamics—what he termed "push and pull"— is evident everywhere in her work. As an example, even though the skeleton's feet place it forward of the central figure of the artist, the geometry of the bones of his upper body flatten it out into the same plane she occupies. Her daughter, clearly stepping behind her, has a facial luminosity equal to that of the other two heads and

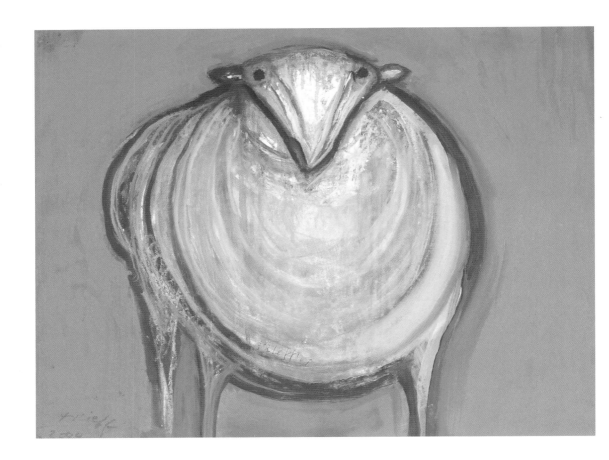

in a line with them, which pulls her into their plane. The use of skulls or skeletons with portraits of self or others is a frequent refrain in art history. As a *memento mori*, or reminder of death, they speak of life's brevity and unimportance in comparison to everlasting death. The habit-like garb on her daughter here and her own robes reinforce the religious aura of the confrontation with death, but Selina's subjects haven't worn "normal" clothes since the 1970s when she painted portraits of friends and family. Her girls often wear leotards with loose-sleeved tops. Aside from a Pierrot or clown's outfit, Selina usually dresses herself in floor-length robes in her paintings. (This is not true of everyday life.) It is not unusual for artists to identify with clowns, particularly for the sadness factor. Franz Kline painted some powerful clown portraits as did a number of early twentieth-century American painters and many Europeans through the ages, culminating in Picasso's vision of them. The clown is a contradictory figure: a smile wreathes his face from ear to ear, red nose to chin, but tears can often be seen running down his cheeks. Harlequin often accompanied Pierrot, but he could be very rough. Slapstick came from the noisy flapping sticks he used on Pierrot and others to control them. It made for entertaining theatre apparently, but it seemed to be the cause of

much of Pierrot's tearfulness.

There is a melancholy sense of the absurdity of this earthly life in Trieff's work, and certainly in the skeleton painting, i.e., *Untitled*, which she shares with Antoine Watteau, the eighteenth-century French painter of the source for her identification with the sad Pierrot standing alone on a stage, arms at his sides. "I saw Watteau's *Gilles* almost as a religious painting; the figure is so confrontational and yet vulnerable," she said. "I responded deeply to his pain."[29] Stillness as a Trieff hallmark is quite evident here. Unlike her husband's work, which is all about motion, Trieff's subjects, be they people or animals, are motionless. Often regally posed, even when sitting flanked by pigs, Trieff looks directly, though noncommunicatively, out at the viewer. Not all of her subjects look outward, but none really smile, though they seem content. They are the epitome of seriousness. Trieff's use of monochrome contributes to the painting's tone.

Selina Trieff's sense of humor comes through most strongly in her paintings of animals. Pigs, sheep, and goats were studied from nature on Martha's Vineyard where she and Robert spent many summers; Louie lived where they did, so he was always available until his demise. The animals seem to have characters, to be thinking something, even questioning. Louie, with one ear up and the other down, always seemed to drape himself over the furniture in amusing ways, and the idea of fully-dressed humans sitting or lying around with pigs or goats is unavoidably funny until you glance at the stoic demeanor of the human subject, usually the artist herself. "The animals I paint, the chickens for instance, are funny. They are goofy; they are two different types of work. The sadness of being comes into the figure paintings and the funny part, that comes out in the animals. It's almost like R&R painting the animals. But the figure is almost a spectre."[30]

Interestingly, Robert Henry went through a phase of painting *Universal Self-portraits*, a series of works attempting to find ways to visualize, to portray a "kinesthetic reality" as he describes it. They were like heads turned inside out and have a strangeness that seems closer to the work of **Miriam Beerman** (born 1923), than any of his other works, or of the other artists' work in the Broad/MSU collection. He was trying to express his deep, inexpressible feelings in a painted image; Beerman uses

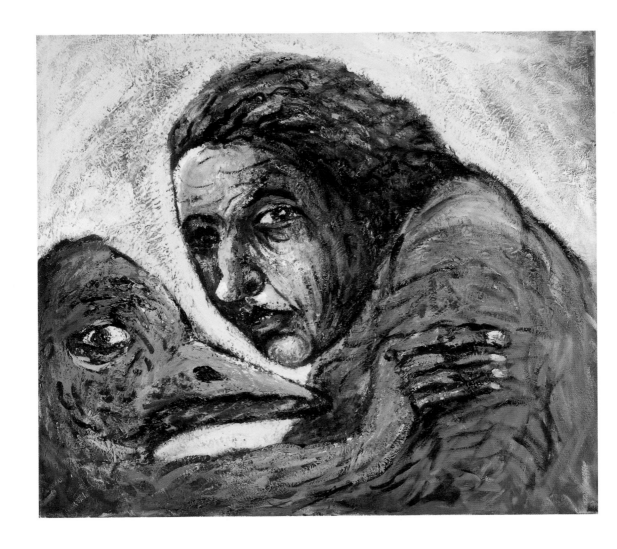

the paint "to release and thus
gain control over her emo-
tions—the requirement for
her expressionism," according
to one observer.[31] A combina-
tion of educational and
personal factors brought this
about over many years. Beer-
man was born in Providence
in 1923 and studied there at
the Rhode Island School of
Design 20 years later with

John Frazier, a much-loved
teacher who headed the
school. Frazier's own paintings
were loosely and generously
painted in clear, bright, warm
colors, and he worked very
closely with her, like a mentor.
Afterward, she studied with
Morris Kantor and Yasuo
Kuniyoshi at the Art Students
League and began to work
more abstractly, a direction

Miriam Beerman
Corridors of the Soul, 1986–87

Oil in canvas, 36 × 40 inches
MSU purchase, funded by an anonymous
New York foundation, 2004.4

encouraged by Adja Yunkers at the New School and then by Stanley William Hayter at Atelier 17 in Paris, for which she received fellowships for three years. There, because she didn't like the atmosphere at his studio, she began the practice of working intensely at home (or, in Paris, in her hotel room) alone all day long, a practice she continues in her late 80s. She was living out on Long Island, painting and teaching in 1958, when she was in a near-fatal car accident that left her with severe facial injuries requiring multiple surgeries. She expressed the brutality she had physically experienced in paintings for the better part of the next ten years, and she also suffered from respiratory and skin afflictions that isolated her and reinforced the drive to work hard and alone.[32]

Her work after the accident lost all traces of abstraction and focused on the human figure, but not in an idealizing way. Crude to the point of brutality, with the frequent employment of drastic exaggerations, the paintings of the 1960s seem like silent screams. Drips and spatters look like blood, and the palette is limited to red and ocher with black. Often the nude subjects are pushed up to the surface so powerfully they destroy its illusion of integrity. The Nazi Holocaust was her main background subject, augmented by tragic events in Latin America, Africa, and Vietnam. Sometimes, in the 1970s, the subject was not human—a bat, lizard, or turkey—but soon her humans themselves became hybridized into partial animals. A male might sprout huge, hairy spider legs, many arms or feline claws, a turtle head, or chicken feet. Her color started to become richer,

and in the 1980s it opened to a wide range of darks and some light. Miriam's brushwork also thickened noticeably over the years until, by the time of the Broad/MSU museum's *Corridors of the Soul*, 1986–87, it could be described as a textured relief. Her style might justifiably be linked to those of Kokoschka, Kubin, Ensor, and Soutine, but her approach to the canvas is markedly different. She wrote:

I am more and more prone to depend totally on intuition or a trancelike state to pick up whatever magic is around. When and if the intellect interferes too much or at the wrong time, I try to regain that indescribable other spirit which carries me along. On rare occasions the painting almost paints itself.[33]

This painting was the product of a dream concerning a

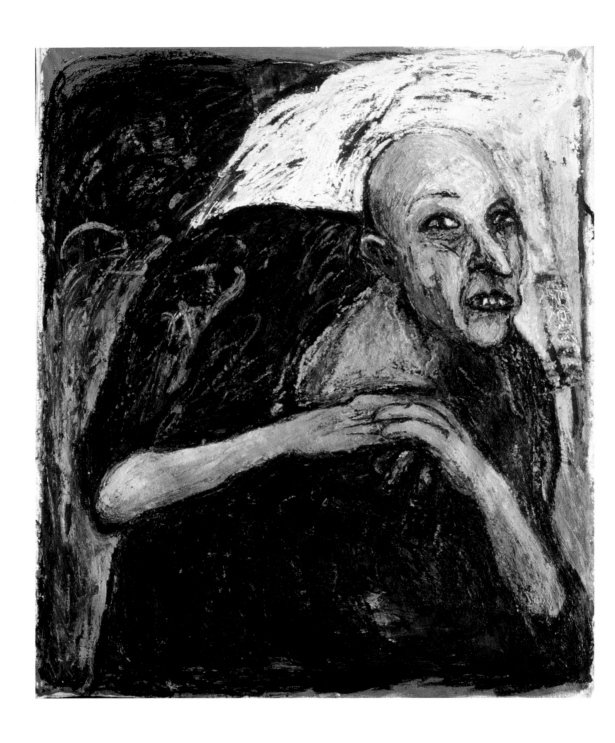

Miriam Beerman
How It Is (Part II), 1996
Oil on canvas, 48¼ × 38 inches
Gift of William B. Jaffe, 2004.19

young friend of hers that involved whispered warnings and protective feelings. Any number of dangers or conspiracies can conceivably be read on their faces, but the blue "bird" seems protective of the woman. Painting from her life in this rare instance produces an unusual calm.

Beerman honored favorite authors such as Pablo Neruda and Samuel Beckett, and artists Chaim Soutine, Paul Cézanne, Alberto Giacometti, Vincent Van Gogh, and Joseph Beuys with paintings in the 1980s, and she continued paintings on the subject of the *Plagues* started in 1976. A decade later, in the summer of 1986, while at the Virginia Center for Creative Arts at Sweetbriar, she painted eight enormous canvases on the ten plagues of Egypt, depicting Yahweh's deeds rescuing the Jews from bondage in Egypt.

Her paintings on even such specific subjects are more evocative than illustrational. She doesn't think much emphasis should be laid on her paintings' meanings because, as she says, "My drawing is very unplanned. Whatever comes out onto the sheet of paper, is a statement from the unconscious, however, if one wants to, there are many possible explanations."[34] She painted a portrait of Beckett with his muse, whom he seems to shun, but she also painted a series titled *How It Is* inspired by the book of that title by Beckett, published in 1964. The hero/narrator of the book crawls unendingly through mud reminiscing on his life, the mud symbolizing purgatory. One is reminded of Dante on the subject:

*Set in the slime, they say: 'We
 were sullen, with
no pleasure in the sweet,*

* sun-gladdened air,
carrying our souls the fumes of
 sloth.
Now we are sullen in this black
 ooze'—where
they hymn this in their throats
 with a gurgling sound
because they cannot form the
 words down there.*[35]

The painting *How It Is (Part II)* focuses on a single existential figure who seems to be cowering in the picture corner with wringing hands. Something dark and formless looms over the left shoulder, but on the other side of the head there is bright light. The face of the bald person is lavender and seems anxious, but not fearful, more curious about what is to come than afraid to face his or her fate. Beerman's world, as dark as it can be, does not seem, at least in this instance, hopelessly mired in inevitable tragedy and chaos. ■

BALTIMORE

The myriad things of the world inspired **Grace Hartigan**'s (1922–2008) paintings, literature among them. Of the three canvases in the Broad/MSU collection, one has its source in legend (King Arthur) another in a legendary history (Mrs. Nash) and the third in anatomy illustrations in medical books. (Grace Hartigan's husband was a physician, hence her interest in that subject matter later in life.) But seeking subjects only started when Hartigan decided she had to find her own way to inspire her paintings. In 1946, when Hartigan arrived in New York, she quickly became "one of the boys" among the Abstract Expressionist gestural paint- ers who eschewed subject matter in favor of feeling through the paint itself. She was known then as George Hartigan and counted Franz

Kline, Jackson Pollock, and Willem de Kooning among her friends. Her rhythmic, calligraphic style at the end of the 1940s shared much with that of James Brooks, also a friend. Soon she began to feel guilty about usurping the Abstract Expressionists' formworld without having struggled to find it herself, and she set out on a search for her own material to paint. Although she believed that no serious artist could ever paint again without taking into account the new con- cepts of space and surface the Abstract Expressionists had discovered, she found herself "obsessed" with the need for content of some recognizable sort, not to describe it, but to convey its essence. She said she wanted "all the implica- tions of the still life without the apples."[1]

She painted her way out of complete abstractions in

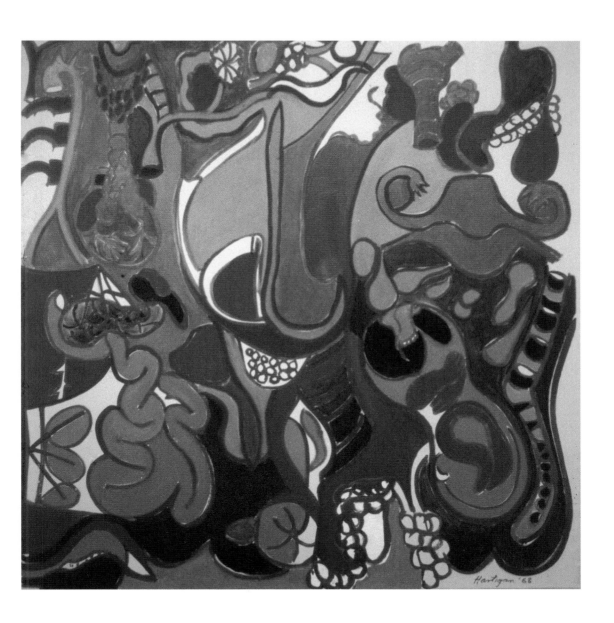

Grace Hartigan
Interrelations, 1968

Oil on canvas, 68¼ × 67½ inches
Gift of Dr. Michael Linnan, 2005.3

Grace Hartigan
Le Mort D'Arthur, 1996

Oil on canvas, 78 × 84 inches
MSU purchase, funded by Mrs. Fay Martin
Chandler, 2003.6

the early years of the 1950s by basing her compositions on the great masters (Dürer, Rubens, Velasquez, Goya, and the modern master, Matisse) until she discovered that all she needed were "snatches of life," of "that which is vulgar and vital in American modern life," fragments of the real, which she hoped had "possibilities [for] transcendence into the beautiful."[2] A market stall laden with vegetables, a bridal store window, a man's formal outfit, her dolls saved from childhood, and, later, travel souvenirs and tableware—all these and many other equally unlikely sights became the starting points for her pictures. When she moved to Baltimore in 1960 with her physician husband, she found the storefronts and street scenes boring compared to those of New York, and she turned inward to things of childhood: coloring books, such as her childhood favorite *The Coloring Book of Ancient Egypt*, and paper dolls of every variety. The linearity of these models was picked up in her paintings and remained a frequent aspect of them for life. In *Le Mort D'Arthur*, for instance, it is far more important than the colors, which function almost as washes. Other types of drawing caught her attention as time went by: Celtic manuscripts, cave paintings, Aztec relief carvings, Japanese scrolls, and anatomical illustrations. Other pictorial subjects were drawn from religion, royalty, mythology, and eras, such as early Christian, Renaissance, and medieval, as well as other cultures: Chinese, Japanese, Greek, and Mayan, for example. The list is not exhaustive.

Much success came to Hartigan immediately. Art critics Meyer Schapiro and Clement Greenberg discovered her and put her in their groundbreaking 1950 *New Talent* show at the Kootz Gallery. She had her first solo New York gallery show at Tibor de Nagy in 1951. A painting of hers entered MoMA's collection in 1953, and her work was soon in the Whitney. She was included in MoMA's prestigious *Sixteen Americans* exhibition in 1956 and was the only woman in MoMA's 1958 exhibition *The New American Painting*, which traveled to eight European countries. She retreated from the scene with the advent of Pop Art, which she hated, and concentrated on her painting and her teaching work with graduate students at the Maryland Institute, which she loved. Nineteen sixty-five was a turning point from the dominance of paint to the control of paint by forceful lines. In

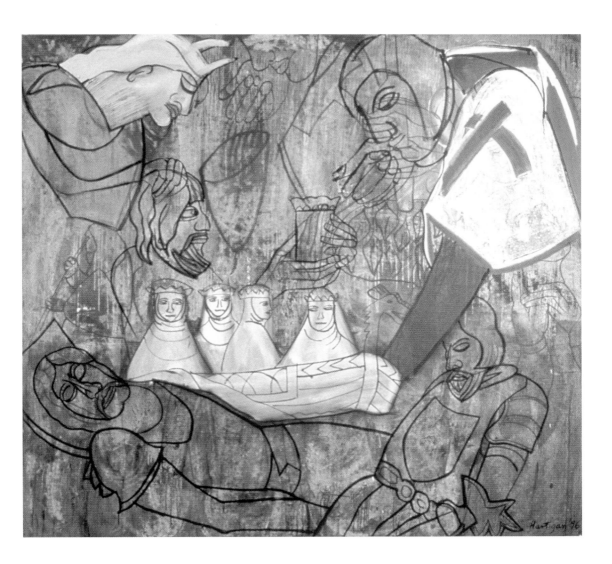

the later 1960s those lines were derived from medical illustrations in her husband's anatomy textbooks, however freely they were utilized. She was investigating the body the way she had previously done with motorcycles in her *Modern Cycle* series. She takes the various body parts out of their body context to examine them. In the museum's *Interrelations*, 1968, a spine, larynx, stomach, pancreas, female reproductive organs, intestines, and some unnamable clumps of vesicles are rearranged across the picture surface in browns, mustard yellow, red, and blue with an unarticulated white area near the top. She

Grace Hartigan
The Second Mrs. Nash, 1988

Oil on canvas, 54 × 42 inches
MSU purchase, funded by an anonymous
New York foundation, 2003.7

played with scale and used juxtaposition like a Cubist. The 1970s saw many marvelous paintings organized linearly in styles from all over the world—including Indian and Japanese theatre—and ages from ancient Egyptian to pre-Columbian and ancient Pompeii. Hartigan outlines her forms in various colors, but they are most often black and more distinct, as they are in *Le Mort D'Arthur*, 1996.

There are two legends concerning the disappearance or death of King Arthur. Hartigan gives us the first, oldest legend—from the tenth century—in which the king, wounded in battle, is taken to the Isle of Avalon to be healed; what happened to him thereafter is a mystery. Early belief held that he is lying there in a cave somewhere, awaiting the day he is needed again by England. Some say he was transformed

into a raven. The "still alive" version was replaced later by a "killed in battle" version. Hartigan shows him sleeping with a protective knight by his side. A boat with women to care for him on his journey to the island comes for him, and a wizard holds up a healing potion, while his wife and son watch over him on either side. The red and white areas are the only specifically painted places in the painting, which is dominated by the drawing on neutral washes of pale lavender and gray tones.

Drawing dominated in her work from the end of the 1960s until 1980. Then she started veiling the drawn imagery behind sheets of color poured down the surface, all but obliterating the imagery. At the end of the 1980s the drawing that started the picture was buried beneath sprays of paint instead

of copious pourings and massed drippings. *The Second Mrs. Nash*, 1988, is typical of this period. It is difficult to discern the woman's features in the welter of sprayed blots of color. There is a definite, drawn chin, a nose, two hands in black gloves, a large floppy black hat and scarf, a large mustard-colored greatcoat with a wavy-edged yoke, and two circles of blurry white replacing her eyes, presumably eyeglasses. She looks eccentric, but that may be reading back into the painting what we know of "the second Mrs. Nash," which may not have been in Hartigan's mind when she painted it.[3] The actual second Mrs. Nash, Juliana Popjoy, was the second long-term mistress of Beau Nash, a famous eighteenth-century dandy who established Bath, England, as a popular resort town for the wealthy. She

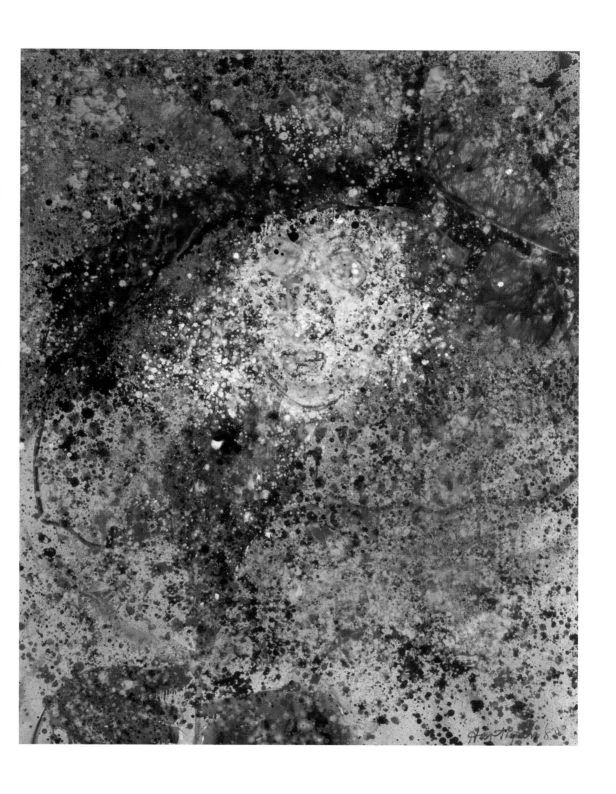

cared for him through a long illness, and after his death she became "unhinged by grief," and vowed never again to sleep in a bed. She "went to live in a large hollow tree" for the rest of her life.[4] For Hartigan, the mysterious portrait serves as an excuse for experimentation with painterly techniques. She appropriates the analytical pointillist style of nineteenth-century artist Georges Seurat, but loosens it to a splatter and combines it with vibrant contemporary colors.[5]

The 1970s were the years of greatest complexity in Hartigan's life and art: her father died, her husband became seriously ill—by trying some experimental vaccine on himself against encephalitis, from which he never recovered—and she

was forced out of her studio and had to find a new one. Her hips were deteriorating and would need repeated surgeries, and her drinking became so heavy that she became ill and had to be hospitalized. Her paintings became bigger and increasingly complex as if echoing her life. She packed them with incident, forms intertwining and breathing space at a minimum. The fragmentation in them was Cubist, but it was also deeply personal. She hated negative space and visible ground, so she packed her forms in tightly. She wrote at the time: "I feel that we are living a very fragmented life. The world—you too. So I perceive the world in fragments. Somehow in painting I try to make some logic out of the world that has been [given]

to me in chaos."[6] She tried to escape that world unsuccessfully, and after her hospitalization she joined Alcoholics Anonymous and gave up drinking. She threw all her energy into her work and helping her students at the Maryland Institute College of Art where she had taught from 1967 on and established a graduate school.

In the 1970s Hartigan had compiled her pictures with abstractions of objects, people, and artworks from various cultures, but in the 1980s she returned to the figure and to store window displays. The neighborhood around her new studio was ethnically mixed and full of interesting shops. The people she painted were often vastly enlarged paper dolls flanked by an alternate outfit, but she also did a large series

of glamorous movie stars, queens, and other heroines from history, religion, and mythology: empresses Theodora and Josephine, a "Renaissance woman" painting, and Saint George. She also deliberately styled some of the paintings after various Renaissance artists—Rogier van der Weyden, Caravaggio, Bronzino, and Poussin. Rivers of thinned paint run down the surfaces of most of the paintings from the early 1980s, but in the last part of the decade she began putting the paintings flat on the floor and pouring colors on the surface, then manipulating them with tools, hands, and feet, nearly obliterating what had been deliberately painted on their surfaces when upright. Painted wet into wet, many of these paintings were water scenes as part of her California coastal series of the late 1980s. She felt as though she finally understood Jackson Pollock when he spoke about being "in the painting " and "one with it."

At one point after that, she discovered a whole group of colors on her studio shelves that she had never used, and she decided to try them out. The unusual hues in the King Arthur painting may be one result of that decision. She kept finding new sources of imagery and trying fresh approaches to the canvas, and her painting was stronger than ever in her last decade. Her life was stable, and she remained firmly grounded in the artistic principles she learned in the New York milieu more than 50 years before. As she put it: "I continue with the formal painting concepts of all-over space. A projecting surface, and the challenge of vibrant color."[7] ▪

CHICAGO

The other American Figurative Expressionist intensely involved with literary sources is **Vera Klement** (born 1929) of Chicago. Born in Danzig to Russian émigrés and growing up with the language (and others), Russian literature—especially poetry—is very important to her. She has translated the poetry of leading modern Russian writers such as Anna Akhmatova, Osip Mandelstam, Vladimir Mayakovsky, and Boris Pasternak. Her paintings are never illustrative of literature, but derive from her personal experience with what she reads. For instance, she has made imaginary portraits based on a poet's iconography, creating compelling juxtapositions and likely situations. Klement states: "The relationship of literature to my own work is as complex as the way in which my work in general reflects who I am, what I see, what I remember, what I dream, what I wish to communicate."[1]

Vera Klement lived in New York City and studied art at Cooper Union, one of the oldest schools devoted to the arts and architecture in the United States. Her very early work was figurative—a clown puppet in harlequin garb in one case—but she was soon caught up in the Abstract Expressionist groundswell originating around her in Greenwich Village. By the early 1960s her very accomplished abstractions were beginning to include an occasional hard-edged element. They were otherwise lushly painted abstractions distinctive for their inclusion of large areas of white. The figure returned by the mid-1960s, squeezed between planes of white or an occasional other color that ranged from loosely painted to hard-edged. A

woman-at-the-window theme recurs, with echoes of Richard Diebenkorn, but the composers of the ultra modern music she favored are a subject all her own. *Stefan Volpe at the Window*, 1963, is hunched over as if looking down and can't be recognized, but Ralph Shapey, an important teacher of composition and a musical force in Chicago, is shown in 1968 with a full face and clothed body as if seated in the corner of a white room. Klement had relocated to Chicago by this time, and in 1969 she began teaching at the University of Chicago (where Shapey taught), from which she retired in 1995. A 1969 painting titled *Treetops* is basically an abstraction of the subject into arced brown shapes of varying sizes edging the bottom and right sides framing a bluish white sky.

She went completely abstract in the early 1970s, painting vertical columns across a horizontal field at first, then dividing the fielding in half across the middle, with columns across the top and different verticals along the bottom. Two spatial situations were thus created. At this point, she exhibited with "The FIVE," a group of abstractionists who banded together against the dominant Chicago Imagism. Abstract Expressionism and avant-garde music, which was highly abstract as well,[2] were her loves, and she had no interest in the naïve and anti-intellectual Chicago style that was fermenting in the sixties. From there, the move to two different kinds of painting, abstract and figurative, on each half of the canvas was a natural step to painting dissimilar diptychs, which she still continues to do. Some are quite disparate in size, the smaller one functioning like a sort of predella panel in an altarpiece, although often atop or on the side rather than running along the bottom.

Klement's figures, both male and female, tend to be half formed or reduced to only their heads. Boats, bells, a footed tub, vessels, and similarly hollow things often occupy one of the panels when the human figure is absent, and abstracted landscapes or tree trunks, sometimes flowers, occupy the other. On the figures and the sparingly selected objects, paint application is thick and often clotted or matted in feeling as if applied in an agitated, violently focused state. It contrasts strongly with the serene whiteness surrounding it and stresses its energy and its brightness. No one else uses such vast expanses of white, and yet

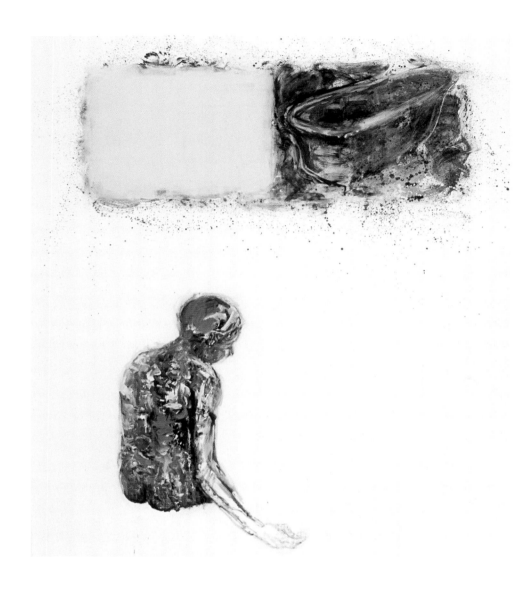

the paintings feel almost crowded with content. Each precious part is so eloquent and so full of mystery in itself and in its relationship to the other element(s). As an example, two paintings from the first years of this century look initially to be lovely and upbeat, but their titles are *Black Roses* and *Black Peonies.* Black flowers, grown since the Middle Ages and used as "Gothic" gifts and for their decorator-friendly contrast by florists, carry inevitable overtones of death. In her *Black Roses*, 2001, black masses are scattered among red and yellow ones in a large floral

Vera Klement
Mara, 2003

Oil and wax on canvas, 84 × 74 inches
MSU purchase, funded by an anonymous
New York foundation, 2005.6.1

wreath curving above a nude, sickly looking, white-haired woman with a greenish tinge to her skin, eyes closed and mouth open as if gasping for air. In the other canvas, three black peonies and a bud float in space like asteroids. As she wrote in a lengthy thought piece on aging and death:

Silence: a metaphor for death.

The maximal condition for the creative act is silence. Can we not say then that in silence a space opens up in which the making of art that is a gift is possible? And that act occurs in the silent space that holds the full awareness of one's death, one's ending/completion. It is in the making of this gift that life, the partner of death, is celebrated.[3]

Certainly death is not a stranger to her canvases, but, as her attitude is as positive as it obviously is, it should come as no surprise that her paintings are never gloomy, her depictions never morbid, her color never weak or recessive, but ever robust and bright. Every gesture on the white is a positive force.

Mara, 2003, just concentrates on the gesture—an empty, upturned hand—a sign of helplessness, emptiness, despair? Perhaps. She used it for a broadside handout at a reading of Louise Glück's poetry at the Poetry Center of Chicago. The poem on the handout is Glück's *Eros*, which concerns recovering from the loss of one man, accepting it, and beginning anew, but while coming to accepting it she is as passive, empty, and unneedful as Mara seems to be. One life is completed, another begins. Then one notices the tub—a tub very like the one in which Jean-Paul Marat was murdered in 1793. The gesture of her arm is exactly the same as that of Marat in Jacques-Louis David's famous painting of his death scene. Her head seems similarly swathed, though she is seen here from the back. Of the two joined rectangles above Mara on the white field, the one with the tub is black and grey, while the adjoining one is a soft pinkish-white. Life and death? Finality and hope?

Many of Klement's canvases focus on mythology as a source of eternal meaning. The golden shower raining down on *Danae* in this 1999 diptych is picked up in part in the canvas to its left, an abstraction of columnar forms with vague architectural implications. Danae's belly is swollen and red, as though beating like a heart with life. Danaë was a daughter of the King of Argos in Greek mythology. An oracle told her

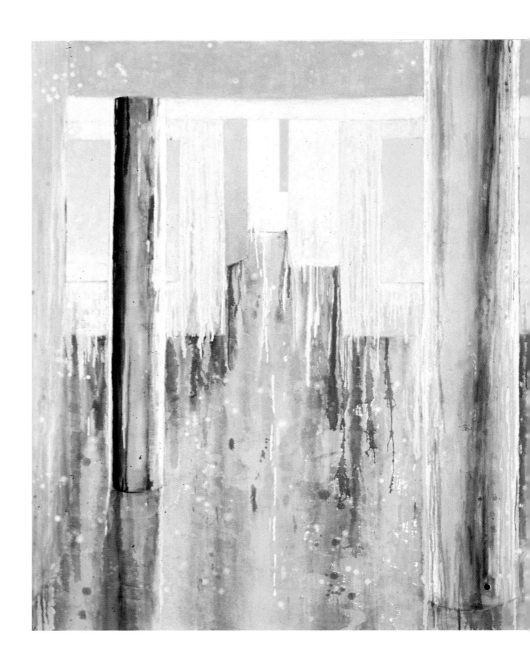

father that he would be killed by her son, so he locked her up in a tower to keep her childless. But Zeus came to her in a shower of gold and impregnated her with their child, Perseus. Her father put them in a chest and cast them into the sea, but Zeus watched over them. They survived and were protected by the king on the island

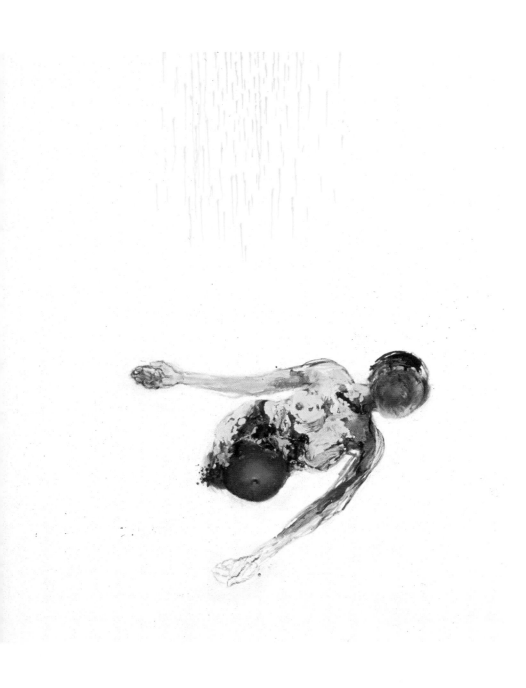

of Seriphos. After Perseus's feat of killing the Medusa and rescuing Andromeda, he accidentally fulfilled the prophecy. The abstractness of the whole story and its real aspects—Perseus's existence and recounted feats—seem perfectly conveyed in both the abstractness of the painting and its throbbing reality. ■

Vera Klement
Danae, 1999

Oil, wax and charcoal on canvas,
84 × 144 inches (diptych)
Gift of the artist, 2005.6.2.A–B

CALIFORNIA

Up until now all the artists under discussion were and are considered New York artists, even though some of them live or lived part- or even full-time outside of New York City. They believed that they shared an energy level far more intense than painters elsewhere, a commitment to risk-taking, and a near-obsessive belief in the importance of what they were doing that made them unique in the art world. Somehow painting under sunny skies and palm trees could not be taken quite as seriously as painting amid the mean city streets of New York. They loved their "whip-lash" lines, "searing" color, "brutish" pictorial structures, "clotted," "gouged," "coagulated" surfaces. Any sign of a nice touch, of French "cuisine" painting was anathema. Whatever you did, it could not look like anything anyone had ever done before. That was easier with Abstract Expressionism than the Figurative Expressionism that followed, since the figure provided something everyone had seen before, which made it even more of a challenge.

Clyfford Still and Mark Rothko were the only two artists from the New York School to spend considerable time teaching on the West Coast, and their influence can still be traced in the artists continuing to be Abstract Expressionists there. But it was also everlasting for Ernest Briggs, Edward Dugmore, and others who came to live in New York. Still made the most powerful impact on the California School of Fine Arts (CSFA) students and other teachers. He came to his first class in 1946 in a long, black overcoat and preached to the

students with a messianic fervor about the radical austerity of the artist's life, demanding absolutes of himself and them in everything. Students like Jon Schueler and John Grillo remember how he spoke of the need for "extreme purity," how he lived in absolute austerity, and made "terrifying demands" on himself and, by extension, on them and his fellow artists. They were convinced that he thought of himself as a new messiah because he spoke so feverishly about painting's potential ability to "blow the world apart" and about the artist as guerrilla fighter in a deadly serious war. Still was the Savonarola of Abstract Expressionism, making eloquent and often vitriolic sermons to students, friends, and captive audiences large and small. He violently attacked the vices he saw running rampant in the art world and called for the regeneration of spiritual and moral values and a devotion to artistic asceticism. He had many converts, but others kept their distance.[1]

Naturally, in time, a reaction set in. Early in 1951, one of San Francisco's most respected Abstract Expressionists, David Park (1911–1960), submitted a small figurative canvas to a competitive exhibition and won a prize. His friends were astonished, many thinking he had just had a weak moment, not realizing that this was only the beginning. There would be many defections, and Figurative Expressionist painting would come to be one of the most important post-war developments on the West Coast. Park had actually begun painting subjects—a *Rehearsal* of the Studio 13 jazz band (he played piano) and *Kids on Bikes*—in 1950. There is a legend that sometime that year he took all of his abstractions to the dump, but it is unsubstantiated. From 1953 to 1955,[2] with the help of a supportive working wife (what he called "the Lydia Park Fellowship") he was able to paint full time, and he slowly moved away from dramatic deep space with enlarged foreground figural elements. Probably because of his friend Elmer Bischoff's influence, he moved toward more classical compositions with nudes in relatively shallow spaces and no specific narratives. In 1955 Richard Diebenkorn returned to San Francisco from New Mexico and, impressed by Park's and Bischoff's latest figurative work, he decided to take up the figure as well.

Park, Bischoff, and Diebenkorn began having drawing sessions together working from a model. Park never made paintings using the

drawings, though, preferring to "call up the subject's image from within," according to his wife, Lydia.[3] He painted people, mostly nudes, but also people in clothes playing in or on the water and people playing music. Even when large, Park's paintings have a fragmentary quality as though they are just a small part broken off from the big picture of the world around him at any given moment. Whole figures are rare because the cropping is severe and unexpected. He is perfectly at ease working small, with less than two-foot dimensions. He fills the foreground with part of something, leaving a pictorial depth that raises the horizon line to the top of the canvas, which permits a great deal of very distant activity to be seen, however faintly. Back in the 1930s, when he was previously painting figuratively but in a semi–Social Realist and semi-Picassoid style mix, he would crowd figures in the foreground and let the background shoot rapidly away or make it an illogically filled space.

Between 1945 and 1947, recent work by Jackson Pollock, Robert Motherwell, Mark Rothko, and Clyfford Still was exhibited in San Francisco in important solo shows. Motherwell had the greatest effect on Park, who was not under the spell of Clyfford Still as so many others were in those years. He disliked Still's flamboyance and was offended by the cultish behavior of his followers, according to his friend Elmer Bischoff.[4] Park began working abstractly late in 1946, sometime after seeing Motherwell's show, adopting his larger format and planar compositions with ample use of white, but continuing to layer his paint on thickly, giving his surfaces a blistered appearance. Large planes, vertically oriented and edged in black lines, are articulated by a few smaller geometric units usually near the top, with an occasional, surprising organic node putting in an appearance. At their best, they seemed proud; at other times, they seemed muddled. Richard Diebenkorn later said that Park's abstract work was "kind of forced . . . he was involved with shape but I never felt there was a terribly important space to his non-objective work. . . . There would be shapes without a good reason, there would be shapes which were representational—they were awkward and got in the way."[5]

When the younger artists at the CSFA who had been swept into the Abstract Expressionist fold by Still were selected for the 1949 Legion of Honor annual exhibition and Park was left out, he decided to go back to the figure and start over, whether he actually destroyed all of his abstractions or just painted over them. While he jettisoned the empty forms, he retained the spontaneity that lay at the heart of Abstract Expressionism. He stated at one point that his "gods" were "vitality, energy, profundity, warmth,"[6] and poet/art critic W. S. Di Piero wrote, describing Park's figural paintings, that his "pictures are about paint and embodiment as indistinguishable states. They offer not only a vision of art's reality, of pigment pushed around on a flat surface, but also of the irreducible reality of human presence. Meaty paint. Meaty beings."[7]

A great deal was squeezed into Park's figurative paintings of the early 1950s. Heads or bodies filled the space from foreground to deep background, except when space opened up midway, leaving people edging off on all sides. Background incident and objects were present and gradually disappeared over the years. In the latter

half of the decade, nude or bathing-clothed standing figures predominate. *Standing Couple*, 1958, in the Krannert Art Museum, is classic in this regard. A man and a woman of equal height stand in identical positions: facing forward but slightly turned to the right, feet touching the bottom edge, heads going off the top edge, both with their left arms behind their backs and clasping their right arms. Light picks up the left sides of their faces, torsos, and legs. Darks edge their right sides. They seem rock solid and yet vulnerably human. No indications of setting or purpose seem necessary. They are Adam and Eve, Mom and Pop, Every Couple—an excuse to paint. He said, looking back:

I saw that if I would accept subjects, I could paint with more absorption, with a certain enthusiasm for the subject which would allow some of the aesthetic qualities, such as color and composition, to evolve more naturally. With subjects the difference is that I feel a natural development of the painting rather than a formal, self-conscious one.[8]

David Park only had a short time to flower. Doctors discovered terminal cancer in 1960 during a second back operation. When he could no longer stand up to paint in oils on large canvases, he finished his last canvas, *The Cellist*, sitting down using a chair-mounted easel rigged by his friends. He began working on paper in gouache, a medium that was new to him. The dazzling images that emerged numbered around 100 his last summer. He died on September 20, 1960.

Park's close friend Elmer Bischoff decided that Abstract Expressionism "was playing itself dry" in 1952 and began to practice sketching from life to prepare for introducing the figure into his paintings. The early results were quite impressionistic, unlike Park's, full of colored light and soft gestures. He created an atmospheric sense of space with rich reds, blues, greens, and luminous grays because of the light they generated. Usually solitary and inactive, his figures seemed almost Hopper-like in their mood and sense of place. In 1973 he went back to abstraction.

Richard Diebenkorn (1922–1993), the third in this little group who drew from the model together in the early fifties, would become the

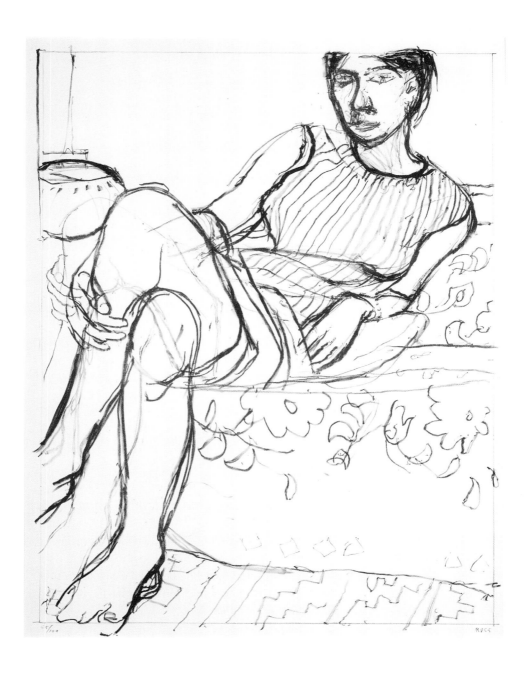

best known of the Bay Area Figurative School, as it was generally termed. He got a late start in 1953 on his return to Berkeley after two years of graduate school in New Mexico and a stint teaching in Urbana, Illinois, but he moved up the ladder of success very quickly. In 1954 he had gallery shows with Paul Kantor in Los Angeles and Allan Frumkin in

Richard Diebenkorn
Seated Woman in Striped Dress,
1965

Lithograph, 28 × 22 inches
MSU purchase, funded by an anonymous
New York foundation, 2004.15.3

Chicago and was included in the Guggenheim's traveling exhibition *Younger American Painters*. He also received a Rosenberg Fellowship, which funded a year of work in his studio. Two years later he was also showing his work in New York at the Poindexter Gallery.

Once he realized the all-over neutrality of abstraction, Diebenkorn sought differences in his paintings "such as outside beside interior; sunlight as opposed to gloom, the presence of person as opposed to emptiness." Having studied Matisse and Cézanne intensely,[9] particularly how Cézanne turned landscape scenes into structured portraits and how Matisse differentiated between indoor and outdoor light, Diebenkorn structured his landscapes practically from the top of the canvas down to the bottom, or, if a figure was included, to the

place she stood or sat, usually a porch, as he eliminated the barrier walls between interior and exterior. The light in the foreground-inhabited space, however, is usually different from the light in the landscape, whether a wall is present or not. In the first years of the sixties, instead of combining exterior and interior spaces within a single painting, Diebenkorn seemed to focus on one at a time—full landscape views or closed interiors. The interiors are usually quite large, even the one of his cleanup area, *Corner of Studio, Sink*, 1963, which measures 70 × 77 inches—never has a sink looked more beautiful—but his small paintings of a glass, a dish, and a tomato, each with a knife, are exquisite too. Two large canvases of 1961 are new presentations of the figure indoors without any outside light, both with

faces not visible, one facing away (*Seated Nude, Hands Behind Head*), the other having her face nestled in her arm (*Sleeping Woman*). A striped carpet border provides the only visual incident in the former painting except for a yellow sunspot on the floor. The rest is close shades of gray, brown, and orangey ocher. *Sleeping Woman*, on the other hand, is full of colors and incident, with things hung on the wall, a blue dress on the sleeper, and her reflection in a mirror behind the back of the sofa on which she has draped herself. Horizontal movement is stressed in both pictures, flattening the space.

This was a characteristic of a number of paintings around this time that seem to be about side-to-side action and frontality. It is also true of his drawings and prints in which arms are often akimbo,

Richard Diebenkorn

Seated Woman in Chemise, 1965

Lithograph, 28⅝ × 22½ inches
Gift of Charles M. Young Fine Prints &
Drawings, LLC, 2004.15.4

or stretched out along a horizontal, and legs cross and extend to the opposite sides of the paper. Even though a print is made by drawing with a waxy medium on a lithographic stone in the printmaker's shop, it has all the spontaneity of a sketch. The indecision and hesitancy for which Diebenkorn was famous, because of all the pentimenti he left scattered over his canvases, are readily noticeable in his prints. His trial-and-error working method naturally produced them. Diebenkorn's wife Phyllis was his model, except for the drawing sessions with Park and Bischoff. In one print she wears a see-through chemise, and he renders her without his customary multiple adjustments. This print seems to be about stability, with her braced legs and arms fixing her solidly in her seat. The other print creates a

sense of restlessness instead, conveyed by the recorded movements of her right arm and left leg. The striped dress and the floral pattern on the upholstery also establish rhythms and activate the scene, as do these records of movement "left behind." Both prints were created in 1965 at Joe Zirker's Original Press in San Francisco along with five others. One hundred of these were printed in black ink, but only a few were done in red.

Diebenkorn's pictorial space got flatter and flatter in the early sixties, and after his trip to Russia and his move to Los Angeles to teach at UCLA he realized that "the painting I did [here] was really flattened out, and so it was as if I was preparing to go back to abstract painting, though I didn't know it."[10] In one painting a woman sits with her long legs crossed under her on a sofa, her high

heel touching the left edge of the horizontal canvas, her right foot extending off the canvas's right side. In 1966 and 1967 he painted a number of canvases with the woman seen from the side, the "L" of her body carving out a rectangle of wall behind her. Even though he gave up the figure after 1967 and his Ocean Park paintings were highly successful and well respected, his figurative paintings are what most people see in their minds whenever California Figurative Expressionism is discussed.

Nathan Oliveira (1928–2010) knew Park and Bischoff, and he had attended some of the same drawing sessions they had in the Bay Area, but his age, background, training, and aims were very different from theirs. For him the figure was paramount, not just one element among

others as it seemed to be for them. His first art epiphany had come while viewing a Rembrandt portrait in his late teens; he decided then and there to become a portrait painter. After studying with Max Beckmann, seeing Beckmann's retrospective and those of Oskar Kokoschka and Edvard Munch, and having heated discussions with other artists—like Bischoff, Park, and Diebenkorn amid the larger discussion of Abstract Expressionism still ongoing— he came to his position:

Some of us became very inde-pendent . . . trying to . . . discover a language that dealt with the figure and also recognizing the contemporary concerns about Abstract Expressionism— somehow trying to develop a language that embodied all of these characteristics An awareness of contemporary painting language, a recognition

of paint for paint's sake, action painting, recognizing a certain obligation that I had to fulfill according to my own needs as a painter, interpreting a form of reality, somehow trying to combine all of these aspects into a language that would represent modern Figure painting.[11]

Oliveira's focus was on the solitary human's exis-tential situation, not telling stories. His non-narrative content produced links to painting and sculpture throughout history that also froze moments for all time. Rodin and Giacometti come immediately to mind. His inclusion in 1959 in the *New Images of Man* exhibition at MoMA was all to do with this universality of his figures. Winning a Guggenheim fellowship to study in Europe in 1958 had enabled him to see figurative painting all over Europe and confirmed

his commitment to it and his rejection of abstraction. Upon his return, working through his idea of "making figures with paint" in a studio his parents-in-law gave him to use while in San Leandro, he established his identity as a painter, which was fixed in the art public's mind by his inclusion in that MoMA exhibition. His first New York gallery show was a sellout, but his second didn't fare as well. Showing with a major gallery in Los Angeles at the same time put a strain on his producing capabilities, and he began to have difficulty finishing paintings. He didn't get excited about his subject again until he began painting women in 1961, starting with a painting titled *Nineteen Twenty-Nine* of a seated woman in a fur-collared coat, and continuing with others on the subject, including the museum's *Standing Woman*

Nathan Oliveira

*Standing Woman with Fur
Collar*, 1961

Oil on canvas, 54 × 50 inches
MSU purchase, 62.9

with *Fur Collar* of the same year. He was painting his mother as she was in his mind, seen in her finery in 1929, the year of the great Wall Street crash—the year his family was destroyed. He worked from photographs, as he was only one year old when this all happened. The eroticism, hinted at by the exposed thigh and garter belt here, is an aspect of all these images, based on childhood memories as well as pictures: "Friends of my mother's sitting with legs crossed and rolled down stockings. Symbols are all experiences. All of these are recollections or have some personal symbolic meaning I hope will fade."[12]

Women became an important, safe subject for Oliveira in the coming years when he was struggling with the lone, existential male. *Spring Nude*, painted in 1962 when he was teaching at Urbana, Illinois, was the largest painting he had made at 8 × 7 feet, and it was completely successful, but he was not doing as well with male subjects. From 1963 to 1968 teaching job changes and a painting block that kept him from finishing canvases combined to make him switch to drawing and lithography as his major mediums. Single

figures, some reflected in mirrors, creating doubles, and couples predominated, and later the couples moved into horizontal, lovemaking positions. Sensuality entered the picture as he made free-spirited watercolors of nudes full of movement and color and with none of the angst of before. He began painting over many of his lithographs. In 1966 he took a permanent teaching position at Stanford, near which he got a huge studio in a former lodge hall with a stage in it. That stage became the first thing he painted on his return to canvas, followed by monumental heads in 1968. At first he painted the empty space, then he added a bed and a woman, and later he created geometric shapes, including a pyramid, which he used as a subject in the space as well.

In the 1970s men came back into the pictures, often vividly dressed and posed like dancers. Women almost disappeared into light, engulfed by their ambience. They were perceived as "magical expressions of the ghostly or spiritual, projected in physical form."[13] As the '70s went by they disappeared altogether, such as in the *Aptos Beach Sequence*, and were replaced by abstract

references to places he had visited and geometric forms, as seen in his *Site* landscape paintings of the late 1970s, which are all mists that let a few shadows and drips and pieces of places real or imagined peek though. Un-naturalistically Turneresque, they are exquisitely beautiful. Also in this decade, Oliveira became deeply involved with making prints. Spurred by his new dealer Martha Jackson, who died suddenly after visiting him in Palo Alto, he took her suggestion to work on a suite of prints *To Edgar Allen Poe*. Just as he always had in paint, he found his image in the process of creating it. To print, he made numerous trial proofs, drawing, changing, printing again, each time working from the palimpsest of the previous incarnation. Unlike painting, this process left him prints (proofs) of all the previous incarnations, instead of burying them irretrievably below the final one. This was immensely satisfying for him. He dedicated the *Poe* suite to Martha Jackson and went on to make many more prints.

Sculpture was tackled next, in the 1980s in his enormous studio. Heads and figures came first, but then the *Site* painting

subjects—large plateaus in the southwest, the Yucatan, and temple sites, with all their mystery and grandeur— appeared, however abstruse. He made flat horizontal bronze slabs, which were bolted together to make very large sculptural expanses. "They are tables of solitude and mystery, ravaged by what Shakespeare called 'the tooth of time,'" according to Peter Selz.[14] The 1970s and 1980s also saw new subjects for paintings and prints. The kestrel was a crucial one, going back to childhood bird drawings. Kestrels are falcons that hover about 10–20 feet above the ground looking for prey to swoop down upon. They need some headwind in order to hover, which is why they were locally named "windhovers," the title Oliveira uses for his paintings of them. In the 1980s some paintings were of just a single large wing, but are still quite powerful images. Animals came in, and some of the standing figures metamorphosed into steles, but the mystery and power of his work has remained a constant.

With the encouragement of a couple of former students, Oliveira began exploring some sculptural ideas in the early 1980s. Standing women and heads predominated, often painted directly on the bronze surface as one might expect in a painter's sculpture, but also some enigmatic sculptural plateaus meant to be viewed from above. Inspired by experiencing the mystery and power of Mayan temple sites in the Yucatan, he made bronzes of great power and solitude. Aside from women, Oliveira's painting subjects have been various over the years: wings, dogs, antlers, steles, and abstracted sites visited here and in Europe.

Paul Wonner (1920–2008) is one of the gentler Figurative Expressionists, along with Oliveira. Late in life he became known as an abstract realist because his detailed still lifes were so abstractly conceived. His pre-1970s works, however, were very much in the expressionist vein of the New York School of which he had been a part from 1946 to 1950, during its formative years. He actually studied at Studio 35, the offshoot of the Subjects of the Artist School founded by Robert Motherwell, Mark Rothko, William Baziotes, and David Hare, a sculptor. Each artist was supposed

Paul Wonner

Gods in Wood and Stone, 1969

Casein on paper, 16½ × 13½ inches
MSU purchase, funded by the Friends
of Kresge Art Museum and the National
Endowment for the Arts, 72.73

to teach one night a week, and on Fridays a speaker was brought in, usually by Barnett Newman. In fact they were all there most nights, and they did not tell the students what to do so much as what not to do: never work from an actual subject, still or living, do not make anything that looked like art as it was known, no models, no still life setups, no stories, no horizon lines, much less landscapes. The students got huge sheets of brown paper, paint, and a spacious workplace. They were encouraged to experiment, to make something neither their teachers nor anybody else had ever seen before. One student, Yvonne Thomas, recalled that "the subject was very real, but no object was accepted as the base for the picture. Only subjective feeling."[15] The Friday-night speakers in Studio 35 were

basically the Abstract Expressionists and the artists they admired.

Originally from Tucson, Arizona, Wonner had gone to New York after serving in the military in Texas during WWII. Then in 1950, when he moved to Berkeley, he came under the powerful influence of Hans Hofmann. Wonner and his partner, William Theophilus Brown, became involved with the artists around the California School of Fine Arts (now the San Francisco Art Institute). David Park and James Weeks took special interest in them, encouraging their adoption of a loose painterly approach to the figure like their own. Wonner worked in a brushy style like theirs until the late 1970s when his edges tightened, light brightened even more, and shadows sharpened as the objects being painted became

near-obsessions to him. Wonner tended to use a great deal of white when painting figures set out of doors. He and the Bay Area Figurative School painters in general were interested in the effects of the bright California light on people and objects and particularly in how it eliminated much bothersome detail. Somehow the subject's presence in the picture space was made more real and believable by the light. Later, he frequently painted his still lifes out of doors in this radiant light as well. It gave them a Vermeer-like clarity, each object quite distant from the others, unlike the usual still life in which everything is traditionally piled up to denote abundance—the genre's ostensible reason for existence. Also differing from the overlapping piles in traditional still lifes is Wonner's extensive and highly

Oliver Jackson
Untitled (6.8.03), 2003

Oil on canvas, 72 × 84 inches
MSU purchase, funded by an anonymous
New York foundation, 2010.9

dramatic use of shadows, which raises the objects to near hyper-reality as well as indicates the specifics of light sources and spatial facts.

Shadows abound in *Gods in Wood and Stone*, which Wonner painted in 1969. He was living in the midst of chaos; he had moved to Southern California to teach in 1962, and by this time campus life in California was in turmoil with sit-ins, anti-war protests, and generalized unrest. Perhaps in response, he went through a prolonged period of searching for new imagery, and *Gods in Wood and Stone* is one of the works on paper from this transitional period. The figures themselves appear to be searching, perhaps lost in the mists around them. Yet they may be coming out of the darkness and into the light. There are two layers of consciousness represented

here: past (the Greek statue) and present (his self-portrait), which reflect his self-doubt and search for identity during this time. Wonner continued working like this until about 1974, when he began the still lifes. Most of the work from this 1968–1974 transitional time was on paper, as it is here, and highly illustrative, with layers of mental awareness. Self-portraits were not uncommon during this time, though they all but disappeared for nearly three decades of making still life paintings. There is a slightly Surreal atmosphere being generated here, which wafts around the still lifes too. The ones set out of doors often have highly dramatic skies with which the absolute quietude and, yes, stillness, of the objects conflicts. Inside, the inert solidity of a flat, usually dark-hued wall directly behind flowers

and other living things and life-enhancing objects does the contradicting. In 2002 Wonner painted a self-portrait at his easel in his studio with a nude male model standing holding a red robe, and until he died, such scenes both interior and exterior were frequent. They recall, distantly, the various seated nude males he painted beginning in 1962 but without their rugged masculinity. His arrangements of the figures and their settings are vaguely allegorical in these late years.

The last West Coast artist to be discussed here was not a part of that local scene. **Oliver Jackson**'s (born 1935) major influences were on the other coast, where he spent some crucial, formative time before moving west. Writing about the San Francisco artistic tenor of the early 1960s,

Thomas Albright said this about Jackson:

His works are as big in ambition as they are in scale. Like much of the new Image painting now current, they seek a resolution between the claims of figurative painting and those of abstraction. But while the new imagism generally falls into a kind of gray zone that betrays little strong feeling for either, Jackson's paintings seethe with the tensions and contradictions of an art that is committed to retaining the strongest elements of both.[16]

Albright sees Jackson's work as two-sided: dense, heavily worked paintings full of gestures, marks, and soft colors, "a little like Philip Guston in a hurricane," and a loose, more open painting full of white space. The dense paintings contain "schematic figures, little stick-like, primitivistic 'paint figures' which sometimes resemble the splayed, humanoid caricatures of de Kooning, sometimes the childlike scrawls of Appel."[17] The figures spin, dance, huddle in a world of tumult

in which everything is in flux and only by joining up and forming circles can they seem to hold on.

Born in St. Louis and educated in nearby states, he taught in St. Louis in the late 1960s and became involved with the Black Artists Group in the area, collaborating with other artists and jazz musicians. Before moving to San Francisco to teach at California State University, Sacramento, he spent time in New York getting to know Willem de Kooning, who took a special interest in him. Pollock was gone by then and the Abstract Expressionists were on the defensive against the inroads of Pop Art. Being both figurative and abstract and fusing the two as he did, de Kooning was the perfect role model for Jackson, who was never imitative in any way but who caught the spirit of New York Abstract Expressionism. His brushstroke remained his own, as did his colorism, subject matter, and spatial sense, but he either picked up on the trademark Abstract Expressionist allover energized surface or had it innately ready to use. The energy in Jackson's paintings has a New York background, but something else as well— a spiritual element. There is a fervor, a wildness that borders at times on the cataclysmic, in his paintings, which is not traceable to New York. "What nobody understands," he said to curator Jan Butterfield in a 1982 interview, "is that it is possible to take inanimate things and so place them that they will make a kind of energy that will really *change you*. We tend to talk about aesthetics—the pleasing relationship of the triangle, the circle and so on. But the dynamic force of a work requires that certain shapes add up to a force which moves you."[18]

This drive to change people, to move them and affect them, which Jackson sees as the artist's role, has a strong religiosity about it, but one that may well not be restricted to any single religious system. As his painted world is described by Butterfield, it has multiple interpretations:

The sacred grove, the burning bush, the magic circle suddenly appear, in Landscapes that are not landscapes but gravity-less areas of free-falling Space, where rituals of every conceivable nature take place without regard for "known" reality. Magicians, judges, wise old men hold court with others of their

kind, and monsters and dancing dervishes whirl in a turgid atmosphere of richly colored paint, like the eye-dazzling blankets of the Navaho, is a repository for magic.[19]

The Broad/MSU museum's 2003 painting *Untitled (6.8.03)* is a modest size for an artist who routinely creates paintings no average room could hold. It seems to have, however, many of the exciting elements Jan Butterfield described, including a figure blowing a golden horn and a wide watery expanse separating the two sides of the painting and the action going on in it. Some figures hold court, others are in free fall; the two sides of the river have differing populaces with potentially unlike functions. Our vantage point seems to be elevated behind the action centered on the water going on below and spreading

outward. Though the painting is not huge, the vista it shows us is. Color is freely applied and not tediously bounded by lines; it seems to evanesce rather than end. Like everything else here, it is vested with a bit of magic of its own. Humdrum activities, boring duties, and dull people would all seem unwelcome in this context.

Oliver Jackson is not one bound by convention in content, in subject matter, and certainly not in size. A large portion of his painted production over the years has been huge—16 feet high, 12 feet wide or bigger being not uncommon to him. One cannot help feeling that enormous apse-like secular spaces should be built around them to create the perfect ambience for them. If he could expand the scale of the everyday world—its doorway and road widths,

ceiling heights, the depths of our visual fields as well as our comprehension of what all of his myriad symbolism means—he would have been transported to paradise. In his sculptural work he may find his greatest freedom. As you might expect, this is a place where he is the freest. Manipulating paint on canvas is like playing tiddlywinks in comparison with facing a giant hunk of full-grown wood you may see something in. Finding that "something," connecting it to what you see for it in the future (or saw for it originally), and making that new something be art and not just a carved (or otherwise manipulated) piece of wood has to be a far bigger challenge than putting paint on canvas. The truly original things he is making wood do deserve a major public exposure situation sooner rather than later. ▪

TRADITION

The dominant force driving most of the variations of Figurative Expressionist painting in the wake of Abstract Expressionism was **Willem de Kooning** (1904–1997), primarily because he was a master of both, in turn and simultaneously. But more important than his dual painting practice was his freedom from subject matter: he painted figures, female and male, without any iconographical import or specific references to subjects from the past, without stories behind them, without using them to make points. It is as though he painted figures because that is what artists do. It is tradition. But the way he painted them was as far from traditional as one could get without being unrecognizable. Many women may have been in his mind when he painted one: his wife, his mother, St. Theresa, Marilyn Monroe, other women in his life, models, women glimpsed anywhere. Each is just a mental starting point from which, and on which, to exercise his willful brush. He intended nothing but the intrinsic value of painting itself—the studio tradition continued—but executed in a wholly new way.

In the 1930s his friend and mentor, Arshile Gorky, was a major influence on him. Together, they spent most of their time viewing and discussing Picasso's work. He was more of a presence on the New York scene than any other European artist. De Kooning's work was quite abstract, using both organic and geometrical forms. His colors—pink, lemon yellow, and blue—predominated then, but he gradually deepened the reds and added others as the years passed,

and in his last painting years he was back to the pastels. Surrealism began to have an effect on him by the forties, causing him to take great liberties with the figure, geometricizing body parts or removing them as though the subject were breaking into pieces while enveloped in a soft cloud of atmosphere. The Depression years tamped the energy in his paintings down, but by the mid-1940s and *Pink Angels*, there was a sudden burst of energy being generated with his (later famous) "whiplash line," which swirled them into existence as if electrically charged. In the latter half of the 1940s he returned primarily to abstraction, with black-and-white paintings that grabbed a lot of attention in 1948 when he had an exhibition of them at the Charles Egan Gallery. Though financially unrewarding, it did bring critical acclaim in the art journals.

Willem de Kooning

Clam Digger, from *Portfolio 9*, 1966

Lithograph, 17⅛ × 22½ inches
MSU purchase, funded by an anonymous
New York foundation, 2004.8

Elaine de Kooning
Harold Rosenberg #1, 1967

Oil on canvas, 28 × 22 inches
MSU purchase, funded by an anonymous
New York foundation, 2002.47

His magnum opus from this black-and-white period was *Excavation*, 1950, but in the same year he began *Woman I*, which took from 1950–52 to complete and unleashed a series of woman paintings as well as a great deal of controversy. His "return to the figure" (which he had never really left) was hailed by many and was a driving element for the rise of American Figurative Expressionism. Loosely painted, colorful abstractions like *Easter Sunday* and *Ruth's Zowie* began to regain dominance as of 1955, but overlapping both approaches had come to characterize his endeavor for life by then. In his later years, the clam diggers he saw on his many walks or bike rides to the beaches near his studio in East Hampton also became a frequent subject. The Broad/MSU museum's print is typical of many "working man at the shore" images and, like his sculpture of a clam digger, seems alive with movement, yet calmly at work. At the same time that he explored this theme (even using it to powerful effect in bronze sculpture), he was painting large, quite abstract ribbons of color on white. One assumes they were meant to be just that, since they don't hint at use as clothing, presence of a person, or setting. They are as abstract as his work in the late 1930s and early 1940s with a backward nod to the favored colors of the time as well. In red so pale it is really pink, and extra pale yellows and blues, these abstract ribbons read as distant relatives to his earliest abstractions in the 1930s. Now some people see them as weak structural underpinnings for missing material to be supported. But taken on their own, they are marvelously gentle early twenty-first-century abstract painted structures quite pleasing to the eye. These were increasingly simplified over the years, with the white space becoming more dominant. They seemed to belong in his new huge, sun-drenched studio.

Elaine de Kooning (1918–1989) was a painter and an art critic. She was born and raised in Brooklyn. Encouraged by an art-loving mother who took her to museums as a child and gave her books on art, she knew she wanted to be a painter quite early. She moved to Manhattan at nineteen to study at the Leonardo da Vinci Art School there. Willem de Kooning was one of her teachers, and she became his student, model, and, in 1943, his wife. The two were active participants in New York City's blossoming

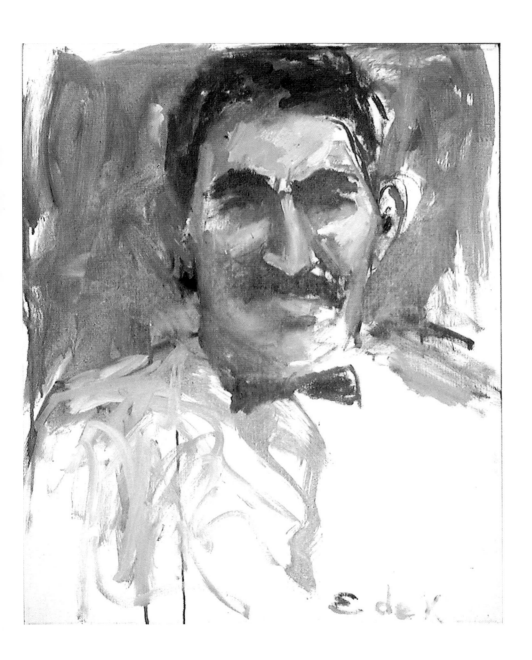

art scene in the 1940s and 1950s. Their circle included Paul Bowles, Edwin Denby (a dance critic who encouraged her to write), Rudy Burckhardt, Arshile Gorky, John Graham, and Milton Resnick.

Aside from attending political rallies and speeches in Union Square, drinking at Romany Marie's, and later the Cedar Tavern, and going to parties and art exhibitions, they frequented poetry readings,

plays, music and dance con-
certs, and later, jazz clubs.

Although her husband
painted primarily female
figures (until his later years,
when men often appeared),
Elaine de Kooning tended
to prefer men as subjects to
paint. Masculinity fascinated
her, and she painted portraits
of her husband, various
lovers,[1] and friends, such as
painter Fairfield Porter, poet
Frank O'Hara, and dancer
Merce Cunningham. She
even painted an 88 × 166 inch
canvas in 1963 of nine men,
all but one seated, titled *Bur-
ghers of Amsterdam Avenue.*

Harold Rosenberg (1906–
1978) was a lifelong friend of
the de Koonings. An author
and critic who wrote for
The New Yorker and many
other literary and political
magazines from the 1930s
until his death, Rosenberg
was a major proponent of
the Abstract Expressionist

movement. He coined the
term "action painting" to
signify/describe a way of
painting that emphasizes
the physical presence and
dynamism of the painter
through strong gestural
brushwork. That would
certainly describe the facture,
or paint handling, of de
Kooning's subject, a powerful
man to whom she and many
other women were highly
attracted. Elaine de Koon-
ing's portrait has energetic
brushstrokes, evidence of the
artist's physical involvement,
which reflect the sitter's
strong personality as well
as the artist's feelings. She
also made some full-length
portraits of Rosenberg that
stress the power of his per-
sonality and his masculinity.

Even in her most abstract
work of the 1940s, Elaine de
Kooning had retained traces
of the figure. She went on
to become known for her

vigorous, action-filled paint-
ings of basketball games and
bullfights, her portraits of
John F. Kennedy and many
celebrities, near abstractions
in the 1950s and 1960s, and,
in her later years, paintings
inspired by a dynamic Pari-
sian statue of Bacchus and
his Bacchantes as seen amid
the leafy trees in the Jardin
du Luxembourg, and later
still by cave paintings she saw
in France. The version of Bac-
chus in the Broad/MSU col-
lection, *Jardin de Luxembourg
I*, from 1977, was done the
winter she went to the Tama-
rind Lithography Workshop at
the University of New Mexico
and did six major lithographs.
In the trembling leaves of the
tree are the cherubic mes-
sengers of Bacchus's desires
and wantonness as he twists
baroquely amid the branches
expressing desire.

She seems swept up
herself in the entwining

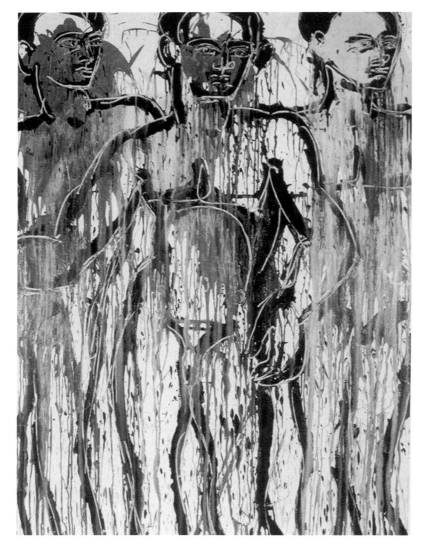

Lester Johnson
Three Figures, Milford, 1965

Oil on canvas, 67½ × 47¾ inches
MSU purchase, funded by an anonymous
New York foundation and the Richard
Florsheim Art Fund, 2003.1

and the 10th Street co-op galleries. James Schuyler, a poet-critic who was part of the downtown scene, aptly described Johnson's situation and that of other developing Figurative Expressionists when he wrote that Johnson's painting was "unequivocally both New York School and rare bird, Action Painting with nameable subject matter."[3] He began teaching at Yale University Art School in 1964 and didn't retire until the late 1980s. He continued to paint and exhibit over the years, and died in 2010.

Johnson is also the first person after Willem de Kooning to come to most minds when thoughts of fusing Abstract Expressionist paint handling and the figure arise. *Three Figures, Milford*, 1965, is a classic example of this fusion. The improvisatory process of image building in Figurative Expressionism is

branches reaching for the heavens, and perhaps she shares the joy and can imagine the pleasures being felt by the participants. Her style changed somewhat with her subject matter. On this subject she once said, "I'm an escape artist. Style is something I've always tried

to avoid. I'm more interested in character. Character comes out in the work. Style is applied to or imposed on it."[2]

Lester Johnson (1919– 2010) came to New York in 1947 and quickly joined the Abstract Expressionist milieu of the Club, the Cedar Tavern,

obvious in this painting, with its overlapping trajectories of painterly gestures. The myriad drips raining over the surface, a legacy from Jackson Pollock, are used here to delineate the contours of figures. They were picked up by the Color Field painters who used gravity to work with their poured paint but used it decoratively, not expressionistically, as Johnson did. Once titled *Three Polycleitan Figures*, presumably for the hip-out *contrapposto* of the central figure in imitation of Greek sculpture, the painting continues to exude a classical air despite its very contemporary facture. These figures stand, whereas so many of Johnson's subjects over the years have been on the move, and they are naked, when clothing is usually present on his monumental everyman and everywoman figures.

Except for the classicizing nudes like this of the mid-1960s, Johnson's pre-1970s paintings were very dark, symbolizing the way he felt about the human condition, living as he did on the Bowery and watching the "bums," as he called them, walking by his basement window. In these early years his subjects wore caps or fedoras and overcoats; later, while some still also wore work clothes, they often wore bowlers and suits. Over the years, the mood and the actual colors of his paintings lightened as he shifted from Bowery bums to successful businessmen, to lunchtime urban street scenes containing men and women in brightly colored clothes—from murky gloom to shimmering sunlight. About one painting he said:

I did this painting on Broadway and 28th Street. During the day there was always activity; import-export salesmen, toy distributors, etc. The luncheonettes were jammed at noontime. In my painting I was working for forms that were alive, that moved across the canvas, and never set, that had some of the noise, chaos and order of the city.[4]

The desperate, anxious quality was replaced from the 1970s on by manic activity and an upward-gazing, dynamic yearning. He tells of coming out onto the street with his wife and daughter and having an epiphanous moment seeing them in the sunlight, a moment that he turned into these later paintings. The Broad/MSU museum's *Summer Group Walking #5* of 1984 is typical of this later Lester Johnson. Young women and men jauntily cross in front of the viewer. The warm light bathes them evenly, leaving no sense of the weather. The

Lester Johnson

Summer Group Walking #5, 1984

Oil on canvas, 20 × 16 inches
Gift of Dr. Neil J. Farkas in memory of his
father Boris Farkas, 85.5.1

males dress like teenagers in jeans and T-shirts while the women wear colorfully patterned floral or striped dresses. It is as if he and they were aware of the Pattern and Decoration movement of the 1970s when he lightened his palette and started painting women. While frontality had dominated earlier, the action is all sideways now. Working girls on their lunch hour or commuting stride purposefully from one side of the canvas to the other, conveying some of the dynamism that his men on the street had previously. But they were either classical in the Greek way or brutish in their aggressive frontality. The men were often packed closely together, sitting, standing, or on the move forward, but their arms and legs were functioning on a diagonal to move the eye across the canvas. Urban crowds occupied Johnson's

world, crowds in motion. He said: "There is no balance in my paintings because balance seems to me to be static. Life, which I try to reflect in my paintings, is dynamic. . . . To me my paintings are action paintings—paintings that move across the canvas, paintings that do not get stuck, but flow like time."[5]

The physicality of the paint in the earlier paintings like the Broad/MSU museum's Polycleitan figures and the very many men in black, dark brown or green, and gray is as important as the human images. Manipulated by his fingers or sticks, pushed up and gouged out, his actions took impasto to an extreme. Sometimes words or images are scrawled into the paint as well. The splashed-on and spattered paint runs freely down the surface like rivulets of blood or tears, unifying the tattered surface. In the later

paintings of women, their movements are so stylized that they seem like manikins or people under hypnosis, under artificial control. Unsmiling, but not sad, their faces and hairdos look like masks and wigs. They look alike. Only their dresses individualize them. The patterning is highly specific and detailed, entertaining the eye, which is otherwise rushed across and out of the picture by their gesturing arms and hands. Johnson's handling of their long legs is unusual, but effective. The odd way they are bent gives them a strength, solidity, and sense of purpose.

The female nude was **Nicholas Marsicano**'s (1908–1991) only subject during a lifetime of painting. It was the credo he lived by:

I paint the figure. Her nakedness is an offense upon which

Nicholas Marsicano

White Angel, 1954

Oil on canvas, 51½ × 43 inches
Gift of Susan Kamen Marsicano, 2004.43

I dare not look. My presence is a mirror of awareness which awaits the invitation to see. The discomforts of her bare existence do not permit the commonplace knowledge of a mercenary eye. The privacy of her person is not an arena for sentimental desires or intellectual documentation. She is a contract to art, an emblematic crest, an acknowledgement to the sovereignty of my being. I make no judgments and I impose no things, no space, no color and no form. The will for clarity is a garment of light from which she and I begin.

I never paint from life; these are mere dialogues which I conduct with the women of art who have conditioned the

Nicholas Marsicano
Double Image, 1962

Oil on canvas, 72⅛ × 68½ inches
MSU purchase, funded by The Judith
Rothschild Foundation, 2003.8

Nicholas Marsicano

Untitled, ca. 1968

Nupastel, acrylic and ink on paper, 26¹/₁₆ ×
20⁹/₁₆ inches
Gift of Susan Kamen Marsicano, 2003.9

manner in which they choose to be addressed.[6]

The excitement of visual contact between clothed artist and nude subject in a public or semi-public context of a classroom never seemed to have lessened for him, even when he was painting from memories decades old. *White Angel*, 1954, is very close to the Abstract Expressionism from which it was born. The French had Fauvism; the Germans, Der Blaue Reiter; Americans had the Ash Can School, but when artists like Marsicano found that the way they wanted to paint was like Jackson Pollock and Willem de Kooning, except what they wanted to paint was the human figure, they became the American Figurative Expressionists. Marsicano's 1950s paintings seem to be more about painting than what is being painted. So

much painterliness is going on in the *Three Graces*, 1954, that the figures are almost indecipherable. The shape of the woman in *White Angel*, painted the same year, is much easier to see, though the many drips and the gestural freedom all over are elements of abstraction. Irving Kriesberg's *The New Baby*, 1953, is less abstract despite the many drips.

In the 1960s, abstraction still outweighed the recognition of anatomical details in Marsicano's work, mainly by being located behind a torrent of drips raining down the painting surface. A black negative space might serve as a rough outline for the figure, and you can sense limbs, a female chest, and a head. The swaths of pigment that outline a figure sometimes form into breast-circles that protrude from the canvas surface. In *Yellow Night*, 1962,

a reclining figure with a white torso and pink and yellow legs extends from the upper right corner of the canvas to the middle of the left side. Ocher, the color that gave the work its title, is massed at the canvas top and sends drips raining down on her body, and the blue color on which she lies is solid until the last few inches at the bottom, where the blue breaks up into its constituent colors in drips. The rough, unarticulated shape of the body breaks down into the head region, torso, and legs. No arms are seen, so she could be facing the viewer or we are seeing her from the back.

In Marsicano's magnificent 1962 painting *Double Image* and other later work, there is less hesitation, fewer drips, stronger color, and surer, more declarative brushwork. The figure is seen from the front and the back, but it

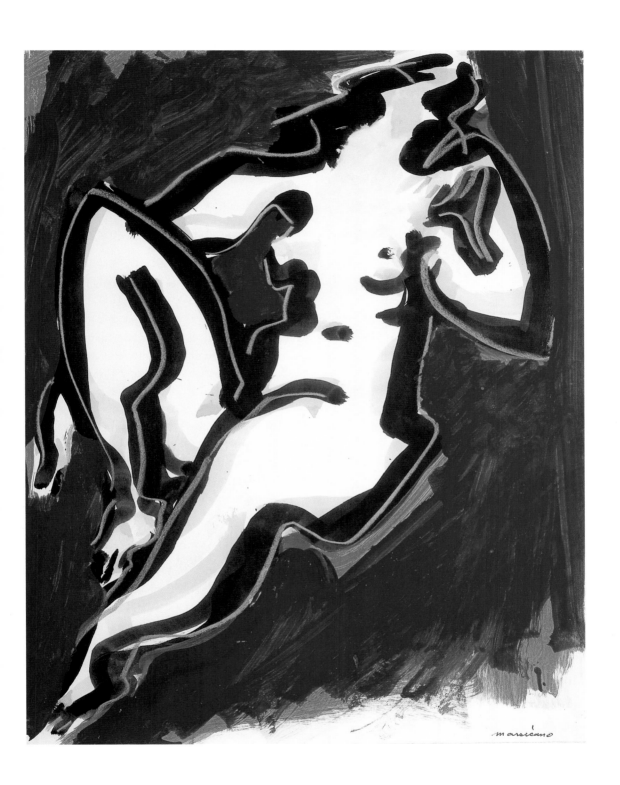

Nora Speyer
Expulsion, 1963

Oil in canvas, 60 × 60 inches
Gift of the artist, 2008.9.1

is really an abstraction of a figure and not a particular person portrayed. A dot for the nipple of one breast and a curving "V" for her pubis are enough to identify her as female from the front; full hips, a narrow waist, and a line for the spine from the back. Magenta, olive, and yellow ocher surround the nude, moving from canvas top to bottom in that order around the two reclining forms. Each figure is thickly outlined in black, on top of which is blue, and obliterating most of both colors is magenta outlining. These heavy outlines follow the bodies' shapes but also, on occasion, are detached, abstract. After 1970 this kind of outlining is sometimes dispensed with, while also turning up alone in works on paper where there is no color, just the black outlines.

In the Broad/MSU museum's *Untitled*, ca. 1968, work on paper, a seated nude outlined in black is surrounded by a field of purple that has been lain over a bright fiery orange, which seeps out from under the purple in various places. A lavender line zips like neon around her body, lighting it up. The white is largely just the paper under everything, but having the most light it shines forth, the body emerging from the darkness all around. This late work on paper is like a bravura recap of possibilities by someone so sure of his abilities that he could, it would seem, move his brush without effort, without thought, as de Kooning was said to have been painting toward the end.

Born in Shenandoah, Pennsylvania, Marsicano studied at the Pennsylvania Academy of Fine Arts and the Barnes Foundation in Merion, Pennsylvania, receiving scholarships from both schools to study in Europe. He taught at Cooper Union in New York from 1948–88, as well as at numerous other art schools. His wife, Merle, was a well-known modern dancer for whom Franz Kline and Willem de Kooning made set designs or backdrops. After retirement, Marsicano enjoyed painting full time in his Woodstock, New York, studio. The Woodstock Artists Association accorded him a major retrospective in 1998. Irving Sandler reviewed a 1961 exhibition of his work in *ARTnews* saying that: "Nicholas Marsicano's serene nudes are abstractions, not inventions. He is involved with turning 'real' figures into the abstract stuff of art, manifesting the transformation in the act of painting."[7]

Nora Speyer (born 1923) paints male and female

nudes playing out, throughout her life's work, the story of Adam and Eve's fall from grace because of the knowledge they gained from eating the apple forbidden to them by God. Her early paintings on the subject were very graphic and Masaccio-like. The 1963 *Expulsion* pictures them cowering from the dark cloud now over them as they flee the Garden of Eden, no longer immortal. As time went by, Adam and Eve became any couple or a single woman, perhaps dreaming, but whether awake or asleep, facing imminent danger. Speyer answered the question she, herself, asked when she said:

How do you paint . . . sorrow, joy, the fear of death and sensuality—as a feeling, not as

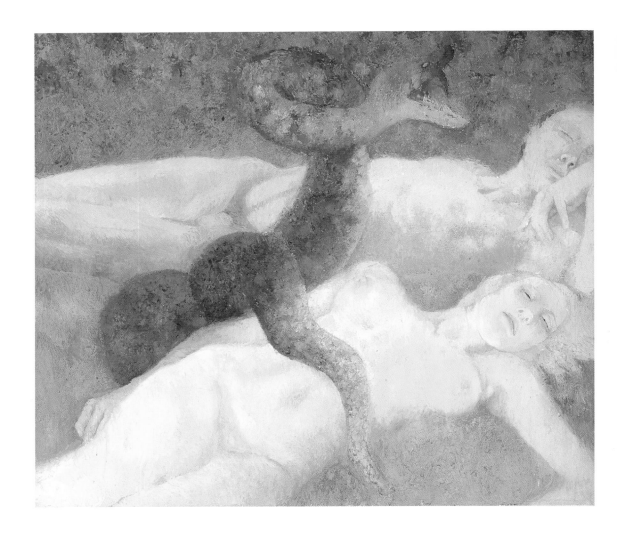

a picture. The visual is only one part of all our senses and there are invisible mysteries that our eyes cannot see. Accordingly, I like the use of myth in that it gives me a timeless freedom of interpretation.[8]

In the beginning a vengeful God is a dark cloud looming over them; later, the serpent seeks out their sleeping selves and disturbs their dreams. Then a demon bends over her troubled sleep, and later still a skull will stand in for the implications of the snake and appear above the sleeper or sleepers.

In the early depictions of the expulsion during the Renaissance, Eve is pictured as reaching out to the snake for the apple, giving it to

Nora Speyer
Man and Woman No. 3 (Eros),
1975
Oil on canvas, 70 × 80 inches
Gift of the artist, 2008.9.2

Adam, and when driven out of Eden she is usually leading the way. In Nora Speyer's paintings on the subject—which has been her lifetime theme—the woman is always dominant. She is often larger than the man and closer to the viewer. The basic story Speyer paints is a combination of sexual thoughts, anxieties, and dreams that lead to sexual union or follow it. The woman is tormented in her sleep through nightmares and anxiety attacks. Demons, bats, hovering skulls, and an enormous snake threaten her. Only in the late *Dream Sequence* paintings of nudes falling freely through space is she alone and free of that anxiety, perhaps because the thing she feared the most, falling, is actually happening and there is nothing she can do to stop it. In the early years, as with *Expulsion*, Speyer's surfaces were so

built up and dug into that they seemed more like reliefs than paintings. Donald Kuspit wrote about her painterly touch:

Her surface is lush and aggressive, exciting and exquisite, raw and refined, candid and reserved, dramatic and subdued, firm and soft, sophisticated and abandoned—all at once. It is as though she has pulled all the stops of painterly sensuality, conveying every sexual mood—from the most active to the most passive—possible through touch alone, independently of her sexual imagery.[9]

Speyer was born and raised in Pittsburgh, Pennsylvania. She studied art at Tyler School of Art in Philadelphia, where she met her future husband, Sideo Fromboluti. They moved to Woodstock, an artists' colony, after his stint in the service,

and she showed her work at the Zena Gallery there in 1954. When they moved to Manhattan, they were swept into the art world scene in Greenwich Village with the Club, the Cedar Tavern, and the 10th Street co-op galleries. They began showing their work there, Speyer with the Tanager Gallery. In 1954 she was one of six artists in a *New Talent* exhibition at The Museum of Modern Art. In the 1970s they started a co-op gallery in Manhattan, the Landmark Gallery, where they showed their work and that of friends and other artists they admired. In the 1980s a comparable situation was established at the Long Point Gallery in Provincetown. They formerly summered on Martha's Vineyard, but for the last four decades they have worked in Wellfleet on Cape Cod in the summers. There she paints the flowers and

Nora Speyer
Demonizing Spirit, 1982
Oil on canvas, 60¼ × 60¼ inches
Gift of the artist, 2008.9.3

trees in Fromboluti's lush garden on Higgins Pond.

The paint is not as heavily built up in the floral and tree paintings as it is in many of the figure paintings. She has stated:

I love the sensuality of heavy paint. It is tactile, it is mysterious, it is abstract. I also love the freedom to say this is flesh, this is my nightmare, this is an expulsion of young people. I feel compassion for them. The paint is the heartbeat and soul of my canvas. The subject is also the heartbeat and soul of my canvas.[10]

The surfaces of the later figure paintings are far less thickly sculpted than the early ones, but more varicolored. A bat might have black eyes and white teeth, but its wings are many-hued—pink, green, red, and yellow; a woman's hair might be green streaked with pink, her skin

bluish-aqua with rivulets of a near red and some olive green running down over her torso from the colors above her body, which is crouched in fear of the bats. Compare the tri-colored *Man and Woman No. 3 (Eros)*, 1975, with *Demonizing Spirit*, 1982, to see the difference. The latter is a symphony of colors that are still tonally close. No outlines for Speyer, just shading using color until the new century. *Fear II* is a simple, striking, and powerful painting of a single woman from the midsection up. Her terrified face—which is turned toward a bright greenish-yellow light—her hands, and her shoulder are outlined in green. The background is split in two, purple toward the left, whitened green to the right. Looking at her surfaces up close, one sees how many daubs or streaks of paint are in any given inch and notices

the frequent use of the other end of the brush to gouge in details like an eyebrow or lid, a frontal nose, or lips. Both Speyer and Fromboluti paint in work clothes using paper plates for palettes. They amass on their work table or the floor, and everything, including them, is spattered with oil paint. They also have regular sessions of drawing from the model even now, long after art school.

Proprioception is the ability to sense the position, orientation, and movement of the body and is something that Nora Speyer has unerringly. Donald Kuspit, who brings this word into his discussion of her work in his catalog for her 2002 retrospective, wrote:

She is a painter of pure sensibility conveying the mystery of sensing through her cryptic surface, an uncanny fusion

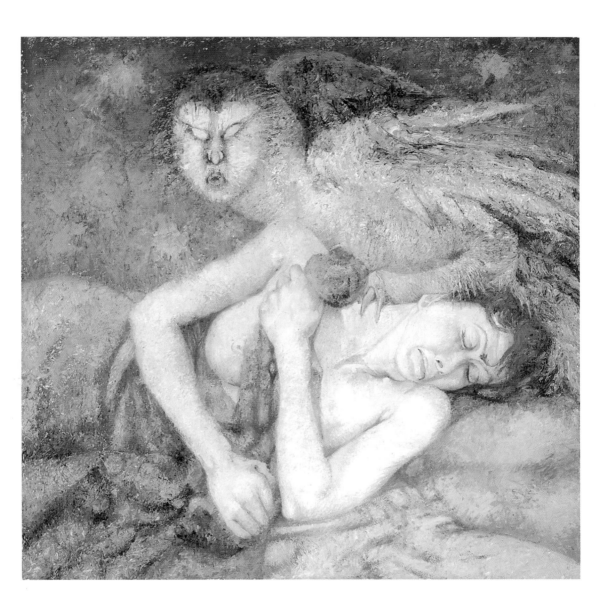

of color and touch, but she is aware of the mystery of the figure, especially when it is emotionally involved with other figures and, above all, sexually engaged."

He sees all of her figures as desire-wracked, driven by the demon of desire even post-satisfaction. Oddly, I find the falling figures of the 1990s even more sexually charged than those indicating bed as the place for desire. Reaching for something to grasp in free fall feels highly sensual and exciting—the figures are

fully alert and alive as never before.

Speyer said:

We have seen paint miracles with our own eyes. In every century for thousands of years artists have spoken to us like no historian or psychiatrist ever can. I find that nothing has changed. The paint is still here and so are its challengers. I tell you that the computer can't replace it any more than it can record the feelings you have toward your mother. Paint can do this. I remember an artist asking me after an anti–Viet Nam rally if the atrocities would affect my work? I said yes. You will have a hard time finding it, but it will be there in the paint.[12]

Sideo Fromboluti (born 1920) is one of the few figure painters actively grappling with the problems of human complexity. He is too honest to idealize his subjects or to ignore their sexuality, and too stubborn to simply de-emphasize their faces to avoid confronting their psychological state. He is too committed and serious to reduce them to bland caricatures or to blow them up into dehumanized billboard cartoons, and ultimately too involved with the mystery of life and of paint to settle for the "magic" of mere imitation—an effect easily achieved through a camera/projection system. Fromboluti draws from live models he knows, acutely observing their moods and behavior, and then emphatically transfers what he sees and senses to paper. As the working drawings evolve into full-scale paintings, the psychological record of the sitter is filtered through his own emotions in the process of coming into physical existence as heavy paint on canvas. This surface is a measure of how much labor went into the painting, as well as a Fromboluti trademark. Unlike his wife's, which can be described as built up and sculpted out of the paint, his works are very actively brushed but not relief-like. In addition, and this is the most important part of any art-making procedure, he submits his subjects to his own innermost obsessions and transforms them into mysterious, semi-symbolic manifestations of an ineffable idea.

This "idea" germinated under highly specific and unusual circumstances for Fromboluti, but, like every artist's hidden obsession, it has been a lasting influence on his work. In the late 1950s, while drinking ouzo and eyeing the dancers in a Greek belly-dancing joint in Greenwich Village one night with Merle and Nick Marsicano, he was deep in

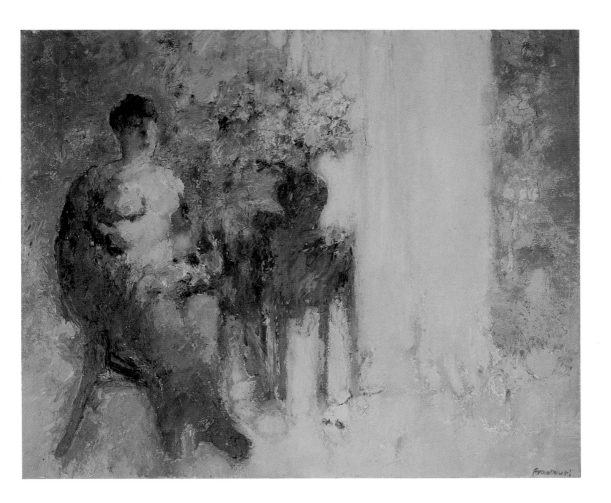

conversation about various painting concepts then under heavy discussion both inside and outside the Artists' Club. "As we mulled over these abstractions," he recalls, "the belly dancer continued to wriggle in the eerie smoke-filled room and it occurred to me as I watched her that she was a non-objective form vibrating in an undulating, mysterious, negative/positive space. This image seemed to fit harmoniously into all our new spatial discoveries."[13]

Fromboluti's discovery of a personal parallel between actual subject matter in three-dimensional space and the Abstract Expressionist picture field that united everything into a single overall sensory feel brought all the strands of his aesthetic position together. His landscapes and still lifes continue the overall sensory feel, minus the human

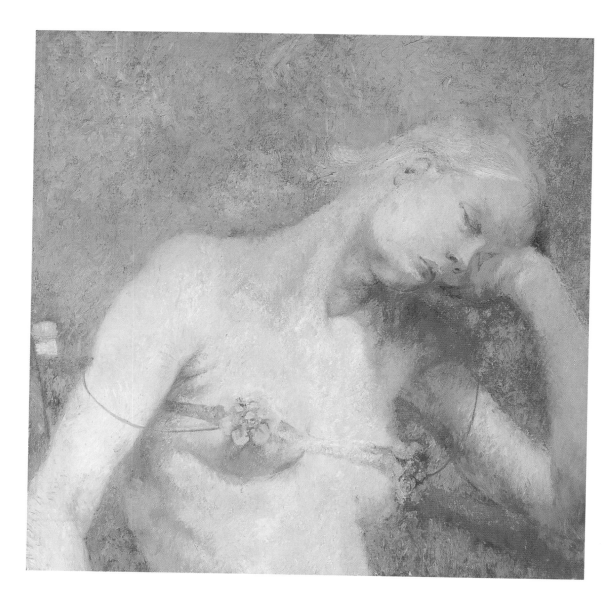

Sideo Fromboluti
Sleeping Entertainer, 1975

Oil on canvas, 60 × 60 inches
Gift of the artist, 2008.10.1

subject. The Broad/MSU museum's collection includes an extraordinarily beautiful still life by Sideo Fromboluti with figures in it, dancing around a Wedgwood cookie jar.

Fromboluti's tawdry vestiges of harem life connect him with Delacroix's *Odalisques*, de Kooning's *Women*, Picasso's dreamy *Family of Saltimbanques*, and with the dancing nymphs on the Greek vases he collects, yet they seem psychologically alive in the present tense. Confronting his frequently somber, sometimes

boredom-deadened, occasionally exhausted, sex-obsessed, or frightened figures can be an unsettling experience. By not living nostalgically in the past, when we imagine life and people were simpler, and instead facing the complex human being of today head on, Fromboluti offers us a view of ourselves we may not like. Any artist who responds in depth to humanity is placed in that dilemma.

Fromboluti considers himself a classicist, albeit a romantic one, and Speyer

Sideo Fromboluti
Night Out #12, 1993
Oil on canvas, 50½ × 60 inches
Gift of the artist, 2008.10.4

the true expressionist. He locks himself in a struggle to overcome the neutrality of his imagery and to convey his feelings by paint alone. He makes an aggressive, essentially abstract attack on it with layers of "shoveled on" pigment, poured washes, turpentine-soaked erasures, and semi-automatic gestures out of which the image is built. An early subject was his wife Nora Speyer, naked and set in a floral interior by a window.

Dancers dominated after the belly-dancer experience—dancers at rest or asleep, like *Sleeping Entertainer*, 1975—sleeping women, then paintings of himself and others around a nightclub or restaurant table. He commemorates these nights out with his wife and sometimes also her sister Darthea, as happened in *Night Out I*, 1992, and with friends in paintings. *Night Out #12*, 1993, is typical of these later paintings: the

atmosphere is smoky and dimly lit, with the focus on the faces of the people and the still life presented on their table. Everything lighted sparkles with a golden glow, and the rest of the painting is bathed in an aura of mystery, the figures barely visible. The busy table is the most well-lit and detailed part of the painting, a glorious display of dazzling, bravura brushwork. Coruscation is the exact term for his sparkling, flashing, gleaming surfaces.

Strangely, the results are calming, soothing rather than activating for the viewer. All of his career he has struggled against an innate lyricism. No matter how brutally he attacks the canvas, or what Abstract Expressionist methods he uses to get the paint there, the results have the same lyrical quality. He began painting this way during WWII while stationed at Fort Riley, Kansas. He was working on a mural of Custer's Last Stand for the Officers' Club, and the reality of the war and his own unhappiness was not jibing with his painting. He began throwing paint at the canvas and slashing at it. Over the years he has continued to apply the paint freely and abstractly, but tonality brings the structure into focus. Every part of his painting is active, cohesive, and spatially located. I have been in Fromboluti and Speyer's studios in New York and on Cape Cod and have seen enough of the globs of paint on a host of paper plates on their easels and work tables and the accumulations of paint in rivulets and splatters on their walls and floors to know how fully into this Abstract Expressionist painting practice they are.

Never interested in angst-ridden subject matter, Fromboluti painted posed figures during the winters and landscapes in the summers on Higgins Pond; flowerscapes, including many gorgeous paintings of the water lily–crammed pond below his studio balcony; trees and water; and, in many instances, sailboats as well as an occasional fisherman on the pond. With the new century came a new subject: the still life. Fromboluti locks himself into a struggle to overcome the neutrality of his imagery and to convey his feelings by paint alone every time he approaches a blank canvas. His concept of the still life goes back to the remembrance of a tiny Cézanne painting of two glorious golden onions on a bed of rotting greens. In the Broad/MSU museum's *Wedgwood Cookie Jar on Paint Table*, 2003, the contrast between the clotted mess of

a paint-encrusted table and studio, and the lovely Wedgwood cookie jar amid the studio debris feels like that in the Cézanne. In a setting full of stale, used, old things like paintbrushes and tubes of paint, beauty dances amid life's mess, the perfect subject for an artist.

Lastly we come to a group of artists, each represented here by a single, outstanding, example of their work.

Robert De Niro Sr. (1922–1993) was a Fauvist at heart with an Abstract Expressionist fervor for paint after giving up abstraction in the early 1950s. He had two teachers: Hans Hofmann and Josef Albers. The former encouraged his love for Fauvism and taught him how to use color to manipulate pictorial space; the latter taught him how color interacts optically and

how important a tight compositional structure is. But his discursive line he learned on his own from Matisse, a lifelong influence. By 1945 he was exhibiting at Peggy Guggenheim's gallery, Art of This Century, in New York, alongside Jackson Pollock. Always an avid Francophile and admirer of Matisse, he painted people with and without clothes, still lifes, and an occasional landscape, and he drew when he was not painting. Whether working with brush or charcoal, his approach was completely free of any constraining demands for likeness. "Illustration is about something," he said with disdain. "Painting *is* something." He managed to combine Abstract Expressionist spontaneity with Fauve color and the rude gestural outlining of Rouault. His subject matter, however, is always calm, unchallenging:

Moroccan women at leisure, nudes, still lifes, and portraits. Occasionally the crucifixion was his subject, and in his hands it somehow carried the implication of bearing personal meaning. His work is daring in execution, traditional in subject matter. Rarely was a painting finished at one go; more often it was scraped down a few times and repainted until he felt he got it right. In a drawing of a still life, the color is either black or the gray of thinned ink on white paper, so you stop to enjoy the deft wriggle of the black tablecover edge at lower left, the ease of handling the bananas, the distant chair, and the bunching drapery.

Like Speyer and Fromboluti, De Niro painted still lifes and landscapes, but mainly the female figure. For him, the figure was his religion. Men and women, and in

Louis Finkelstein

Two Figures, Two Heads, 1998

Oil on canvas, 54 × 44 inches
MSU purchase, funded by The Judith
Rothschild Foundation, 2004.18

particular Greta Garbo as Anna Christie, preoccupied him. A number of his many exhibitions have featured her image. He frequently drew from a model to find inspiration for paintings. Working out of a huge studio in the heart of SoHo, thanks largely to his son's success as an actor, De Niro set aside one end of the space as a floor-to-ceiling cage for exotic birds that kept a constant cacophony of sound all around him. The first time his work was exhibited at the Guggenheim Museum was in the 1940s. It is next to impossible for someone other than Picasso to maintain a level of public appreciation decade after decade and successfully take on the new developments without losing one's identity. So he buried himself in his work, marginalizing himself, but maintaining his identity in the art world.

De Niro painted the nude in every imaginable exotic setting conjured up by patterns and decorations of chairs, tables, draperies, robes, etc., in which his (almost) invariably female sitters posed. Harems, seraglios, Roman baths, any places of luxurious attention to the female body were evoked by his studio setups. Sometimes small groups of lovelies were the subject. There never seemed to be an end to the possibilities for a painting. Faces, personalities, were of no value; there was never any action, drama, story, or point being told or done. Only the sinuous line existed, usually a very thick, juicy, slow-sliding line encasing the body in a simple form. It surrounds a flesh-colored body with warm skin and casually accents it with indications of basic female sexual parts. When sitting, the subject is

not actually seated but in a sort of standing/sliding position without moving. The thick encasing line protects the subject but also locks her into a situation or surround that seems charged with sensuality.

Louis Finkelstein (1923–2000) lived and breathed art all of his life. He started visiting New York's Metropolitan Museum of Art at the age of eight. Six years later he took WPA art classes, followed by studying at Cooper Union Art School, the Art Students League, and the Brooklyn Museum Art School. He emerged with a probing, analytical approach to painting tempered by a commitment to spontaneity and a refusal to conform to any given style. He taught, lectured, and wrote essays about other artists' work; he took part in innumerable

Sherman Drexler
Standing Figure, 1963
Oil canvas, 72 × 49 inches
Gift of the artist, 2010.4

panel discussions and was, as painter Rosemarie Beck put it, "the aesthetic conscience of his generation."[14] There was no aspect of art or art history he could not talk about in a thoughtful, fresh, and convincing way.

During his 1971 sabbatical in Aix en Provence, Finkelstein absorbed the subjects of Cézanne's paintings. Using them raised his landscape painting to a new level. In the 1990s figure and landscape came together for him along with a new ease in accepting a multiplicity of possibilities in a given work. In his last canvases, unexpected and drastic changes occur—shifts in scale, disembodied heads, and compressed, warped space. Expressionistically painted heads, figures, and landscape elements are jumbled together. The landscape is greatly de-emphasized in T*wo Figures*,

Two Heads, 1998, chock full of figural material in two separate scales. The heads are enormous, easily three times the size of the nudes', the one packed into the space below the crouched running male, the other an armrest for the reclining female nude's right arm. The male is bluish-white with occasional flesh-like spots and seems braced to flee or fight. The large-breasted female lies wantonly back, luxuriating in a suggestive way. She is all rosy, tan-flesh tones; the male, on the other hand, seems very tense, ready to spring into an aggressive or defensive action of an unknown kind. A few small patches of green are the only referents to landscape in the painting . Finkelstein's landscapes tend to be highly colorful like this with little or no deliberate relation to the actual site. He seems to have

seen in abstract colors—here, for instance, red, yellow, and blue dominate and a patch of lavender sings out for attention. Two more examples are *Landscape, Bushes, and Trees* of 1997, which is all blues except for a patch of green, and his 1999 *Bastion de Cézanne*, which has only a few touches of green.

Sherman Drexler (born 1925) paints mostly women, nude, usually walking away into the picture space or coming toward you out of its depths and darkness. They can be based on sports figures, but they are filtered through a lifetime of closeness to his wife, Rosalyn Drexler—an author, Pop painter, and his ultimate imaginative source. Drexler, though unique in many ways, is a typical artist's artist—he lives to paint. His wife writes plays so he knows theatre, he knows

books (Books and Company even gave him a show), he knows sports (he paints over newsprint photos of athletes, making them into female nudes)—especially women's wrestling (again, useful in his art)—and poetry (which he collects in illustrated books), but most of his energy and all of his resources are poured into his studio. In a bizarre press release it was once written that he "has been known to close his eyes while painting to shield himself from the brightness of his vision."[15] This might exaggerate the intensity of his vision, but it is not hyperbole in terms of the intensity of his obsession with the human image.

Drexler studied with Robert Motherwell and Fritz Bultman at Hunter College when he got to New York in 1955, and through Bultman he got almost as much of Hofmann's teachings as if he had studied with him directly. Even though Bultman was primarily an abstractionist in painting, sculpture, and collage, he always drew from the figure and used what he learned in doing so in his abstract work. But whatever the inspiration, Drexler has been painting the figure, emphatically isolated upon a field of solid color,

for as long as anyone can remember. Long ago, Andy Warhol visited his studio on 14th Street and, reacting to the near obsession with the subject, exclaimed to his entourage: "Look at all these paintings of female nudes! Everywhere. Aren't they marvelous!" Then he asked, "Where did you get the idea?" as if it were the strangest subject in the world. Drexler said, "The presence of a direct mysterious single figure has always fascinated me."[16] And he has spent his life painting it. Large and small, on canvas, on paper, on scraps of wood, metal, broken crockery, rocks, bricks, a fragment of wallboard—anywhere he can imagine a figure emerging from a surface. He works and reworks his images, leaving layers of changes. Thus the surfaces are built up and seem like archeological artifacts brought to light out of the Dark Ages.

The nude is a timeless subject, and in Drexler's hands it points us back in time to cave paintings. A course on the subject while studying in Berkeley in his youth and visits to art-decorated caverns later in life were vital to him. "I was completely overwhelmed by how wonderful and breathtaking [the

experience] was. I responded strongly to it because I wanted my work to have the same inevitability and naturalness."[17] In the mid-1980s he and a few fellow artists, including Elaine de Kooning, visited the caves of France and Spain including Lascaux and Altamira. When he saw the caves he said that he had the same reaction he had to Albert Pinkham Ryder's work: "I thought they were just total marvels: ineluctably made and eternally locked in."[18]

Drexler summed up his life story in this way:

As a kid I drew deep sea divers, dirigibles, fighting planes, sharks, and baseball players. But as I grew older the unadorned human figure caught my attention. I now spend time picking up discarded stones, rocks and blocks of concrete, looking for pictures that are hidden in their coarse surfaces. My medium includes charcoal, acrylic, and oil. I dream of Lascaux, Pompeii, Egypt, Africa, Rodin, Ryder, Giacometti and Giotto.[19]

He had an exhibition of these found, salvaged-object paintings at MoMA PS1 in Queens in 1984. Erika Passantino wrote that in the studio, surrounded by large paintings of female figures dancing,

crouching, standing, lunging, or whatever, but none at rest, Drexler's "joy is visible, so also is his endless search for form in found objects, as though he were conjuring the forces that first drove the cave painters to animate their surroundings."[20]

The Broad/MSU museum's *Standing Figure* of 1963 is typical: a woman, who would remind you of his wife if you knew her, exiting, walking away from us into the darkness, unafraid, unclothed, painted with soft contours in a loving, gentle way. He has painted males, horses, and the prehistoric animals he saw in the cave paintings he visited. Hardly twenty-first-century subject matter, but timeless instead. And sometimes he put his nude woman onto the cave wall with a bison or two as if she belonged in that Edenic time, which just might be what he has been painting all along.

Wolf Kahn (born 1927) was part of a group that was always involved with landscape as well as the figure, but gradually let the figure drift out of the picture. Figures only played an important role for Kahn in the 1950s and earlier. Once he devoted himself to the peopleless,

bucolic scene, however, with landscapes and barns replacing the figure, color increasingly became the protagonist, the *raison d'être* of his work. His acclaim, his fame, has to do with his handling of color. A large number of the landscapes are so simplified that they could easily be mistaken for soft-edged, color field abstractions. Never detailed, his barns may be as simplified as a dark triangle-topped mass filling the picture space and allowing only bits of sky at the upper corners, as happens in his *First Barn Painting* of 1966. Much later, in 1994, he painted *Landscape Sequence*, which consists merely of five softly brushed horizontal bands of color— pale pink, saturated blue, bluish-green, pink, and then the green again at the bottom edge. The latter is especially abstract because the wide band of blue is not the sea one would think it to be. The paintings of this time are his most abstract.

The Broad/MSU museum's painting dates from 1957 and is a spectacular, first-rate example of what Kahn could do with the figure in its setting in those early years. The canvas depicts the artist's wife, the painter/collagist Emily Mason, in a home they occupied in

Venice, Italy, in 1957. It is a room bursting with sunlight so bright that edges are blurred and things melt together. Kahn sacrifices the materiality of objects like the desk and the vase of flowers to the atmosphere he has created around them. Paint is applied with expressionistic zeal, his subject becoming secondary to technique. When Kahn had his first solo show at the Hansa Gallery in 1953, *New York Times* reviewer Stuart Preston said that his "brush might have been guided by a tornado."[21] For subject matter, however, in the 1950s when Abstract Expressionism was at the height of its strength, Kahn turned to other sources of inspiration. Early twentieth-century French painters like Pierre Bonnard and Édouard Vuillard and their images of intimate interiors attracted him. He took their subject

and infused it with his own radiant color, successfully escaping the neutral palette of contemporary abstract art while still retaining its active brushwork. The viewer is reminded of Impressionism, but the brushstrokes bring one back into the reality of the contemporary use of the mark to speak of the painter's emotions and today's existential angst. All that rough energy, that brusqueness, speaks to our time, not the past. Kahn wrote about why that is so:

A philosophy was at hand to provide a sound basis for what we had been doing naturally. It was called existentialism, and it proclaimed that all generalities were suspect, apart from those limited truths that arise from a perception of the unique instance. This was an idea made to order for the way we all painted and lived. Down with security

and predictability! Instead, we looked for that precise moment when, on the canvas, all the elements meshed, when everything "worked."[22]

During the years in which Kahn emerged as an artist (the 1950s), Abstract Expressionism reigned, but his generation did not feel right adopting the Abstract Expressionist look without practicing what it meant. What they took from it, however, was the painterliness, the counter-illusionism, and the forward thrust of the paint and the picture plane. The influence Bonnard had on him is clear in the Broad/MSU museum's painting, which in turn is typical of Kahn's 1950s work. Bonnard's Intimist scenes of a woman in an interior are a direct ancestor in terms of their subject matter and the translucency of the paint. Light pours out

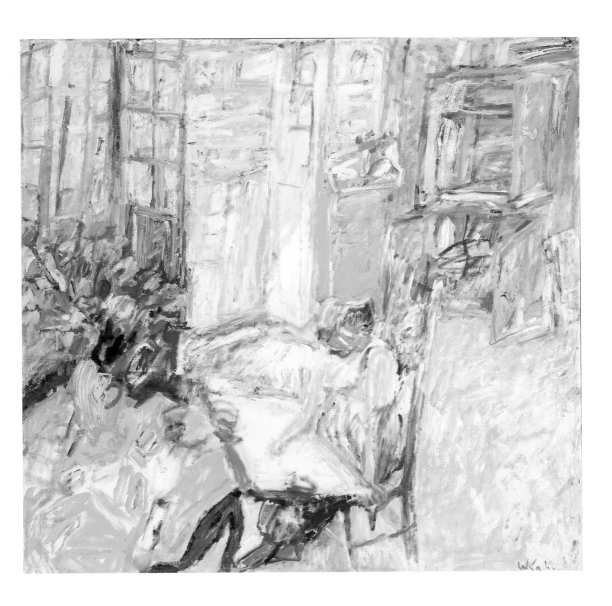

of the painting as well as into the room his subject occupies. Bonnard painted his wife, as did Wolf Kahn his. A painter, Emily Mason is the daughter of Alice Trumbull Mason—one of the founders of the American Abstract Artists—and according to Kahn, she brought "a state of grace" into his life.[23] (Sharing quarters with Robert De Niro Sr. at the time, he was, like De Niro, depressed, before she entered his life.) The warmth he felt toward her is beautifully expressed in this sunny painting. ∎

AFTERWORD

The idea of creating a figure out of paint itself, and having that figure represent the artist, seems almost inconceivable now. But by the mid-twentieth century New York artists were coalescing into two leading groups of practitioners: those committed to abstraction and those who felt it impossible to paint without painting something really in existence. The latter were not realists, they were not sticklers for painting likenesses, they just wanted to paint "about something." Religious, political, rational vs. irrational ideas—ideas of any kind were not entailed. Their answer to the question of what made a good subject was what was simple, easy to do: paint the figure. No detail was important, no gesture, apparel, setting, or intent to concern the viewer. That is where the paint took over. Actively brushed, full of color and shading, background sketchy: focus on the figure. Detail in general was kept to a minimum—a line for a nose, black smudge for an eye, long straight swath of pigment for a leg, and a dozen or so of such elements could a figure make.

The freedom was exhilarating! The artist went from being a job-lot painter to expressing the feelings of a generation, a post-war, "new world" situation created by the people who had fought and won the war. Even though a bomb ended it, people fought that war. Gestures mean a lot more when they are attached to a person or purpose than just an abstract trace of an arm movement. Attached it is irrefutable. The gesture alone, the mark, not supported by its maker's presence, does

not have the same effect. It is the difference between a speaker and an orator. Pollock spoke of being "in my painting" and in *Number 1A, 1948*, 1948, he literally was, leaving his handprints along the top edge to prove it. Those artists disinterested in abstraction, however, simply wanted to paint figures with their new-found gestural freedom. It is what made things so exciting for everyone in those early days of America's rising role in the "Art World."

The Kresge Art Museum focused on Figurative Expressionism because it has been a consistently under-explored or undercelebrated area of modern American art, well worth full art historical inclusion and general art appreciation. Among the riches to be tapped here are emotions over the full spectrum, rethinking modernism's prison of abstraction, and the simple joy of painting what one wishes, the way one wants to paint it. Besides the joy of doing, there is the joy of seeing it done. Works of art falling into this area came to this collection in various generous ways: from the artists themselves (often paintings with special meaning for them that they wanted safe forever); from their loving families, caring dealers, and friends; from purchase funds established by artists Judith Rothschild and by Richard Florsheim; from the Office of the Vice President for Research and Graduate Studies; from the Friends of Kresge; and from the National Endowment for the Arts. An anonymous New York foundation was—by dint of the many artists and the many aspects of this exhibition it sponsored—the major donor, without whom none of this would have been possible. We are all immensely grateful. ■

NOTES

INTRODUCTION

1. John I. H. Baur, *Revolution and Tradition in Modern American Art* (Cambridge, MA: Harvard University Press, 1951), 36.
2. Clement Greenberg, "Art," *The Nation* 162 (April 13, 1946): 455.
3. Paul Brach, "Fifty-Seventh Street in Review: Franz Kline," *Art Digest* 26 (December 1, 1951): 19.
4. Alfred Barr Jr., "Introduction," in *The New American Painting, as Shown in Eight European Countries, 1958–59* (exhibition catalog) (New York: The Museum of Modern Art, 1959), 15–16.
5. Thomas B. Hess, "U.S. Painting: Some Recent Directions," *Art News Annual* 25 (1956): 81.
6. All quotations by artists in the collection are from statements made to the author unless otherwise noted.
7. Leo Steinberg, "Introduction," *The New York School: The Second Generation* (exhibition catalog) (New York: The Jewish Museum, 1957), 5–6.
8. Thomas W. Styron, *American Figure Painting 1950–1980* (exhibition catalog) (Norfolk, VA: Chrysler Museum, 1980).
9. I organized *Emotional Impact: New York School Figurative Expressionism* in 1984, and it was circulated to six venues in the United States in 1985–86 by the Art Museum Association of America (now the AFA). Most of the artists who were in that exhibition are included here, but more have been added, most importantly from the West Coast, the relevance of which I ignored at that time.
10. Paul Schimmel and Judith Stein, "Introduction," in *The Figurative Fifties: New York Figurative Expressionism* (exhibition catalog) (Newport Beach, CA: Newport Harbor Art Museum, 1988), 16.

PROVINCETOWN

1. Bultman continued to draw from the model in a Hofmannesque manner emphasizing the body axes for the rest of his life, but his paintings and later collages and sculptures were always abstract.
2. Robert Beauchamp, "Self-Interview," in *Robert Beauchamp: An American Expressionist*, Robert Beauchamp, Ronald A. Kuchta, and April Kingsley (Syracuse, NY: Everson Museum of Art, 1984), 17–21.
3. Robert Beauchamp, quoted in "The Reappearing Figure," *Time*, May 25, 1962, 62.
4. Beauchamp, "Self-Interview," 19.

5. Unidentified reviewer, clipping probably taken from *Art News*, about his guest show at the Tanager Gallery in 1954.

6. Beauchamp, "Self-Interview," 20.

7. Joan Marter, "Robert Beauchamp: Haunting Images," *Arts Magazine* (February 1979): 146–47.

8. Robert Beauchamp statement in *Art Now* 1, no. 8, October 1969.

NEW YORK

1. Eleanor Heartney, "George McNeil's Dangerous Beauty," in *George McNeil: The Late Paintings 1980–1995* (exhibition catalog) (Glen Falls, NY: The Hyde Collection, 1999), 22.

2. Carter Ratcliff, "George McNeil: Geometer," *George McNeil: Three Decades of Prints* (Montclair, NJ: Montclair Art Museum, 1991).

3. George McNeil, interview with the author, March 24, 1984.

4. Ibid. He told me that it was extremely difficult to imitate, and he had been trying to do it convincingly for quite some time.

5. Ibid.

6. Heartney, "George McNeil's Dangerous Beauty," 19.

7. The two also probably have more figures dancing through their canvases than any other Figurative Expressionists, including Emil Nolde, except possibly for those of Oliver Jackson and Jay Milder.

8. Jacques Lipchitz, "My Dear Mr. Kriesberg . . ." in *Irving Kriesberg* (exhibition catalog) (New York: Curt Valentin Gallery, 1955).

9. George Preston Nelson, "Irving Kriesberg: Deep Current Beneath the Mainstream," *Arts Magazine* 62, no. 4, 26–27.

10. Letter from Kriesberg to Louise Ross, in author's possession, n.d.

11. He titled one 2004 painting *Green Dormition*. In it an all-green figure (head, hands, and clothed body all the same soft green) lies amid a host of birds, animals, and people crowding around the bier, at the head of which stands a guardian figure in white, hooded and covered in quilted armor, looking away. The reclining figure, however, seems alert and "dormition" means falling asleep/dying and ascending to heaven.

12. Letter to Louise Ross.

13. Dore Ashton, "Irving Kriesberg," in *Irving Kriesberg, Paintings—Drawings* (exhibition catalog) (New York: Terry Dintenfass Gallery, 1978).

14. Kriesberg quoted in Lori Bookstein Fine Art, "Irving Kriesberg Changeable Paintings

1956–68," press release, 2004. He actually created a number of feature-length animated films, which were shown in museums between 1945 and 1980.

15. Irving Kriesberg with Judith Gleason in *Tashilham*, directed by Shari Robertson (1997; MUSE Film and Television, Inc.).

16. Kriesberg made many trips to the Far East, including Tibet, and had artifacts from his journeys all over his SoHo loft, including dozens of Asian red cloth banners strung at ceiling height completely around the space.

17. Milder is a descendant of Rabbi Nachman, a Hasidic mystic whose teachings were an important early influence on him. The numbers that come to pervade many later paintings have their source in Cabalistic numerology, astrology, and science.

18. Jay Milder, interview by Martha Henry in *Jay Milder: Urban Visionary, Retrospective 1958– 1991* (Brooklyn, CT: New England Center for Contemporary Art, 1991). Interviews took place in New York, NY, in March 1990 and June 1991.

19. Zoahar (or Zohar) is the version of the Cabbalah written by Moses de Leon, a twelfth-century mystic who lived in Southern France. Milder says his is the strongest compilation of those ideas.

20. Dinah Guimaraens, *Jay Milder Expressionismo*, edited by Dinah Guimaraens (exhibition catalog) (Rio de Janeiro: Museu de Arte Moderna, 2006), 26.

21. Ibid.

22. Judd Tully (*Cover*, 1993) quoted in *Jay Milder Expressionismo*, 26.

23. Robert Henry, *Allegory at the Edge: Recent Paintings* (New York: Cortland Jessup Gallery, February 3–28, 1998).

24. Henry worked on the *Martyr* series from 1992 to 1997, but it is uncannily close to depicting the real events that took place on September 11, 2001.

25. Announcement card for *Still Moving (and other oxymorons)*, exhibition at CJG (Cortland Jessup Gallery) Projects International, September 26–October 20, 2001.

26. Quoted in Gillian Drake, "Robert Henry," in *Cape Arts Review*, 2008.

27. Quoted in J. L. H., "A Review: River Run Gallery," Martha's Vineyard, 1975.

28. *Selina Trieff: Master of the Look* (catalog and exhibition), Provincetown Art Association and Museum, July 27–September 2, 2007, Harold B. Nelson, Director (Provincetown: Provincetown Art Association and Museum, 2007), 38.

29. *Selina Trieff*, 39.

30. Ibid., 40.

31. Alison G. Weld, *Miriam Beerman: Works from 1949 to 1990* (exhibition catalog) (Trenton: New Jersey State Museum, 1991).

32. She did marry late in 1959, but her husband died unexpectedly at the age of 43 in 1973. They had one son, William Jaffe, in 1962.

33. Miriam Beerman, "Primal Ground," in *Primal Ground: Miriam Beerman, Works from 1983–1987* (exhibition catalog) (Montclair, NJ: Montclair Art Museum, 1987), 3.

34. Miriam Beerman, interview by Sharon Patton in *Witches Demons & Metamorphoses* (exhibition catalog) (Montclair, NJ: College Art Gallery, Montclair State College, 1987).

35. Dante Alighieri, "How It Is," *Inferno*, Canto VII, translated by Michael Palma (New York: W. W. Norton & Company, 2002), 77.

BALTIMORE

1. Grace Hartigan in Cleve Gray, "Remeurgers and Hambrandts," *Art in America*, June 1963, 123.

2. Grace Hartigan, statement in *Twelve Americans*, edited by Dorothy Canning Miller (exhibition catalog) (New York: The Museum of Modern Art, 1956), 53.

3. She told me she called it that because she had painted the subject before.

4. A notice announcing Juliana Popjoy's 1777 death, *The Gentleman's Magazine*, April 1777, 195.

5. Robert Beauchamp went through a phase of covering his paintings with fine spatter in the mid-1970s, but it was usually all one color.

6. Allen Barber, "Marking Some Marks," *Arts Magazine*, June 1974, 50.

7. Charlotte Streifer Rubinstein, *American Women Artists* (Boston: Avon Books, 1982), 282.

CHICAGO

1. Vera Klement, quoted in a press release for "Russian Poetry Readings" by the artist, during her exhibition *Vera Klement: Drawings*, Block Museum, Northwestern University, September 2–October 28, 2001.

2. Electronic music, and much instrumental modern music as well, is highly spatial. Closing one's eyes to the physical and translating the sounds into visual elements one enters a world that is all enveloping and marvelous.

3. Vera Klement, "An Artist's Notes on Aging and Death," *Art Journal* 53, no. 1 (1994): 73–75.

CALIFORNIA

1. Mary Fuller McChesney, *A Period of Exploration: San Francisco 1945–1950* (exhibition catalog) (San Francisco: Oakland Art Museum, 1973). All quotations in this section are from McChesney, who interviewed all the surviving teachers and students at CSFA from 1945–50.

2. In 1955 he was appointed to the faculty of U.C. Berkeley.

3. Lydia Park, quoted in Helen Park Bigelow, "David's Depth of Face," in *David Park: A Singular Humanity* (exhibition catalog) (San Francisco: Hackett-Freedman Gallery, 2003).

4. Richard Armstrong, citing an interview with Bischoff on June 1, 1988, in *David Park* (exhibition catalog) (New York: Whitney Museum of American Art, 1988), 136.

5. Richard Diebenkorn, quoted in Armstrong, 28–29.

6. Armstrong, 30. From a statement written by Park to accompany illustrations of his 1951–53 work in *The Artist's View* 6, September 1953. *The Artist's View* was a small periodical published by a group called Painters, Poets, & Sculptors in San Francisco.

7. W. S. Di Piero, "A Troublesome Thing," in *David Park: A Singular Humanity* (exhibition catalog) (San Francisco: Hackett-Freedman Gallery, 2003).

8. Armstrong, 42.

9. The Diebenkorns were invited by the Soviet Artists' Union to visit Russia, where Richard was bowled over by the Matisses he saw in the Shchukin Collection, among others never seen outside Russia.

10. Jane Livingston, *The Art of Richard Diebenkorn* (New York: Whitney Museum of American Art, 1997), 59.

11. Quote from interview with Susan Larsen, Oral history interview with Richard Diebenkorn, May 1, 1985–December 15, 1989, Archives of American Art, Smithsonian Institution, Washington, D.C., 107–108.

12. Frederick S. Wight, *Nathan Oliveira* (exhibition catalog) (Los Angeles: UCLA Art Galleries, 1963).

13. Thomas Albright, "Oliveira Turns to Women," *San Francisco Chronicle*, November 1972, 88.

14. Peter Selz, *Nathan Oliveira* (exhibition catalog) (Berkeley: University of California Press, 2002), 94.

15. Yvonne Thomas, conversation with the author, March 14, 1988.

16. Thomas Albright, "Coming Up from Underground," *ARTnews*, January 1983, 78.

17. Ibid.

18. Jan Butterfield, "Interview" in *Oliver Jackson* (exhibition catalog) (Seattle: Seattle Art Museum, 1982).

19. Ibid.

TRADITION

1. Though they never divorced, they each nevertheless had many affairs. They separated in the 1960s only to reconcile in the next decade when she conquered her alcoholism and moved to East Hampton to help him do so as well.

2. Grace Glueck, "Elaine de Kooning, Artist and Teacher, Dies at 68," *New York Times*, February 2, 1989, 19.

3. James Schuyler, "Lester Johnson," *Selected Art Writings*, ed. Simon Pettet (Santa Rosa, CA: Black Sparrow Press, 1998), 212. Originally published in *ARTnews*, March 1958.

4. David Cowan, "Lester Johnson," *Lester Johnson, Oil Paintings from the 1960s* (exhibition catalog) (Boston: Acme Fine Art and Design, 2007).

5. Lester Johnson in Burt Chernow, "Lester Johnson: In New York and P-town," *Provincetown Arts* 12, January 1996.

6. Nicholas Marsicano, Statement, *Nicholas Marsicano: Master and Mentor* (exhibition catalog) (Woodstock, NY: Woodstock Artists Association, 1998).

7. Irving Sandler, "Review: 7 Shows for Spring '61," *ARTnews*, April 1961, 45, 60.

8. Quoted in William P. Scott's essay for *Nora Speyer* (exhibition catalog) (Paris: Galerie Darthea Speyer, 1989).

9. Donald Kuspit, "Demon Lovers and Primal Scenes: Desire and Death in Nora Speyer's Paintings," *Nora Speyer, Paintings and Collages* (Provincetown, MA: Provincetown Art Association and Museum, 2002), 10.

10. *Nora Speyer: Dream Sequence* (exhibition catalog) (New York: Denise Bibro Fine Art, 2000).

11. From an interview with the author in August 1980 at the artist's Cape Cod studio.

12. Ibid.

13. Sideo Fromboluti, quoted in "Introduction," in *Figure and Landscape Painting* (exhibition catalog) (New York: Landmark Gallery, 1980).

14. On Finkelstein, from a conversation with Rosemarie Beck at a cocktail party hosted by Yvonne Thomas in New York sometime in early 1990s.

15. Aaron Berman Gallery, "Sherman Drexler by/about Sherman Drexler," news release, 1977.

16. Sherman Drexler in "Sherman Drexler

Interview with Phong Bui," *The Brooklyn Rail*, July–August 2009.

17. Ibid.

18. Ibid.

19. Sherman Drexler in *Still Working: Under-known Artists of Age in America*, eds. Stuart Shedletsky and Ann Eden Gibson (Seattle: University of Washington Press, 1994), 40.

20. Erika Passantino, "Where Past and Future Meet: The janus-faced nature of the studio," in *Still Working*, 1994.

21. Stuart Preston, "Review of Hansa Gallery Exhibition," *New York Times*, November 3, 1953.

22. Richard Lippold and Wolf Kahn, "1948–1957: The Testimony of Two Artists," in *A Century of Arts and Letters*, eds. R. W. B. Lewis and John Updike (New York: Columbia University Press, 1998), 150–51.

23. Martica Sawin, *Wolf Kahn: Landscape Painter* (New York: Taplinger Publishing Company, 1984). ■

SELECTED NOTES
ON THE ARTISTS

OBERT BEAUCHAMP (1923–1995)

Born in Denver, Colorado, Beauchamp studied at the Colorado Fine Arts Center, Cranbrook Academy of Art, and the Hans Hofmann School of Fine Art, New York and Provincetown.

SELECTED SOLO EXHIBITIONS

1953–1960: Tanager, March, and Great Jones Galleries, NYC; 1964–1969: Green and Graham Galleries, NYC; Richard Grey Gallery, Chicago; Obelisk Gallery, Boston; Utah Museum of Fine Arts, University of Utah, Salt Lake City; 1971: Utah Museum of Fine Arts, University of Utah, Salt Lake City; 1983: French & Co., Dain, Terry Dintenfass, and Monique Knowlton Galleries, NYC; 1984: *Robert Beauchamp: An American Expressionist*, Everson Museum of Art, Syracuse, NY; 1980s and 1990s: Gruenbaum, Monique Knowlton, and Vanderwoude-Tannenbaum Galleries, NYC; Long Point Gallery, Provincetown, MA; *Figurative Expressionists of Provincetown*, Berta Walker Gallery, Provincetown, MA; Cape Cod Museum of Art, Dennis, MA; *Robert Beauchamp—A Passion for Paint: The Final Years*, Provincetown Art Association & Museum, Provincetown, MA; 2000 onward: Acme Fine Art, Boston; ACME Gallery, Los Angeles; David Findlay Jr. Fine Art, NYC

SELECTED GROUP EXHIBITIONS

1953: *Rising Art Talent*, Walker Art Center, Minneapolis; 1962: *New U.S. Figure Painting*, MoMA, NYC; 1963: *66th Annual American Exhibition: Directions in Contemporary Painting and Sculpture*, The Art Institute of Chicago; 1967: *Annual Exhibition*

of Contemporary American Painting, Whitney Museum of American Art, NYC; 1972: *Ten Independents*, The Solomon R. Guggenheim Museum, NYC; 1981: *American Figure Painting 1950–1980*, The Chrysler Museum, Norfolk, VA; *Beast: Animal Imagery in Recent Painting*, P.S. 1, Queens, NYC; 1999: *Alchemies of the Sixties*, Rose Art Museum, Waltham, MA; 2006: *Artful Jesters*, Brattleboro Museum and Art Center, Brattleboro, VT; 2007: *Shining Spirit: Westheimer Family Collection*, Oklahoma City Museum of Art, Oklahoma City, OK

MIRIAM BEERMAN (b. 1923)

Miriam Beerman is the recipient of more than twenty-five grants and awards and has participated in many artist-in-residence programs. Her work can be found in over fifty museums, including the Metropolitan, Whitney, Montclair, Skirball, Neuberger, San Diego, Yale, Zimmerli, New Jersey State, Queens, Kalamazoo Institute of Arts, Everson, Corcoran, Victoria and Albert, and Vassar.

SELECTED SOLO EXHIBITIONS

1965: *Miriam Beerman, Paintings, Drawings, Collages*, Brooklyn Center, Long Island University, NYC; 1971: *The Enduring Beast*, Brooklyn Museum, Brooklyn, NYC; 1972: *The Enduring Beast: Drawings and Paintings*, Graham Gallery, NYC; 1974: *Miriam Beerman: Collage, Drawing and Painting*, Montclair Art Museum, Montclair, NJ; 1987: *Miriam Beerman, Primal Ground: Works from 1983–1987*, Montclair Art Museum, Montclair, NJ; 1991: *Miriam Beerman: Works from 1949–1990*, New Jersey State Museum, Trenton; 1997–1998: *Miriam Beerman: Artist's Books*, Jersey City Museum, Jersey City, NJ; 2001: *Miriam Beerman*, Baird Center, South Orange, NJ; 2002: University of Wisconsin

Gallery, Oshkosh; 2004: Chautauqua Center for the Visual Arts, Chautauqua, NY; 2006: *Miriam Beerman: Eloquent Pain(t)*, Everson Museum of Art, Syracuse, NY; 2007: College Art Gallery, Queensborough Community College, Queens, NYC

SELECTED GROUP EXHIBITIONS

1958: *Recent Acquisitions*, Whitney Museum of American Art, NYC; 1960: Boston Arts Festival, Boston; JB Speed Art Museum, Louisville, KY; American Federation of Arts, NYC; National Gallery of Canada, Ottawa, Ontario; 1968: *The Humanist Tradition in Contemporary Painting*, New School Art Center, NYC; 1972: *Women in the Arts*, The Stamford Museum, Stamford, CT; 1973: *American Painting*, Whitney Museum of American Art, NYC; 1977: *Images of Horror and Fantasy*, Bronx Museum of the Arts, NYC; 1982: *The Interior Self: Three Generations of Expressionists View the Human Image*, The Montclair Art Museum, Montclair, NJ; 1986: *The Brutal Figure: Visceral Images*, Robeson Center Gallery, Rutgers University, Newark, NJ; 1989: *The Holocaust in Contemporary Art*, Holman Hall Art Gallery, Trenton State College, Trenton, NJ; 1991: *The Apocalyptic Vision*, Zimmerli Art Museum Rutgers University, Newark, NJ; 1994: *Still Working*, Corcoran Gallery of Art, Washington, DC (traveled); 1999: *Artist's Books*, Connecticut College, New London, CT; 2004: Corcoran Gallery of Art, Washington, DC

NANNO DE GROOT (1913–1963)

In 1956, Nanno de Groot rented Fritz Bultman's studio in Provincetown for the summer. The linear "stick" figures, influenced by Morris Graves, that populated his work prior to this were barely discernible as either male or female. That changed with his new paintings

of "Ladies in Chairs." Pat de Groot, his wife and the subject of the painting *Lady in the Kimono*, asserts that her husband often used the shape of a chair to frame a sitter who actually was standing. She feels that this is "one of his strongest paintings." It was among the last to contain a figure, as he turned to land- or sea-scapes, and an occasional still life, thereafter.

SELECTED SOLO EXHIBITIONS

1952: Saidenberg Gallery, NYC; 1954, 1955: Bertha Schaefer Gallery, NYC; 1958, 1960, 1965: H.C.E Gallery, Provincetown, MA; 1960: Stamford Museum, Stamford, CT; 1971: Jack Gregory Gallery, Provincetown, MA; 1982: Provincetown Art Association and Museum, Provincetown, MA; 1987–2003: Julie Heller Gallery, Provincetown, MA; 2007: *Nanno de Groot: Earth, Sea & Sky*, Acme Fine Art, Boston

SELECTED GROUP EXHIBITIONS

1953: Hansa Gallery, NYC; 1954, 1955: Tanager Gallery, NYC; 1961: Parma Gallery, NYC; 1962, 1963: H.C.E. Gallery, Provincetown, MA; 1993: Provincetown Art Association and Museum, Provincetown, MA; 1994: *Reclaiming Artists of the New York School: Toward a More Inclusive View of the 1950s*, Baruch College, City University, NYC; *New York-Provincetown: A 50's Connection*, Provincetown Art Association and Museum, Provincetown, MA; Anita Shapolsky Gallery, NYC; 1997: Everson Museum of Art, Syracuse, NY

ELAINE DE KOONING (1918–1989)

De Kooning was born in Brooklyn, New York, where her mother encouraged her interest in the arts. She studied with Conrad Marca-Relli at the Leonardo da Vinci Art School and met Willem de Kooning, Arshile Gorky, and Milton Resnick there, all of whom became lifelong friends. She met ballet critic Edwin Denby and photographer Rudy Burckhardt through de Kooning and began attending ballets with them and learned to write reviews. In 1943 she and de Kooning married, and soon thereafter they began working in separate studios. She began writing reviews for *ARTnews* and painting her sports imagery from newspapers. They never divorced, but lived separately. In 1975 she moved into a house near Willem's in The Springs in East Hampton to try to help him gain control over his drinking.

SELECTED SOLO EXHIBITIONS

1954, 1956: Stable Gallery, NYC ; 1957: Tibor de Nagy Gallery, NYC; 1959: *Retrospective*, Lyman Allyn Art Museum, New London, CT; 1960: Graham Gallery, NYC; 1964: *25 Portraits of J.F.K.*, Pennsylvania Academy of the Fine Arts, Philadelphia (traveled); 1989: *Elaine de Kooning: Portrait Drawings*, Guild Hall, East Hampton, NY; 1991: *(Black) Mountain Paintings from 1948*, Joan T. Washburn Gallery, NYC

SELECTED GROUP EXHIBITIONS

1951: *9th Street Art Exhibition*, Stable Gallery, NYC; 1953, 1954, 1955, 1956: Stable Annual, Stable Gallery, NYC; 1956: *Expressionism*, Walker Art Center, Minneapolis, MN (traveled); *Young American Painters*, MoMA (traveled); 1957: *Artists of the New York School: Second Generation*, The Jewish Museum, NYC; 1958: *Action Painting, 1958*, Dallas Museum for Contemporary Arts, Dallas, TX; 1960: *60 American Painters: 1960*, Walker Art Center, Minneapolis; 1980: *The Fifties: Aspects of Painting in New York*, Hirshhorn Museum and Sculpture Garden, Washington, DC; 1988: *Figurative Fifties: New York Figurative Expressionism*, Newport Harbor Art Museum, Newport Beach, CA (traveled);

1990: *East Hampton Avant-Garde, A Salute to the Signa Gallery*, Guild Hall Museum, East Hampton, NY

WILLEM DE KOONING (1904–1997)

Willem de Kooning moved to the United States from Holland in the mid-1920s and lived and worked in New York City and East Hampton, Long Island. In 1943 he married Elaine Fried. His whole life, he was a "both/and" person, always wanting to keep his options open. He is most identified with the Abstract Expressionist movement, but no one style can sum up what type of painter he was: abstract or figurative, minimal or baroque, and who, if anyone, influenced him. In his later years, it is thought that he suffered from Alzheimer's disease, and the significance of his work from this period is much debated.

SELECTED SOLO EXHIBITIONS

1939: Public mural commission for the 1939 New York World's Fair; 1948: *Willem de Kooning*, Charles Egan Gallery, NYC; 1968, 2011: *Retrospective*, MoMA, NYC; 1974: *de Kooning: Drawings and Sculpture*, Walker Art Center, Minneapolis, MN (traveled); 1983: Whitney Museum of American Art, NYC; 1994: National Gallery of Art, Washington, DC; 1995: *Willem de Kooning: Paintings from the 1980s*, San Francisco Museum of Modern Art (traveled); 2006: *Willem de Kooning: Late Paintings*, State Hermitage Museum, St. Petersburg, Russia, and Museo Carlo Bilotti, Rome; 2007: *Willem de Kooning: The Last Beginning*, Gagosian Gallery, NYC

SELECTED GROUP EXHIBITIONS

1936: *New Horizons in American Art*, MoMA, NYC; 1944: *Abstract and Surrealist Art in the United States*, Cincinnati Art Museum, Cincinnati, OH (traveled); 1949: *The Intrasubjectives*, Samuel M. Kootz Gallery, NYC; 1950: Venice Biennale, Venice, Italy; *Young Painters in the U.S. and France*, Sidney Janis Gallery, NYC; 1951: *Abstract Painting and Sculpture in America*, MoMA, NYC; *9th Street Art Exhibition*, Stable Gallery, NYC; 1959: *New American Painting as Shown in Eight European Countries 1958–1959*, MoMA, NYC; 1962: *Newman-De Kooning*, Allan Stone Gallery, NYC

ROBERT DE NIRO SR. (1922–1993)

Born in Syracuse, New York, De Niro began making art at the age of five. By the time he was twelve he was able to enroll in adult classes at the Syracuse Museum, and he did so well that he was given his own studio there. He studied with Hans Hofmann in the summer of 1939 and then spent two years with Josef Albers at Black Mountain College in North Carolina before returning to study with Hofmann again in 1941. He met Virginia Admiral in this class and they were married in 1942. Their son, the actor with his father's name, De Niro Jr., was born the next year. De Niro and his wife separated shortly thereafter. The younger De Niro lived with his mother, but saw his father and their illustrious friends often.

SELECTED SOLO SHOWS

1945: *Art of This Century*, Peggy Guggenheim Gallery, NYC; 1950, 1952, 1953, 1954: Charles Egan Gallery, NYC; 1958, 1960, 1962, 1965, 1967, 1971: Zabriskie Gallery, NYC; 1978, 1979: Charles Campbell Gallery, San Francisco; 1980, 1982, 1984, 1986: Graham Modern, NYC; 1981: Mint Museum, Charlotte, NC; Asheville Art Museum, Asheville, NC; 1986: Crane Kalman Gallery,

London; 1994, 1996–2000, 2003: Salander O'Reilly Galleries, NYC; 2010: *Apres avoir vu Matisse: Robert De Niro, Sr. Peintures, Dessins*, Musée Matisse de Nice, Nice, France; 2012: DC Moore Gallery, NYC

SELECTED GROUP EXHIBITIONS

1956: Whitney Museum Annual and Stable Gallery Annual, NYC; 1957: *Artists of the New York School: Second Generation*, Jewish Museum, NYC; 1960: *Figure in Contemporary Painting*, American Federation of Arts, NYC; 1962: *Recent Figure Paintings*, MoMA, NYC; 1984: *Emotional Impact: New York School Figurative Expressionism*, Art Museum Association of America, San Francisco (traveled); 1995: *American Masters of Watercolor: A 100 Year Survey*, Southern Alleghenies Museum of Art, Loretto, PA; 1998: *Seeing the Essential: Selected Works by Robert De Niro Sr., Paul Resika and Leland Bell*, Hackett-Freedman Gallery, San Francisco

RICHARD DIEBENKORN (1922–1993)

In his art studies at Stanford University in the early 1940s, Diebenkorn was exposed to the twentieth-century American Modernists and their European forebears; then, stationed in the eastern United States during the war, he absorbed the museums and collections of the American northeast. Post-war he studied at the California Institute of the Arts on the G.I. Bill and then spent a year in the Woodstock art colony. He moved to Albuquerque to study and developed his first mature visual statements. Seeing Arshile Gorky's retrospective and experiencing the landscape from a low-flying plane fused together in Diebenkorn's work into a linear and spatial pictorial language with endless possibilities.

SELECTED SOLO EXHIBITIONS

1948: California Palace of the Legion of Honor, San Francisco; 1958: *Richard Diebenkorn: Recent Paintings*, Poindexter Gallery, NYC; 1976–1977: *Retrospective*, Albright-Knox Gallery, Buffalo, NY (traveled); 1988: MoMA, NYC; 1989: *The Drawings of Richard Diebenkorn*, The Phillips Collection, Washington, DC; 1992: *Richard Diebenkorn*, The Museum of Contemporary Art, Los Angeles; 1997–1998: *Richard Diebenkorn*, Whitney Museum of American Art, NYC (traveled); 1999: *Ocean Park Paintings*, Lawrence Rubin Greenberg Van Doren Fine Art, NYC; 2000: *Early Abstractions*, Lawrence Rubin Greenberg Van Doren Fine Art, NYC; 2002: *Clubs and Spades*, The Fine Arts Museum of San Francisco, California Palace of the Legion of Honor, San Francisco; 2004: *Richard Diebenkorn: Prints 1949–93*, Katonah Museum of Art, Katonah, NY; 2006: *Richard Diebenkorn*, Pasadena Museum of California Art, Pasadena, CA; 2007: *Diebenkorn in New Mexico: 1950–1952*, Harwood Museum of Art, University of New Mexico, Taos, NM (traveled); 2010: *Richard Diebenkorn: Paintings and Drawings 1949–1955*, Greenberg Van Doren Gallery, NYC

SELECTED GROUP EXHIBITIONS

1960–1961: *The Figure in Contemporary American Painting*, American Federation of Arts, NYC (traveled); 1978: Venice Biennale, Venice, Italy

SHERMAN DREXLER (b. 1925)

Sherman Drexler primarily paints the female nude, standing and turned three-quarters away from the viewer as if moving back into space and about to disappear. The nude is generically based on his wife (the artist and

writer Rosalyn Drexler) but she stands in for every woman, and he has been painting her all his life. In the 1980s he first showed his mini-paintings on rough fragments of wood, rock, and brick, and in 1984 his work was shown at P.S. 1 in Queens in a closet space.

In addition to sixteen years of teaching at City College, most recently as full professor, he has taught at Parsons School of Design, the University of Pennsylvania, Philadelphia, Cooper Union, and the School of the Art Institute of Chicago.

SELECTED SOLO EXHIBITIONS

1956: Courtyard Gallery, Berkeley, CA; 1961, 1962: Tibor di Nagy Gallery, NYC; 1961–1963: Tirca Karlis Gallery, Provincetown, MA; 1969: Graham Gallery, NYC; 1970: Skidmore College, Sarasota Springs, NY; 1974: Drew University, Madison, NJ; 1975: Grey Art Gallery, New York University, NYC; 1976: Landmark Gallery, NYC; 1977: Aaron Berman Gallery, NYC; 1980: Books & Company, NYC; 1982: Max Hutchinson Gallery, NYC; 1984: P.S. 1, NYC; 2005: *Sherman Drexler: Art Paradise: 50 Years of Painting*, Mitchell Algus, NYC

SELECTED GROUP EXHIBITIONS

1994: *Still Working: Underknown Artists of Age in America*, Parsons School of Design, NYC (traveled)

LOUIS FINKELSTEIN (1923–2000)

Born in New York City, Finkelstein painted, taught, and wrote about art there all his life, teaching at Queens College, living in Manhattan, and talking or writing about art at every opportunity. After taking WPA art classes, he studied at New York's Cooper Union Art School, the Art Students League, and the Brooklyn Museum School of Art. He taught at

the Brooklyn Museum School, the Philadelphia College of Art, and the Vermont Studio Center, but most of his teaching time was spent at CUNY's Queens College (where he was the head of the art department for more than twenty-five years) and Yale University. He was a visiting artist/critic at many art-focused U.S. colleges and published over two dozen articles on artists such as John Marin, Willem de Kooning and George McNeil, and on various subjects concerning art and art education. His work is included in many important institutional collections and he has received many awards, including three Fulbrights and awards from the College Art Association, the National Endowment for the Arts, and the National Academy of Design.

SELECTED SOLO EXHIBITIONS

1950: Pyramid Gallery, NYC; 1958: Attico Gallery, Rome; 1970s–1980s: Ingber Gallery, NYC; 2000: *Louis Finkelstein—Paintings 1971–1999*, Cantor Fitzgerald Gallery, Haverford College, PA; 2003: *Louis Finkelstein: The Late Pastels, 1990–1999*, Lori Bookstein Fine Art, NYC (traveled)

SELECTED GROUP EXHIBITION

1975: *Painterly Representation*, Ingber Gallery, NYC (traveled)

SIDEO FROMBOLUTI (b. 1920)

Sideo met Nora Speyer, his wife, at Philadelphia's Tyler College of Fine Arts, and they have had nearby studios ever since. They consider themselves to be very different kinds of painters, attacking very different problems, but paying only surface attention to their many-layered oil paintings, one might not think so. Nora is the Expressionist and Sideo the Classicist . . . or is it the other way around?

GRACE HARTIGAN (1922–2008)

Born in Newark, New Jersey, Hartigan studied
drafting at the Newark College of Engineering
and drawing with artist Isaac Muse. She was
active in the New York art world by 1950 and
is the only woman pictured in a famous pho-
tograph of the Abstract Expressionists group
from the same year. Feeling the need for her
own images and methods, she began to work
from store window displays and other usable
figuration found on New York streets and in
stores, mail-order catalogs, and magazines.

She was a teacher and then the director of
Hofberger Graduate School at the Maryland
Institute.

ROBERT HENRY (b. 1933)

Henry lives in New York City and Wellfleet,
Massachusetts. He taught at Brooklyn College.

Henry's earliest work clearly shows the effect of Hans Hofmann's example and teaching on his color, loose and varied paint handling, and push/pull construction of the picture space. Other teachers—like William Baziotes, Ad Reinhardt, and Kurt Seligman—may have stimulated Henry's imagination. He became uniquely obsessed with how we see and how to represent that pictorially.

SELECTED SOLO EXHIBITIONS

1954, 1955: James Gallery, NYC; 1964, 1965: East End Gallery, Provincetown, MA; 1968: Area Gallery, NYC; 1972, 1973, 1975, 1977: River Run Gallery, Edgartown, MA; 1972, 1974, 1976, 1978: Green Mountain Gallery, NYC; 1976: Paul Kessler Gallery, Provincetown, MA; 1979, 1981: Blue Mountain Gallery, NYC; 1981, 1983, 1985, 1987: On the Vineyard Gallery, Vineyard Haven, MA; 1982, 1986, 1989: Barbara Ingber Gallery, NYC; 1987: Joseph Gross Gallery, University of Arizona, Tucson; 1990, 1991, 1993, 1995, 1999, 2000–2012: Berta Walker Gallery, Provincetown, MA; 1998: Cortland Jessup Gallery, NYC; 2000: Janus Avison Gallery, London, UK

SELECTED GROUP EXHIBITIONS

1955: Sun Gallery, Provincetown, MA; 1971: *Ten Figurative Painters*, Stony Brook University Art Gallery, Stony Brook, NY; 1973, 1974, 1975, 1978, 1980: Landmark Gallery, NYC; 1987: *The World is Round: The Artist and Expanded Vision*, Delaware Art Museum, Wilmington, DE, and Hudson River Museum, Yonkers, NY (traveled); 1996: *Yellow*, O'Hara Gallery, NYC; 1998: *Bridge Hashi*, Sakai City Museum, Osaka, Japan; 1999: *Pushed-Pulled, Students of Hans Hofmann in the Cape Museum of Fine Arts Collection*, Cape Cod Museum of Art, Dennis, MA; *Figurative Expressionists in Provincetown*, Berta Walker Gallery, Provincetown, MA

OLIVER JACKSON (b. 1935)

Oliver Jackson's bibliography is nineteen pages long, a dozen references per page. He has works in more than twenty major museums, including MoMA, the Met, the Corcoran, the MoCAs in Chicago and San Diego, and the Oakland, Portland, San Francisco, and New Orleans museums. Jackson's San Francisco Bay Area studio seems to have no end of room for working in a variety of media: painting, sculpting, drawing, and printmaking in many different ways. He thinks big in a biblical, inevitable way, very often on canvases with dimensions far too large for the average hanging site in both height and width. His work would seem "at home" beside a major Tintoretto in a cathedral, but not in a typical apartment or gallery. The figures he paints seem to have purpose or function, yet to be caught in overwhelming forces.

SELECTED SOLO EXHIBITIONS

1990: St. Louis Art Museum, St. Louis, MO; 1993: Triton Museum, Santa Clara, CA; 1994: *Oliver Jackson: Works on Paper*, Crocker Art Museum, Sacramento, CA; *New California Art: Oliver Jackson*, Newport Harbor Museum, Newport Beach, CA; 1996: *Oliver Jackson: The Incised Line*, Artists' Forum, San Francisco; 1997: *Oliver Jackson: 1978–1996, Paintings, Sculpture, and Works on Paper*, Porter Troupe Gallery, San Diego, CA; 1997–1998: *Oliver Jackson: The Figure Revealed*, 425 Market Street, San Francisco; 2000: *Oliver Jackson: Installation*, Harvard University Art Museums, Cambridge, MA; *Oliver Jackson: Recent Paintings, Sculpture, and Work on Paper*, Fresno Art Museum, Fresno, CA; 2012: *Oliver Jackson*, Contemporary Art Museum, St. Louis, MO

1971: *Black Untitled II/Dimensions of the Figure*, Oakland Museum, Oakland, CA; 1975: *Contemporary California Artists: Carlos Gutierrez-Solana, Oliver L. Jackson*, San Francisco Museum of Modern Art, San Francisco; 1983: *Biennial Exhibition*, Whitney Museum of American Art, NYC; 1986: *American Painting: Abstract Expressionism and After*, San Francisco Museum of Modern Art, San Francisco; 1989: *Selections from the Permanent Collection*, Museum of Contemporary Art, Chicago; 1994: *The Essential Gesture*, Newport Harbor Art Museum, Newport Beach, CA; 2004: *Echoes of Africa*, American Adventure Pavilion, Epcot, Walt Disney World, Orlando, FL; 2005: *Africa in America*, Seattle Art Museum, Seattle, WA

LESTER JOHNSON (1919–2010)

Born in Minneapolis, Minnesota, Johnson lived in Connecticut and died in Southampton, New York. He won numerous scholarships to art schools from 1939 to 1941 and took first prize in the Midwest Artists Competition in 1941. He studied in Minneapolis, St. Paul, and Chicago art schools from 1942 to 1947, then went to New York City. In 1973 he received the Guggenheim Fellowship and was Director of Graduate Painting at the Yale School of Art and Architecture from 1969 to 1974. He won the Brandeis University Creative Arts Award for Painting in 1978, was an Elected Associate at the National Academy of Design in 1987, and was an adjunct professor of painting at Yale University in New Haven, Connecticut, from 1964 to 1989.

SELECTED SOLO EXHIBITIONS

1951: *Lester Johnson*, Artists Gallery, NYC; 1977, 1980, 1990: Gimpel & Weitzenhoffer Gallery, NYC; 1983: *1957–1967 Lester Johnson: The Early Paintings*, Zabriskie Gallery, NYC; 1989: *Retrospective*, David Barnett Gallery, Milwaukee, WI; 1991: *A Print Retrospective, 1960–1990*, Erector Square Gallery, New Haven, CT; 1994: Edward Thorp Gallery, NYC; 2004: *Lester Johnson: Four Decades of Painting*, James Goodman Gallery, NYC; 2005: *People Passing By: Paintings, Drawings, and Prints by Lester Johnson*, William Benton Museum of Art, University of Connecticut, Storrs; 2011: *Lester Johnson's Last Paintings*, Steven Harvey Fine Arts Projects, NYC

SELECTED GROUP EXHIBITIONS

1958: *Artists of the New York School: Second Generation*, Jewish Museum, NYC; 1960: *Figure in Contemporary Painting*, American Federation of Arts, NYC; 1967: The Aldrich Museum of Contemporary Art, Ridgefield, CT; *The 1960s*, MoMA, NYC; 1968: Whitney Museum of American Art (biennial), NYC; 1969–1971: *The Human Situation: Street Scene*, Martha Jackson Gallery, NYC; 1972: *Ten Independents*: *An Artist Initiated Exhibition*, Solomon R. Guggenheim Museum, NYC; 1983: *Emotional Impact: New York School Figurative Expressionism*, Art Museum Association of America, San Francisco (traveled); 1985: *The Artist Celebrates New York*, MoMA, NYC (traveled); 1986: *Naked/Nude*, MoMA, NYC

WOLF KAHN (b. 1927)

Born in Stuttgart, Germany, Kahn was sent to England at age 13 in a transport of refugee children two weeks before the outbreak of WWII. In 1940, he joined his father in America and began studying at the High School of Music & Art in New York. In 1946, after a stint in the Navy, he began studies with Stuart Davis at the New School and finished out the

forties studying with Hans Hofmann before going to the University of Chicago for his BA. With a loft studio at 813 Broadway in the heart of the 1950s co-op gallery scene in Greenwich Village, and being a founding member of the Hansa Gallery where he began showing his work in 1953, Kahn was an important part of the post-AbEx generation. He summered in various countries and states until 1968, when he bought a farm in West Brattleboro, Vermont. He was awarded a Fulbright for study in Italy in 1962 and in 1980 was elected a member of the National Academy of Design and elected to the National Board of the College Art Association.

SELECTED SOLO EXHIBITIONS

1956–1995: Grace Borgenicht Gallery, NYC; 1962: Kresge Art Center, Michigan State University, East Lansing; 1963: Kansas City Art Institute, Kansas City, MO; 1966: Sabarsky Gallery, Los Angeles; 1971: Meredith Long Gallery, Houston, TX; University of Nebraska Museum of Art, Lincoln; David Barnett Gallery, Milwaukee, WI; Chrysler Museum, Norfolk, VA; Princeton Gallery of Fine Art, Princeton, NJ; 2007, 2009, 2011, 2012: Ameringer McEnery Yohe, NYC

SELECTED GROUP EXHIBITIONS

1957: *New York School: The Second Generation*, Jewish Museum, NYC; 1960: *Young America*, Whitney Museum of American Art, NYC

VERA KLEMENT (b. 1929)

Vera Klement lives in Chicago, Illinois, and was Professor Emerita at the University of Chicago. Born in Poland, Klement learned to speak many languages in addition to Polish, including German, Russian, and, later, English. She has used this knowledge to translate

the poetry of many modern writers and then transform it into visual matter that she makes her own. Working abstractly, she ignored Chicago Imagism and developed a both/and approach including figurative and abstract elements on dissimilar diptychs in a given work. Figures are rarely more than a head and torso; a section of woods, boats, bells, a footed tub, vessels, and other hollow things sometimes replace the figure. The brightly-colored elements contrast strongly with the serene whiteness surrounding them and stress their energy and brightness. No one else uses such vast expanses of white, and yet the paintings feel almost crowded with content.

SELECTED SOLO EXHIBITIONS

1974: Artemisia Gallery, Chicago; 1975: Krannert Center for Performing Arts, Urbana, IL; 1976: Chicago Gallery, Chicago; 1982, 1984: CDS Gallery, NYC; 1983, 1985, 1989, 1990, 1991, 1992: Roy Boyd Gallery, Chicago; 1987: *Retrospective 1953–86*, Renaissance Society, Chicago; 1995, 1996, 1997, 1999, 2001: Fassbender Gallery, Chicago; 1999: *Retrospective*, Chicago Cultural Center, Chicago; 2001: Mary and Leigh Block Museum of Art, Northwestern University, Evanston, IL; Union League Club of Chicago, Chicago; Fort Wayne Museum of Art, Fort Wayne, IN; 2003: University of Arizona Museum of Art, Tucson; 2004: Daum Museum of Contemporary Art, Sedalia, MO; Maya Polsky Gallery, Chicago; 2007: Alfedena Gallery, Chicago; *Poetry as Painting*, University Art Gallery, Indiana State University, Terra Haute; 2008: *Paint into Icon*, Rockford Art Museum, Rockford, IL

SELECTED GROUP EXHIBITIONS

1980: Museo de Arte Contemporanae, São Paulo, Brazil; 1981: *Chicago Show*, Liberia (traveled); 1982: *Jewish Themes/Contemporary*

American Artists, The Jewish Museum, NYC; 1984: *Alternative Spaces*, Museum of Contemporary Art, Chicago; 1985: Indianapolis Museum of Art, Painting and Sculpture Today, Indianapolis, IN; 1987: *Surface: Two Decades of American Art*, Terra Museum of American Art, Chicago; 1988: *Chicago Contrasts*, Munich and Berlin, Germany; 1989: *Lines of Vision: Drawings of Contemporary Women*, Brookville, NY (traveled); Mitchell Museum, Mt. Vernon, NY; 1990: *Locations of Desire: Phyllis Bramson, Michiko Itatani, Vera Klement*, Illinois State Museum Gallery, Chicago; Brody's Gallery, Washington, DC; 1994–1995: *Still Working*, Corcoran Gallery of Art, Washington, DC (traveled); 1996, 2004: *Art in Chicago 1945–1995*, Museum of Contemporary Art, Chicago; 2005: *Contemporary American Artists*, CDS Gallery, NYC

IRVING KRIESBERG (1919–2009)

Growing up in Chicago, Kriesberg spent a lot of his free time in the Field Museum, which boasts having "4.6 billion years under its roof." As an adult he dedicated himself to exploring different world cultures and utilizing them as an artist. The human figures he painted echoed our ancient ancestors, and his sculptures are primarily animals, birds, or creatures of prey. Color was his forte and he published three books on it, still in print.

SELECTED SOLO EXHIBITIONS

1954: St. Louis Art Museum, St. Louis, MO; Detroit Institute of the Arts, Detroit, MI; 1955: Curt Valentin Gallery, NYC; 1962: Graham Gallery, NYC; 1966: Kumar Gallery, Delhi, India; 1967: Yale University Gallery, New Haven, CT; 1978, 1980, 1982: Terry Dintenfass Gallery, NYC; 1980, 1981: Brandeis University, Waltham, MA;

1981, 1983: Jack Gallery, NYC; 1985, 1987: Graham Modern, NYC; 1990: Scheele Gallery, Cleveland, OH; 1992, 1994: Katharina Rich Perlow Gallery, NYC; 1996, 2005: Peter Findlay Gallery, NYC; 2005, 2008: Lori Bookstein Fine Art, NYC; 2012: *Retrospective*, Longview Museum of Fine Art, Longview, TX

SELECTED GROUP EXHIBITIONS

1946: Art Institute of Chicago, Chicago; 1952: *New Talent*, MoMA, NYC; *Fifteen Americans*, MoMA, NYC; 1953: The Detroit Institute of Arts, Detroit, MI; 1954: St. Louis Art Museum, St. Louis, MO; 1972: *Ten Independents: An Artist Initiated Exhibition*, Solomon R. Guggenheim Museum, NYC

NICHOLAS MARSICANO (1908–1991)

Marsicano's solid grounding in traditional figurative art, study at the Pennsylvania Academy of Fine Arts and the Barnes Foundation, followed by painting in southern France on Cresson and Barnes scholarships, permitted him full leeway to paint the nude in his own new way. In *ARTnews* Irving Sandler wrote that his "serene nudes are abstractions, not inventions." He is "turning 'real' figures into the abstract stuff of art."

SELECTED SOLO EXHIBITIONS

1957–1967: Schaefer, Wise, and Great Jones Galleries, NYC; Huntington Galleries, Huntington, WV; 1971–1983: Sachs, Landmark, and Gruenbaum Galleries, NYC

SELECTED GROUP EXHIBITIONS

1955: *Vanguard 1955*, Stable Gallery, NYC, and Walker Art Center, Minneapolis; 1961: *Six Decades of 20th Century American Painting*, Des Moines Art Center, Des Moines, IA; 1962: *Recent*

Painting USA: The Figure, MoMA, NYC; 1969: *Painting as Painting*, The University of Texas Museum, Austin; *New American Painting & Sculpture: The First Generation*, MoMA, NYC

GEORGE McNEIL (1908–1995)

George McNeil joined the Federal Art Project of the WPA in 1935, and in 1936 he helped to form the American Abstract Artists. He served in the Navy during WWII, then began a lengthy teaching career in Wyoming, California, and New York City. Before 1977, his figures represented states of being that could be termed generic. *Waiting II*, for example, seems fraught with anxiety or fear about what is being awaited. The figure seems both frightened and frightening. Other states of mind he explored were joy, penitence, elation, maternal love, awe at the night sky, and uncertainty. Subjects varied from a party girl to Nijinsky to a green enchantress, and from Clarabel to Charles Ives. He often used pure color and extreme figural distortion in an effort to lift his paintings to the highest state of pictorial excitement.

SELECTED SOLO EXHIBITIONS
1956: de Young Museum, San Francisco; 1982: Museum of Fort Lauderdale, Fort Lauderdale, FL; Jorgensen Gallery, University of Connecticut, Storrs; 1984: Artists' Choice Museum, NYC; 1985: State University of New York, Binghamton; 1989: University of Hartford, Hartford, CT; 1991: Montclair Art Museum, Montclair, NJ; 1993: New York Studio School, NYC; 1999: North Dakota Museum of Art, Grand Forks; The Hyde Collection, Glens Falls, NY

SELECTED GROUP EXHIBITIONS
1939: New York World's Fair; 1947: Art Institute of Chicago, Chicago; 1950, 1990: Provincetown Art Association and Museum, Provincetown, MA; 1951, 1969, 1985: MoMA, NYC; 1951: *9th Street Art Exhibition*, Stable Gallery, NYC; 1953, 1957, 1961, 1965, 1968, 1984: Whitney Museum of American Art, NYC; 1954, 1955: Stable Gallery, NYC; 1961: Solomon R. Guggenheim Museum, NYC; Cleveland Museum of Art, Cleveland, OH; Yale University Art Gallery, New Haven, CT; 1962, 1966: Pennsylvania Academy of the Fine Arts, Philadelphia; The Wadsworth Atheneum, Hartford, CT; 1972, 1987: Brooklyn Museum, Brooklyn, NYC; 1986: Corcoran Gallery of Art, Washington, DC; 1992: Tucson Museum of Art, Tucson, AZ; 1993:Whitney Museum of American Art, NYC

JAY MILDER (b. 1934)

From the start in the late 1950s, Jay Milder established a multifunctional practice of showing his work in the United States as well as in Latin America and drawing material and psychic energy from both to supercharge his own paintings. Milder's work was included in many group exhibitions that focused on the figure as an expressive medium, its potential links to fantasy, and as a way to enliven abstraction. The clearest expression of this is *The Rhino Horn* exhibition, which made 15 stops on its 1970–1971 tour. Milder's work is represented in over fifty museums and public collections. He has received a dozen honors and awards, in large measure for the cultural interaction and exchange he fosters in the Americas.

SELECTED SOLO EXHIBITIONS
1958: City Gallery, NYC; Sun Gallery, Provincetown, MA; 1960: Allan Stone and Zabriskie Galleries, NYC; Museo de la Universidad de Puerto Rico, San Juan, Puerto Rico; 1961: Museo des Bellas Artes, San Juan, Puerto Rico; 1963:

Dayton Art Institute, Dayton, OH; 1964: Joslyn Art Museum, Omaha, NE; Ohio Wesleyan University, Delaware, OH; Martha Jackson Gallery, NYC; 1968–1977: Bienville Gallery, New Orleans, LA; 1972: The Chrysler Museum, Norfolk, VA; 1973: Mint Museum of Art, Charlotte, NC; 1979: Ingber Gallery, NYC; 1987–1989: *Jay Milder—Messiah on the IND*, Richard Green Gallery, London, England (traveled); 1991–1992: *Jay Milder: Urban Visionary, A Retrospective 1958–91* (traveled); 1994: Elizabeth Harris Gallery, NYC; 1997: *Retrospective*, Hugo de Pagano Gallery, NYC; 2000: Museum of Fine Arts, Rio de Janeiro, Brazil; 2003: Museum of Modern Art, Salvado, Brazil; 2004: Lohin Geduld Gallery, NYC

SELECTED GROUP EXHIBITIONS

1989: *The Expanding Figurative Imagination*, Anita Shapolsky Gallery, NYC; 1991 *Private Stories*, Alitash Kebede Fine Art, Los Angeles; 2005: *Celebration*, Lohin Geduld Gallery, NYC

NATHAN OLIVEIRA (1928–2010)

Oliveira had an epiphanous experience as a teen when he saw his first Rembrandt portrait and decided then and there to be an artist. He studied with Max Beckmann and saw the retrospectives of Beckmann, Oskar Kokoschka, and Edvard Munch. All of these things—plus heated discussions with artist friends like Bischoff, Park, and Diebenkorn within the larger general discussion of Abstract Expressionism still ongoing—led to his style: a fusion of action painting and a figural reality. Oliveira focused on the human's solitary existential situation as the primary subject of modern painting.

SELECTED SOLO EXHIBITIONS

1959: *Major Comprehensive Exhibition of Five Years of Work*, Paul Kantor Gallery, Beverly Hills, CA; 1984: *Nathan Oliveira: A Survey Exhibition 1957–1983*, San Francisco Museum of Modern Art, San Francisco (traveled); 2002: *The Art of Nathan Oliveira*, San Jose Museum of Art, San Jose, CA (traveled); 2011: *Nathan Oliveira: A Memorial Exhibition*, John Berggruen Gallery, San Francisco

SELECTED GROUP EXHIBITIONS

1959: *New Image of Man*, MoMA, NYC; 1962: *Recent Painting USA: The Figure*, MoMA, NYC (traveled); 1976: *The Humanist Tradition in Contemporary American Painting*, New School Art Center, NYC; *Painting and Sculpture in California: The Modern Era*, San Francisco Museum of Modern Art, San Francisco; 1980: *The Painterly Print*, The Metropolitan Museum of Art, NYC; 1989: *Bay Area Figurative Art 1950–1965*, San Francisco Museum of Art, San Francisco (traveled); 1991: *American Realism and Figurative Art 1952–1990*, The Miyagi Museum of Art, Sendai, Japan (traveled); 2008: *Summer in the City 2008*, John Berggruen Gallery, San Francisco; *Ashes to Life – A Portuguese American Story in Art*, Sanchez Art Center, Pacifica, CA

NORA SPEYER (b. 1923)

Born to an artistic mother in Pittsburgh—along with Nora Speyer's sister, Darthea Speyer (who had a highly respected modern art gallery in Paris), and architect brother, James Speyer (whose last position was as curator of twentieth century art at the Art Institute of Chicago)—Speyer seemed fated to be an artist. She studied at Philadelphia's Tyler College of Fine Art where she met her husband-to-be Sideo Fromboluti, and they have been painting in adjoining studios—full time and year round—ever since. Speyer's primary subject is humankind's fall from a

God-given state of grace due to the acquisition of knowledge. This theme seems to evolve over many years of use. In early depictions, the figures cower in their attempt to escape God's wrath. Later, Speyer shifts the emphasis to the aftermath of the sexual act and the role of the snake (knowledge) in their downfall.

SELECTED SOLO EXHIBITIONS
1957–1966: Tanager, Stable, and Poindexter Galleries, NYC; Galerie Paul Facchetti, Paris; 1970–1977: Landmark Gallery, NYC; Tirca Karlis, Provincetown, MA; Galerie Darthea Speyer, Paris; 1978–1984: Long Point Gallery, Provincetown, MA; Landmark Gallery, NYC; Gross McLeaf Gallery, Philadelphia, PA; William & Mary College, Williamsburg, VA; Museum of Art, Pennsylvania State University, University Park; Brownson Art Gallery, Manhattanville College, Purchase, NY; 1985–2002: Long Point Gallery, Provincetown, MA; 1987: Ingber Gallery, NYC; 1989, 1996, 2001: Galerie Darthea Speyer, Paris; 1996, 1998, 2002: Denise Bibro Fine Art, NYC; 2002: Provincetown Art Association and Museum, Provincetown, MA

SELECTED GROUP EXHIBITIONS
1947: Contemporary Gallery, Philadelphia, PA; 1955: *New Talent*, MoMA, NYC; 1958: *Carnegie International*, Carnegie Institute, Pittsburgh, PA; 1968: *The Obsessive Image 1960–68*, Institute of Contemporary Art, London; 1969: *Salon de Mai*, Museum of Modern Art, Paris; *Certain Figure Trends Since the War*, Musée d'Art, Saint-Étienne; 1973: *IX Painters*, Fordham University, NYC; 1974: *Women's Work*, Museum of the Philadelphia Civic Center and Port of History Museum, Philadelphia, PA; 1975: *Art on Paper*, Weatherspoon Art Gallery, Greensboro, NC; *Works By Women*, Kresge Art Center, Michigan State University, East Lansing; 1978: *5*

Contemporary Artists, Allentown Art Museum, Allentown, PA; 1981: *14 Provincetown Artists*, Weatherspoon Art Gallery, Greensboro, NC; 1984: Juried Exhibition, National Academy of Design, NYC; 1985: *Male Nude, Women Regard Men*, Hudson Center Galleries, NYC; 1993: *Relatively Speaking: Mothers and Daughters in Art*, Sweet Briar College, Sweet Briar, VA (traveled).

SELINA TRIEFF (b. 1934)

Selina Trieff was born in New York City, where she still lives. She studied with "Mr. Ebullience," Hans Hofmann, and also with "Mr. Austerity," Ad Reinhardt, so it should be no surprise that her paintings are unlike anything else in contemporary art. Their iconic force and surface treatment have their closest parallels in late medieval and early Renaissance paintings. The frontality, hieratic power, high seriousness, icon-like gold and regal red surfaces, backgrounds, and clothing all work together to recall a distant but critical period in art history. In 2004, Vineyard Video Productions made a one-hour documentary about her and Robert Henry titled *Their Lives in Art: Robert Henry and Selina Trieff.*

SELECTED SOLO EXHIBITIONS
1960: Nonagon Gallery, NYC; 1961, 1962, 1965: Area Gallery, NYC; 1962, 1963: Sun Gallery, Provincetown, MA; 1972, 1973, 1975, 1976: Riverrun Gallery, Edgartown, MA; 1978: Indianapolis Art League, Indianapolis; Galleri Anna H., Göteborg, Sweden; 1982: Manhattanville College, Purchase, NY; 1983: Rutgers University, New Brunswick, NJ; 1984, 1989, 1999: Galleri Cassandra Drøbak, Norway; 1984, 1986: Artes Gallery, Oslo, Norway; 1995: Berta Walker Gallery, Provincetown, MA; 1999: Galleri Cassandra Drøbak, Norway 2008: *Master*

of The Look, Providencetown Museum and Art Association, Providencetown, MA; 2010: *Contemporary Icons*, Ruth Bachofner Gallery, Santa Monica, CA

SELECTED GROUP EXHIBITIONS

1964: *Contemporary American Figure Painters*, Wadsworth Atheneum, Hartford, CT; *Contemporary Figurative Painting*, Institute of Contemporary Art, University of Pennsylvania, Philadelphia, and the Hartford Museum of Contemporary Art, Hartford, CT; 1971: Stamford Museum and Nature Center, Stamford, CT; 1973: *Women Choose Women*, New York Cultural Center, NYC; *Sons and Others*, Queens Museum, Queens, NYC (traveled); 1978: *Women Artists, '78*, The Graduate Center of the City University of New York, NYC; 1980: *Image, Self Image*, Pace University, NYC; 1981: Provincetown Art Association and Museum, Provincetown, MA; 1982: National Academy of Design, NYC; 1983–1984: *Hans Hofmann as a Teacher*, MoMA, NYC (traveled); *New York/ Indiana Connection: Women Artists*, Snite Museum of Art, University of Notre Dame, Notre Dame, IN (traveled); 1998: *4th Annual Holiday Group Show*, Ruth Bachofner Gallery, Santa Monica, CA; 2008: *Women of a Certain Age and Beyond: Dotty Attie, Louise Bourgeois, Ann Chernow, Nancy Spero, Selina Trieff*, The Gallery of Contemporary Art, Sacred Heart University, Fairfield, CT; 2009: *Femme on Femme*, Cypress College Art Gallery, Cypress, CA

PAUL WONNER (1920–2008)

Based in San Francisco, Paul Wonner had two distinct chronological periods in his long, art-filled life: the last was mainly still lifes, but the first was figurative and heavily influenced by the other Bay Area painters he knew, such

as Richard Diebenkorn and David Park. These two primary purveyors of figural painterly expressionism inspired his use of gesture and aggressive color to meld figure and surroundings, gesture, and content in reality-based settings. Influenced by the figurative artists around him, his subject matter had a narrative richness tempered by a natural tendency to keep psychological nuances and implications private. *Gods in Wood and Stone* is a perfect example of both the kind of compelling mystery that may enshroud a fine example of his work in that deeply emotionally complex time and his response to it.

SELECTED SOLO EXHIBITIONS

1956: de Young Memorial Museum of Art and San Francisco Museum of Modern Art, San Francisco; 1958–1965, 1978, 1981, 1985, 1988, 1990, 1991, 1992, 1994, 1996, 1998: John Berggruen Gallery, San Francisco; *Paul Wonner: Still Lifes*, Art Institute of Southern California, Laguna Beach; 1959, 1960, 1962, 1963, 1964, 1965, 1967, 1968, 1971: Felix Landau Gallery, San Francisco; 1960: Santa Barbara Museum of Art, Santa Barbara, CA; 1962: California Palace of the Legion of Honor, San Francisco; 1964, 1971: Poindexter Gallery, NYC; 1965: Marion Koogler McNay Art Institute, San Antonio, TX; 1972: Santa Barbara Museum of Art, Santa Barbara, CA; 1972, 1974: Charles Campbell Gallery, San Francisco; 1981: *Paul Wonner: Abstract Realist*, San Francisco Museum of Modern Art, San Francisco (traveled); 1999 and 2003: DC Moore Gallery, NYC; 2008: *Paul Wonner: A Memorial Exhibition*, John Berggruen Gallery, San Francisco

SELECTED GROUP EXHIBITIONS

1957–1958: *Contemporary Bay Area Figurative Painting*, Oakland Art Museum, Oakland, CA;

1962–1963: *Recent Paintings USA: The Figure*, MoMA, NYC; 1964: *Pittsburgh International Exhibition of Contemporary Painting*, Carnegie Institute, Pittsburgh, PA; 1976–1977: *Painting and Sculpture in California: The Modern Era*, San Francisco Museum of Modern Art, San Francisco, and the Smithsonian American Art Museum, Washington, DC; 1981–1982: *Contemporary American Realism since 1960*, Pennsylvania Academy of Fine Arts, Philadelphia, PA; 1982: *Realism and Realities: The Other Side of American Painting 1940–1960*, Rutgers University Art Gallery, New Brunswick, NJ; 2009: *California Calling: Works from Santa Barbara Collections, 1948–2008*, Santa Barbara Museum of Art, Santa Barbara, CA

INDEX

Drexler, Sherman, 4, 5, 9, 12; exhibitions, 132; influences on, 132, 133; wife Roslyn, 130, 133; *Standing Figure*, 130, *131*, 133; surface of, 132; women, figures, nudes and, 130, *131*, 132–33

Dugmore, Edward, 80

Dürer, Albrecht, 64

E

East Coast artists, 4

8th Street art school, 12

Eli and Edythe Broad Art Museum: drawings/mixed media, 53, 114; Figurative Expressionist collection, 55, 121–22, 138; paintings, 57, 62, 97, 109, 125, 133, 134; prints, 102, 105

Emotional Impact: New York School Figurative Expressionism (exhibition), 131 (n. 9)

Ensor, James, 19, 57

exhibitions. See *by specific name*

existentialism, 3, 59, 88, 90, 134

expressionism, 30, 56; American, 24, 34, 80, 91; brutish, 38, 80, 125; Europeanized, 2; "formed," 27; German, 1, 112. See also *movements by name*

F

Fauves, 1, 19, 112, 125; color of, 13; De Niro and, 127; style, 32

Fifteen Americans (exhibition), 30

figural style. *See* Beauchamp, Robert; de Groot, Nanno; Diebenkorn, Richard; Drexler, Sherman; Milder, Joy; Müller, Jan; Thompson, Bob; Trieff, Selina

figuration, 8, 9, 12, 13

Figurative Expressionism, 1, 3, 80; American, 4, 6–9, 14, 16, 24, 28, 72–73, 106, 112; California, 87; classicists and, 5, 13, 81, 82, 107, 109, 123; de Kooning importance in, 102; exhibitions, 8–9, 138, 139 (n. 9); figuration and, 8, 9,

12, 13; fusing with Abstract Expression, 106; growth of, 5, 81, 88, 102; idea behind, 137; influence of, 3; New York style of, 8, 91; paint itself and, 2, 8, 135; painterly ideals of, 4; passion in, 4; process as primary in, 2; style of, 6–7, 90–91, 106, 121; surface, 9; symbolic subject matter and, 3; underexplored, 138; West Coast growth of, 8, 81–97

Figurative Fifties, The: New York Figurative Expressionism (exhibition), 8–9

"figurative hybrid," 7–8, 27, 28, 32

figurative painting, 73, 89, 90, 91; Bay Area School of, 84, 87, 93, 95; European, 88; expressive, 19; revival of, 8–9; traditional, 100

figure: built from paint, 8, 88, 137; distortion of, 13, 28, 30; reality and, 8; as subject, 3, 4, 24, 80, 100, 137; return to, 5, 19

Finkelstein, Louis, 4; figures and landscapes of, 130; influences on, 130; as teacher, 128, 130. Works: *Bastian de Cézanne*, 130; *Landscape, Bushes, and Trees*, 130; *Two Figures, Two Heads*, 128, 129

FIVE, The, 73

"formed expressionism," 27

Forum 49 (exhibition), 14

Frazier, John, 56

Fromboluti, Sideo: as Action Painter, 125; brushwork of, 120, 125; classicist, 123; drawing, live model, 120; figure and, 5, 125; friends of, 120–21; influences on, 125; post-war memories of, 5–6, 121; style of, 4, 120, 122–25; surface of, 120; wife Nora Speyer and, 124. Works: *Night Out I*, 124; *Night Out #12*, *123*, 123, 124; *Sleeping Entertainer*, *122*, 122, 124; *Wedgwood Cookie Jar on Paint Table*, 122, *124*, 125, 127; *Woman in Interior*, 120, *121*

Frumkin, Peter, 84

Fuseli, Henry, 19

imagery, 3, 9, 27, 28, 30

imagination, 6, 19, 34, 36, 40, 47

imagism, 72, 95

impasto, 16, 109, 118

Impressionism, 68, 83, 134–35; "dark" Munich
 School, 2. *See also* Bonnard; Cézanne;
 Degas; Gauguin; Manet; Matisse; Seurat;
 Soutine; Vuillard

Intimist, 134

J

Jackson, Martha, 90

Jackson, Oliver: brushwork of, 96; influences
 on, 94, 96; painting of, 95, 96–97; sculpture
 of, 97; spiritual energy of, 96; style of, 95–97,
 140 (n. 7); as teacher, 96. Works: *Untitled
 (6.8.03)*, 94, *95*, 97

James Gallery, 6

Jaspers, Karl, 3

Jay Milder Expressionismo (exhibition), 40

jazz, 37, 40, 96, 103; visual, 14, 24, 81

Jewish Museum, 7

Johnson, Lester, 4; as Action Painter, 106, 109;
 Figurative Expressionist, 106–109; fusion of
 figure and expressionism by, 106; galleries
 and, 6, 13, 106; impasto of, 109; painterly
 gestures and style of, 106, 107, 109; as
 teacher, 106. Works: *Men*, 13; *Summer Group
 Walking #5*, 107, *108*, 109; *Three Figures,
 Milford*, 106, *106*–107; *Three Polycleitan
 Figures*, 107, 109

K

Kahn, Wolf: brushwork of, 133, 134; color as
 protagonist of, 133, 134; exhibitions, 134;
 expressionist, 134; figure and, 133; friends
 of, 135; influences on, 133, 134; landscapes
 of, 133; style of, 7, 133–35; wife Emily Mason,

133–34, *135*, 135. Works: *First Barn Painting*,
 133; *Landscape Sequence*, 133; *September
 Light*, 133–34, *135*

Kalamazoo Institute of Arts, 85

Kantor, Morris, 56

Kantor, Paul, 84

Katz, Alex, 9

Kees, Weldon, 14

Klement, Vera: Abstract Expressionism and,
 72; abstraction and, 72, 73; in Chicago, 73;
 exhibitions, 73; as Figurative Expressionist,
 72, 73, 77; imagination and, viii, 72; literary
 life of, 72, 73, 77; paint use by, viii, 73–74;
 style of, 72; as teacher, 73. Works: *Black
 Peonies*, 74; *Black Roses*, 74, 75–76; *Danae*
 (diptych), 76–77, *75*, 77; *Mara*, *74*, 75; *Stefan
 Volpe at the Window*, 73; *Treetops*, 73

Kline, Franz, 16, 62, 106, 114; clown portraits of,
 46, 54; creative style of, 2–3; galleries and,
 24; struggles of, 6

Kokoschka, Oskar, 57, 88

Kootz Gallery, 64

Krannert Art Museum, 83

Kriesberg, Irving, 37; allusion of, 29; American
 Expressionism and, 32, 34; animal world of,
 28; books by, 36; brushwork of, 28, 30; as
 colorist, 28, 31–32, 36; dancing as subject
 of, 39; emotional style of, 4, 30, 31–32, 36;
 exhibitions, 30, 31; Fauvist influence on,
 32; figure and, 31–32; film by, 36, 140–41
 (n. 14); fusion of, 34; imagery of, 29, 32,
 30, 34, 36, 140 (n. 11); influences on, 31, 141
 (n. 16); Mexico-liberated, 30; style of, 30,
 34, 36; video by, 36. Works: "Changeable
 Paintings," 36; *Dancer with Sheep*, 30;
 Green Dormition, 140 (n. 11); *Harvest
 Woman Tiger's Belly*, 32; *The Journey*, 34,
 35, 36; *Malcolm*, 32, *33*, 34; *The New Baby*,
 29, *29*, 30, 112; *Roslyn Diary (Altarpiece)*,
 36; *Storyboard Scenes*, 36; *Street Faces*, 31;